PERSPECTIVE DRAWING FOR INTERIOR SPACE

PERSPECTIVE DRAWING

FOR INTERIOR SPACE

CHRISTOPHER NATALE, MFA

FAIRCHILD BOOKS | NEW YORK

Executive Editor: Olga T. Kontzias
Assistant Acquisitions Editor: Amanda Breccia
Senior Development Editor: Joseph Miranda
Assistant Art Director: Sarah Silberg
Production Director: Ginger Hillman
Production Editor: Andrew Fargnoli
Copyeditor: Susan Hobbs
Ancillaries Editor: Noah Schwartzberg
Executive Director & General Manager: Michael Schluter
Associate Director of Sales: Melanie Sankel

Cover and Text Design: Tim MacKay
Page Layout: Dutton & Sherman
Cover Art and Text Illustrations: Christopher Natale

Library of Congress Catalog Card Number: 2011923277
ISBN: 978-1-60901-071-3
GST R 133004424

Printed in Canada
TP14 CH12

To my loving and supportive family—especially my wife, Nicole,
and my new baby twins, Noël and Nicholas.

CONTENTS

EXTENDED CONTENTS

PREFACE

While teaching college-level perspective classes I have encountered only two types of perspective books—very basic and very advanced. The first type limits its instruction to the very basic skills and doesn't venture into more detailed drawings or processes. The second type of book is so advanced that it assumes the reader already has a good understanding of perspective. The purpose of this book is to combine the successful core elements of both types of textbooks. This text teaches basic techniques and principles of perspective, so that a beginning student can understand how and why perspective drawings are created. Each chapter helps the reader develop and then advance those basic skills. The reader's basic understanding of these elements is enhanced and they can then create complete interior spaces while using different techniques.

This book breaks down the drawings into a step-by-step process, showing each stage of development. Each chapter begins with specific objectives, and each object starts with its geometric form; these objects show the basic principles of perspective. The more advanced chapters show how to incorporate the basic principles and develop the concept into complete interior spaces. Some of the techniques outlined in this book show the reader how to use scaled floor plan and elevation views to create volume and correct proportion to a perspective drawing. Each chapter enables the reader to create interior spaces while using completely different techniques.

TEACHING PHILOSOPHY

My philosophy as it pertains to perspective is simple—you must understand the basic fundamentals or rules to one-point, two-point, and three-point perspectives. When the basics are understood, it's then just repeating the same rules to create more complex drawings. This is because any room drawn in two-point perspective follows the same rules and principles as a simple cube in two-point.

ABOUT THE AUTHOR

Christopher Natale has been teaching perspective at the college level for more than 10 years and is an associate professor in a Council for Interior Design Accreditation (CIDA) interior design program. He is an accomplished furniture designer and fabricator with a BFA from the College for Creative Studies, and a MFA with an emphasis in furniture design from Arizona State University. He has more than 20 years of hands-on expertise in metals and wood. His product design experience includes both computer-aided design and traditional illustration methods. His original designs and custom pieces have gained wide recognition among prestigious galleries, private clients, and interior design firms. His work regularly appears in television and magazine features, juried exhibitions, and invitational shows.

In addition to his track record as a creative artist, his teaching experience includes college-level curriculum development, lectures, demonstrations, and class projects that cover the entire range of the artistic process, from creative problem solving to all aspects of manual and computer-aided drafting and rendering to finished production techniques. He is also the author of *Furniture Design and Construction for the Interior Designer,* also published by Fairchild Books.

ACKNOWLEDGMENTS

I would first like to thank all of the students over the years in my perspective classes. These students have helped me develop a better understanding of what works in the classroom. They have also helped me develop lectures and projects that push their technical and creative skills. Thank you to Olga Kontzias for her guidance through the outline and writing process. I would also like to thank Joseph Miranda and the production team at Fairchild Books. And last I would like to dedicate this book to my newborn twins, Nicholas and Noël.

PERSPECTIVE DRAWING FOR INTERIOR SPACE

1

Perspective Drawing, Tools, and Other Essential Information

Perspective can be divided into three basic types: one-, two-, and three-point perspectives. The point refers to the vanishing point or how many vanishing points are in the drawing. When a three-dimensional object or space is being created on a flat surface plane like a piece of paper, in order to imply depth, some of the object lines converge to a vanishing point or points. This makes the object appear to have volume. To help demonstrate the difference between these point types, the examples in Figures 1.1 through 1.3 show a cube first in one-point, then rotated into two-point, and then tilted forward into three-point perspective. In one-point perspective, the cube's front is flat to the viewer. That front surface plane is a simple square, and the top and side surface planes are drawn to a single vanishing point.

In three-point perspective, the left and right vanishing points stay the same, but a vertical point is added. Now instead of the vertical lines of the cube beginning parallel to each other, they converge to that third vanishing point. This type of perspective is based on the number of vanishing points; however, there are some exceptions to this rule. For example, a room or space can be drawn in a one-point perspective and have a chair turned and drawn in two-point. That type of setup would have three vanishing points, but is not considered a three-point perspective. It's a one-point room with a two-point perspective chair. Figure 1.4 shows an example of this with a two-point small cube on top of a larger one-point cube.

PERSPECTIVE VS. ISOMETRIC DRAWINGS

Both perspective and isometric drawings will show an object in a three-dimensional form; however, these two types of drawings are completely different from each other. An isometric drawing uses predetermined angles, for example 30 degrees, to create an object's depth. This creates a drawing that can be measured, because all angled sides are parallel to one another. Therefore, a cube drawn in isometric view will have a front edge that will be the same size as the back edge. (See Figure 1.5.)

This is not the case with a perspective drawing. A perspective drawing cannot be measured because the depth is being drawn to a vanishing point, creating the illusion of depth. This is the way the human eye judges depth, by objects becoming smaller as they move away from the viewer. That same cube drawing in perspective will have the back edge smaller than the front edge.

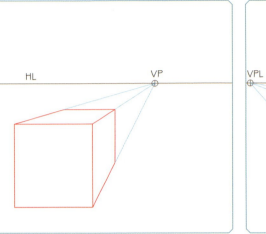

Figure 1.1
Cube drawn in one-point perspective.

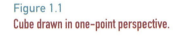

Figure 1.2
Cube drawn in two-point perspective.

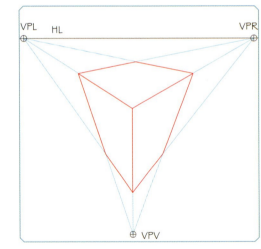

Figure 1.3
Cube drawn in three-point perspective.

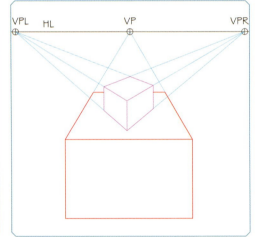

Figure 1.4
Combination of one- and two-point perspectives.

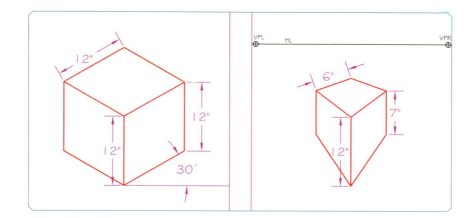

Figure 1.5
The image on the left shows a cube drawn in isometric view; the cube on the right is drawn in perspective view.

CONE OF VISION

The cone of vision refers to the space the human eye can see. This does not include peripheral vision; it refers only to a person's vision looking straight ahead. This cone is 60 degrees looking outward from eye to eye as shown in Figure 1.6. Not all drawing need a cone of vision to be created, but when drawing in perspective it is easiest to create by drawing a center line as the middle of the face and creating a 30-degree line on each side of center to produce the full 60-degree angle. Images outside this cone can become distorted.

TOOLS AND MATERIALS

This section describes and shows illustrations of the different types of drawing tools needed for perspective drawing. When sketching in perspective you need only a pencil and paper; but to create accurate, detailed perspective drawings, the following tools are essential.

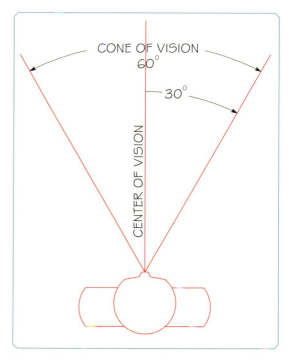

Figure 1.6
Top view of a person with the center of vision and the cone of vision.

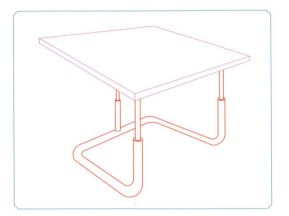

Figure 1.7
Drafting table.

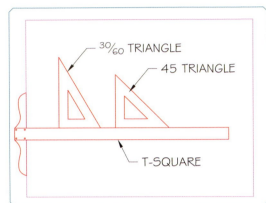

30/60 TRIANGLE

45 TRIANGLE

T-SQUARE

Figure 1.8
T-square with a 45-degree and 30/60-degree triangles.

Figure 1.9
Adjustable triangle.

Drafting Table The drafting table should have an adjustable top that tilts and square sides. The square sides are for the T-square, so it can be used to create accurate drawings. There are also drafting tops that tilt, are portable, and are used with a standard desk or table such as a dining table. (See Figure 1.7.)

T-square The T-square is used to create horizontal lines in a perspective drawing. A parallel ruler can be used in place of a T-square. (See Figure 1.8.)

Triangle The triangle is used with the T-square or parallel ruler to create vertical lines in a perspective drawing. The triangle is available in different angles and sizes including 45 degree, 30/60 degrees, and adjustable. (See Figures 1.8 and 1.9.)

Parallel Ruler The main difference between a T-square and a parallel ruler is that the parallel ruler is attached to the drafting table top and uses a cable system to create equal pressure on the straight edge.

TIP Use the T-square or parallel ruler to create all the horizontal lines and the triangle at a right angle with the T-square or parallel ruler to create all the vertical lines. This simple step will drastically speed up the drawing time. (See Figure 1.10.)

Scale Ruler The scale ruler is used to create proportional drafted images by measuring at a scale factor in inches and feet or the metric system. (See Figure 1.11.)

Templates Templates are available in circle, ellipse, and furniture styles. The circle and ellipse templates are useful for creating curves, but curves can also be created by using a compass or French curve set. (See Figure 1.12 and 1.13.)

PARALLEL RULER

Figure 1.10
Parallel ruler.

Figure 1.11
Architectural scale in front and a metric scale in back.

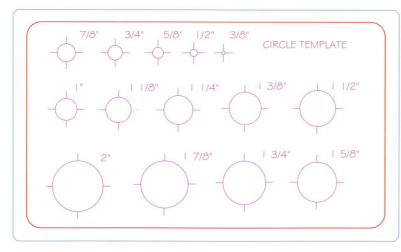

7/8" 3/4" 5/8" 1/2" 3/8"

CIRCLE TEMPLATE

1" 1 1/8" 1 1/4" 1 3/8" 1 1/2"

2" 1 7/8" 1 3/4" 1 5/8"

Figure 1.12
Circle template.

Figure 1.13
Typical French curve set.

Figure 1.14
Different types of papers.

Paper The type of paper used for perspective depends on the medium that will be used. Sketch paper is used for pencil drawings, whereas marker paper is used for ink and marker rendering because it is somewhat translucent, which makes it good for overlaying sketches to create final drawings. Vellum is another type of paper that can be used for pencil, ink, and marker, but the marker stays wet longer than on marker paper, creating a different look.

TIP To speed up the drawing process, use the T-square or parallel ruler to make sure the paper is square to the drafting table and then tape the paper down to the table. (See Figure 1.14.)

Pencils Pencils have a range from hard to soft leads. The hard leads create lighter lines while the soft leads create darker lines. An easy way to understand this lead system is with the HB pencil, which is the same as a #2 pencil. If you think of HB as the middle of the range, then 2H is lighter, followed by 4H, and so on. The 2B is darker than HB, and as the numbers get larger the pencil is darker. (See Figure 1.15.) From hardest to softest, the leads are 9H | 8H | 7H | 6H | 5H | 4H | 3H | 2H | H | F | HB | B | 2B | 3B | 4B | 5B | 6B | 7B | 8B | 9B.

Technical Pens Technical pens have a range based on the tip thickness. These pens can be bought individually or in a set. A set might have the following pens: .005, .01, .03, .05, .07; the higher the number, the thicker the tip. (See Figure 1.16.)

Erasers Many types of erasers are available. The most useful seem to be the white plastic or classic pink erasers to remove larger areas and the kneaded eraser or pencil-style eraser to remove smaller spots. (See Figure 1.17.)

2H

HB

2B

4B

Figure 1.15
Typical types of pencils used for drafting and perspective.

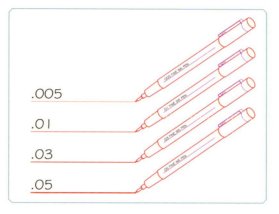

.005

.01

.03

.05

Figure 1.16
Basic technical pen set.

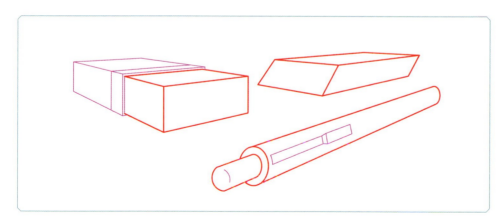

Figure 1.17
Different styles of erasers that are good for perspective drawings.

2

Drawing Basic Geometric Forms in Perspective

This chapter illustrates how to draw basic geometric forms such as solid and transparent cubes, pyramids, cones, and cylinders. We start with one-point forms and finish with two-point forms to create the basic foundation for drawing in perspective. These forms are the building blocks for creating more complex images like furniture and complete rooms, which are covered in later chapters. By the end of this chapter you will have the ability to create basic geometrics such as the cube, pyramid, cone, and cylinder. You will be able to draw these forms as solid and transparent objects in one-point and two-point perspective. Also this chapter introduces the idea of volume of objects and the space between those objects, so that the picture plane becomes an infinite three-dimensional space.

For instructional purposes, most of the chapter's images in this book were created in AutoCAD. This was done to create a consistent step-by-step process. Table 2.1 shows the basic lines used in the drawings.

Table 2.1
Color Key for Drawings

New Object line	————————
Old Object line	————————
Construction line	————————
Guideline	· · · · · · · · · ·

COMPARING ONE-, TWO-, AND THREE-POINT PERSPECTIVES

As they are listed, the number of points refers to the vanishing point or points. One-point perspectives have only one vanishing point (VP) because of the position of the object or interior space as shown in Figures 2.1a and 2.1b. When the position is turned or changed, the drawing or photo can become a two-point perspective. The easiest way to tell if the object is in two-point is when the front corner of the object is closest to the viewer as shown in Figures 2.2a and 2.2b.

This is also true for interior spaces, except now the back corner of the room is the furthest from the viewer. When this is the case there will no longer be one vanishing point, but two, a vanishing point left (VPL) and vanishing point right (VPR). See Figures 2.3 and 2.4, which show the difference between one- and two-point perspective as it relates to a complete interior space.

Figure 2.1a
This first photo was taken with the table positioned as a one-point perspective.

Figure 2.1b
This photo shows the edges of the table drawn outward until they converge. An extra line was drawn where these edges intersect to show that the base detail should come from the vanishing point.

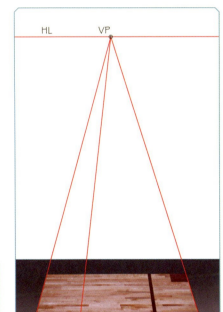

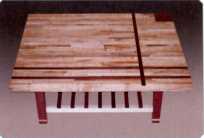

2

Figure 2.2a

Here is the same table in Figure 2.1a, turned so the front corner is now closest to the viewer. By doing this the object is now in two-point perspective, and the edges of the table can be drawn outward until they intersect.

Figure 2.2b

The intersection points become the vanishing point left and vanishing point right. A horizon line can also be drawn across the page connecting the points.

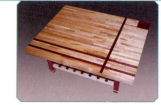

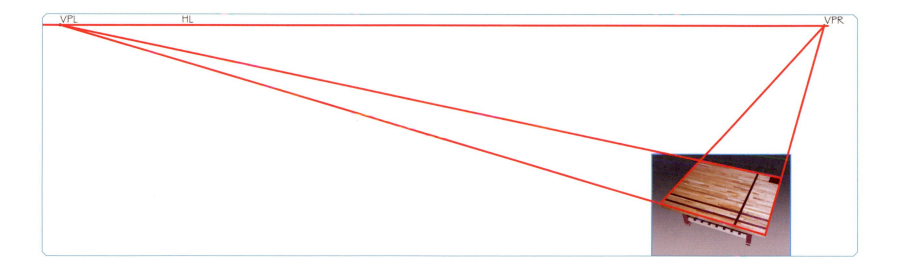

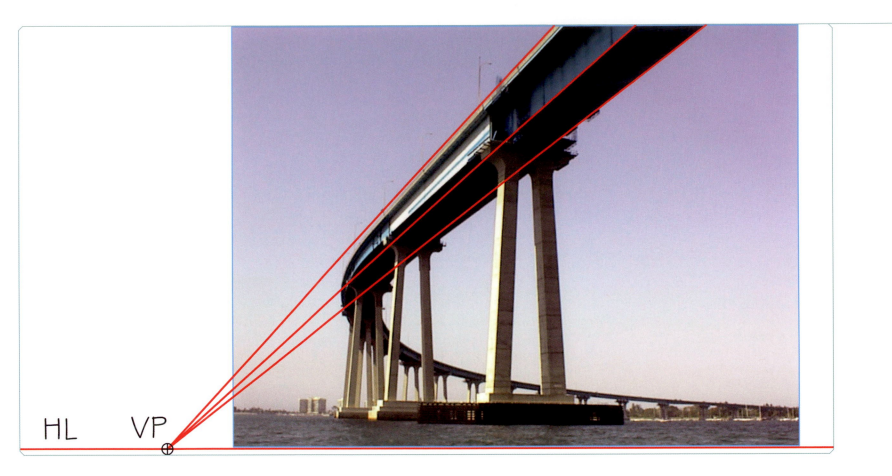

HL **VP**

Figure 2.3
The Coronado Bridge in San Diego. Eye level is low because the photo was taken at the water level, and there is a single vanishing point on the horizon line for the straight part of the bridge.

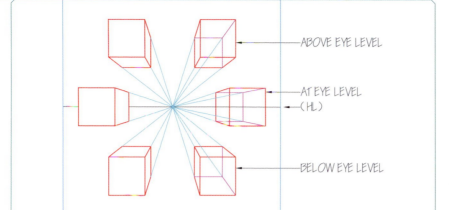

ABOVE EYE LEVEL

AT EYE LEVEL
(HL)

BELOW EYE LEVEL

Figure 2.4
An example of solid cubes to the left and transparent cubes to the right of the vanishing point, above, below, and at eye level.

ONE-POINT PERSPECTIVE

One-point perspective is viewing an object or room so that the placement shows the front of the object or back of the room as flat to the viewer. These types of drawings have only one vanishing point.

Terms for One-Point Perspective

- **Horizon line (HL):** This line represents the viewer's eye level in the drawing.
- **Eye level (EL):** This line is the same as the horizon line. Eye level is the term used for interior drawings; the actual horizon may not be seen because it is blocked by walls.
- **Vanishing point (VP):** This single point in the one-point perspective represents from where lines are drawn to create distance; therefore, any line traveling from the front to the back of an object lines up with the vanishing point. The vanishing

point is placed on the (HL) or (EL) line as shown in Figure 2.3.

- **Below eye level:** The object is drawn below the horizon line or looking down on an object.
- **Above eye level:** The object is drawn above the horizon line or looking up at an object.
- **Eye-level view:** The object is drawn over or in front of the horizon line, so that part of the object is slightly above and below the horizon line.

Rules for One-Point Perspective

When drawing a cube or object flat to the ground, the lines are drawn in one of three basic ways:

1. Lines are drawn perpendicular to the horizon line to create the height.
2. Lines are drawn parallel to the horizon line to create the width.
3. Lines are drawn to the single vanishing point to create the depth.

Repeating these lines creates the back of the object, adds detail, and creates volume in the object. There are exceptions to these rules; for example, if the object is tilted (not flat to the ground) or if there is an angle such as a wedge or pyramid-shaped object.

To set up the one-point perspective, start by creating a horizon line (HL). There is one vanishing point (VP) in these types of drawings. The VP can be placed anywhere on the horizon line; however, after the point is placed it cannot be moved. Think of a photograph—the vanishing point represents what the viewer or camera was aiming at in the photo. When the picture is taken, that picture is frozen in time and cannot be changed. The same principle applies to a one-point perspective. All objects drawn in the one-point perspective have lines that converge to that single point.

CREATING A CUBE

The purpose of creating a solid cube is to quickly define the total space of an object. A transparent cube is a great way to see the total volume or three-dimensional space of the object as well as a starting point for creating furniture that may have negative space, curves, and other details such as shelves, feet, and legs. The first part of this chapter shows how to create both solid and transparent basic cubes. Then, using the cube as a starting point, it shows how to create other geometric objects in one-point perspective. This chapter repeats this process for two-point and three-point perspective.

One great thing about perspective is after you understand how to create geometric objects, you can use the same basic steps to create other more complex objects such as furniture. You then just repeat those steps to create the details. In later chapters you see the transparent cube used to create tables, chairs, and other pieces of furniture as well as to create the placement of objects in a room.

SOLID CUBE

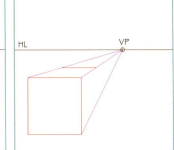

Step 1. Create a horizontal line across the page. This is the horizon line (HL). Place the vanishing point (VP) on the horizon line. Note the VP can be placed to the left, right, or centered.

Step 2. Draw the front of the cube, which is a square. Top and bottom lines are parallel to the HL while the vertical line should be perpendicular to the HL.

Step 3. Draw lines from the outside corners to the VP.

Step 4. Decide on a depth for the cube, and draw a perpendicular line to the HL between the two lines that converge to the vanishing point.

TRANSPARENT CUBE

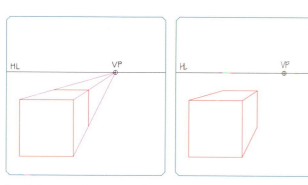

HL VP

Step 1. Create a solid cube.

HL VP

Step 2. Draw a line from the left front corner to the VP.

HL VP

Step 3. Draw a line from the back corner parallel to the HL until it intersects with the line in Step 2, and then draw a line upward from that intersection to the top corner.

NOTE All the lines from Steps 2 and 3 should intersect with one another.

HL VP

Completed cube.

HL VP

Step 5. Draw a vertical line from the intersection in Step 4 downward to complete the solid cube.

HL VP

Step 6. Erase any construction lines.

CUBES AT DIFFERENT LEVELS

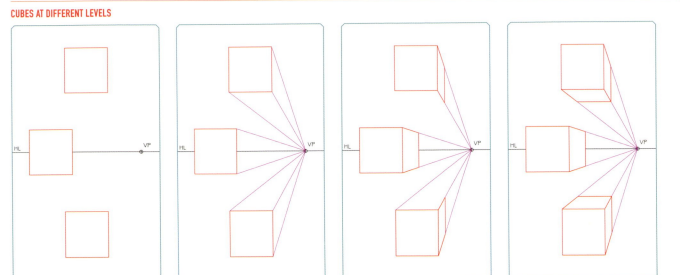

Step 1. Draw a horizon line, and place a vanishing point on that line. Then draw three squares—one above, one below, and one centered on the HL.

Step 2. Draw lines from the outside edges to the VP.

Step 3. Draw a perpendicular line to the HL for each square to create the back edge. This completes the cube that is on the HL.

Step 4. Draw a parallel line to the back edge to complete the cubes above and below the horizon line.

WEDGE

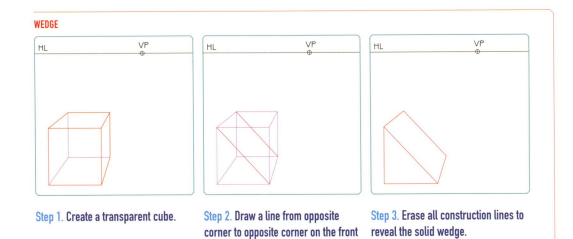

Step 1. Create a transparent cube.

Step 2. Draw a line from opposite corner to opposite corner on the front surface plane and repeat on the back surface plane.

Step 3. Erase all construction lines to reveal the solid wedge.

PYRAMID

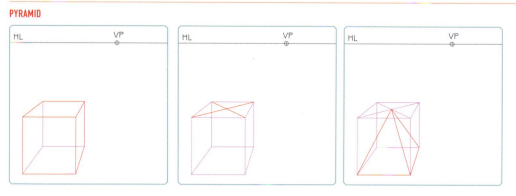

Step 1. Create a transparent cube.

Step 2. Find the center of the cube's top by drawing lines from opposite corners. The center of the top surface plane is where these lines cross.

Step 3. Draw lines from that center line down to the outside corners, and erase the rest of the transparent cube.

SHORTCUT TO CREATING A PYRAMID

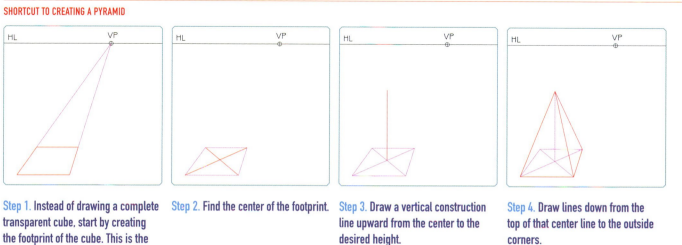

Step 1. Instead of drawing a complete transparent cube, start by creating the footprint of the cube. This is the bottom surface plane.

Step 2. Find the center of the footprint.

Step 3. Draw a vertical construction line upward from the center to the desired height.

Step 4. Draw lines down from the top of that center line to the outside corners.

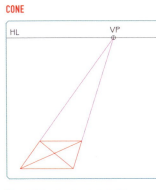

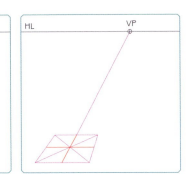

Step 1. Create a footprint of the desired base size of the cone, and find the center of the footprint. The next steps will create an ellipse in the footprint, which is the base of the cone.

Step 2. Draw a line parallel to the HL through the center point across the footprint.

Step 3. Draw a line from the VP through the center point across the footprint.

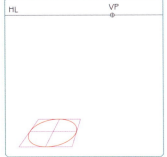

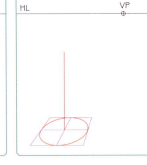

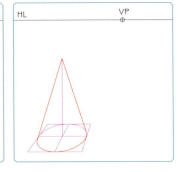

Step 4. Draw the ellipse through the outside intersection points from Steps 2 and 3.

Step 5. Draw a vertical construction line upward from the center to the desired height.

Step 6. Draw two lines down from the top of that center line to the outside edges of the ellipse.

CYLINDER

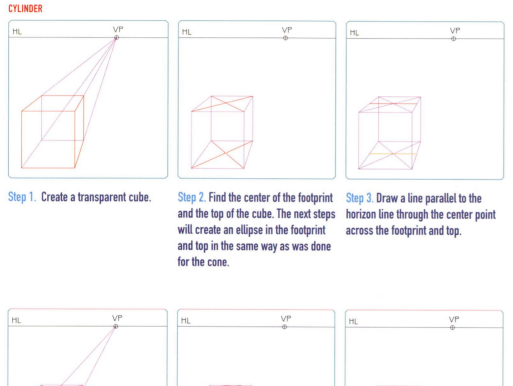

Step 1. Create a transparent cube.

Step 2. Find the center of the footprint and the top of the cube. The next steps will create an ellipse in the footprint and top in the same way as was done for the cone.

Step 3. Draw a line parallel to the horizon line through the center point across the footprint and top.

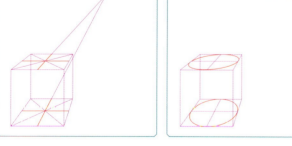

Step 4. Draw a line from the vanishing point through the center point across the footprint and top.

Step 5. Draw the ellipse through the outside intersection points from Steps 3 and 4.

Step 6. Draw two vertical lines down from the outside edges of the top ellipse to the base ellipse.

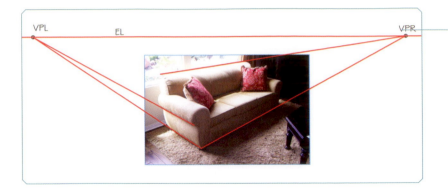

Figure 2.5a
Two-point view of a sofa standing at about 6 feet.

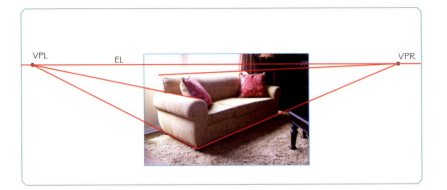

Figure 2.5b
Two-point view of the same sofa sitting at about 3 feet.

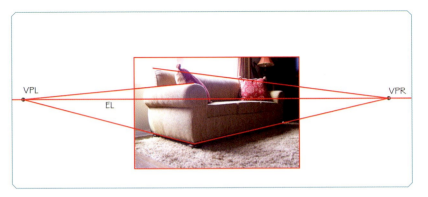

Figure 2.5c
Two-point view of the same sofa now at about 1 foot 6 inches.

TWO-POINT PERSPECTIVE

Two-point perspective is viewing an object so that the placement shows the front corner of that object closest to the viewer. It is like spinning the one-point object to a 45-degree angle. In a room drawing, the back corner is the furthest from the viewer. These types of drawings have two vanishing points—a vanishing point left (VPL) and a vanishing point right (VPR).

Terms for Two-Point Perspective

- **Horizon line (HL):** This line represents the viewer's eye level in the drawing, just like the one-point perspective.
- **Eye level (EL):** This line is the same as the horizon line. Eye level is the term used for interior drawings; the actual horizon may not be seen because it is blocked by walls. This line is used in all types of perspective. (See Figures 2.5a through 2.5c. Note that these photographs were taken from the same point; just the height of the camera was changed.)

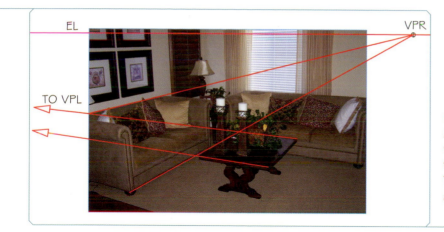

EL · · · · VPR

TO VPL

Figure 2.6

Figure 2.6

An example of a two-point interior space with the vanishing point right slightly outside the photo and the vanishing point left far off the page to the left. The left point is using the edges of the coffee table and the right point is using the edges of the sofa.

- **Vanishing point left (VPL):** In a two-point perspective, one vanishing point is to the left of the center of the picture plane; therefore, any line traveling from the front to the back on the left surface plane lines up with the vanishing point left. This point is also used in three-point perspective. (See Figure 2.6.)
- **Vanishing point right (VPR):** The second point in the two-point perspective is to the right of the center of the picture plane; therefore, any line traveling from the front to the back on the right surface plane lines up with the vanishing point right. This point is also used in three-point perspective. (See Figure 2.6.)
- **Bird's-eye view:** The object is drawn below the horizon line or looking down on the object.

- **Frog's-eye view:** The object is drawn above the horizon line or looking up at the object. This is also known as worm's-eye view.
- **Eye-level view:** The object is drawn over or in front of the horizon line, so part of the object is slightly above and part slightly below the horizon line.

Rules for Two-Point Perspective

When drawing a cube or object flat to the ground, the lines are drawn in only three basic ways.

1. Lines are drawn perpendicular to the horizon line to create the height.
2. Lines are drawn to the vanishing point left to create the depth on the left side of the object.
3. Lines are drawn to the vanishing point right to create the depth on the right side of the object.

Repeating these lines creates the back of the object, adds detail, and creates volume for the object. There are exceptions to these rules, such as if the object is tilted (not flat to the ground) or if there is an angle such as a wedge or pyramid-shaped object.

To set up the two-point perspective, start the same way as with the one-point perspective by creating a horizon line (HL). Remember that the horizon line represents eye level in the drawing. There will be two vanishing points—a vanishing point left (VPL) and a vanishing point right (VPR). These vanishing points will be placed on the horizon line, and after the points are placed they cannot be moved. They create the angle for the object or room for that drawing. All objects drawn in two-point perspective have lines that converge to either the VPL or VPR in order to show depth.

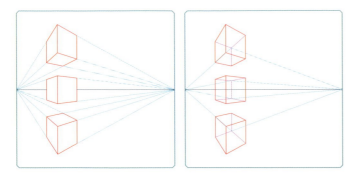

Solid cubes: bird's eye, eye level, and frog's eye.

Transparent cubes: bird's eye, eye level, and frog's eye.

SOLID CUBE

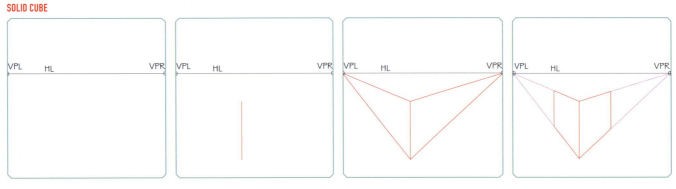

Step 1. Create a horizon line (HL) across the page, and place two vanishing points on the horizon line, one point on the left side, the vanishing point left (VPL), and one on the right side, the vanishing point right (VPR).

Step 2. Draw the front vertical edge of the cube; this line is perpendicular to the horizon line.

Step 3. Draw lines from the top and bottom of the front vertical edge to both vanishing points.

Step 4. Decide on a depth for the cube, and draw a line perpendicular to the HL between the two lines that converge to the vanishing points.

TRANSPARENT CUBE

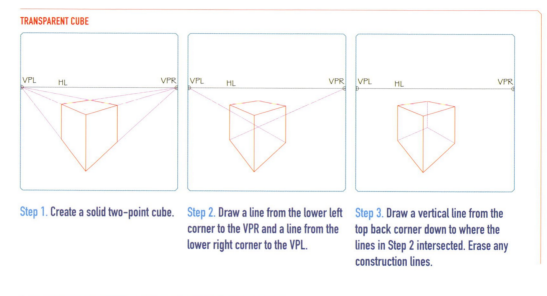

Step 1. Create a solid two-point cube.

Step 2. Draw a line from the lower left corner to the VPR and a line from the lower right corner to the VPL.

Step 3. Draw a vertical line from the top back corner down to where the lines in Step 2 intersected. Erase any construction lines.

Step 5. Draw a line from the top back left line to the VPR and a line from the top back right line to the VPL. Where these two lines intersect creates the top of the cube.

WEDGE

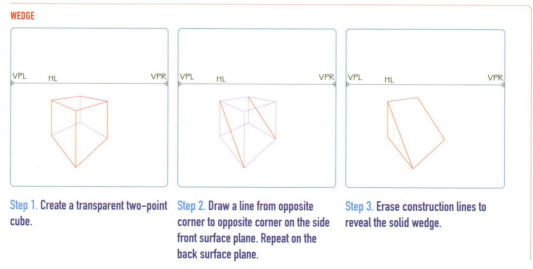

Step 1. Create a transparent two-point cube.

Step 2. Draw a line from opposite corner to opposite corner on the side front surface plane. Repeat on the back surface plane.

Step 3. Erase construction lines to reveal the solid wedge.

PYRAMID

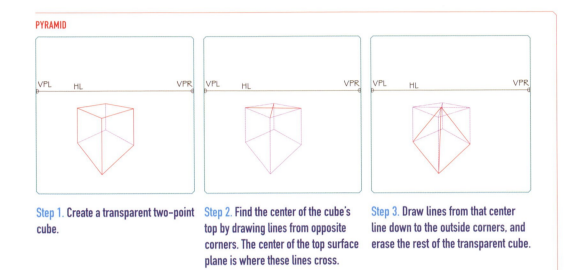

Step 1. Create a transparent two-point cube.

Step 2. Find the center of the cube's top by drawing lines from opposite corners. The center of the top surface plane is where these lines cross.

Step 3. Draw lines from that center line down to the outside corners, and erase the rest of the transparent cube.

SHORTCUT TO CREATING A PYRAMID

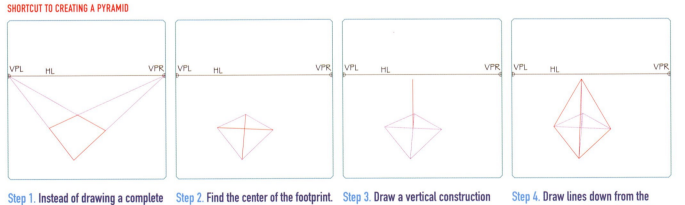

Step 1. Instead of drawing a complete transparent cube, start by creating the footprint of the cube in two-point perspective. This is the bottom surface plane.

Step 2. Find the center of the footprint.

Step 3. Draw a vertical construction line upward from the center to the desired height.

Step 4. Draw lines down from the top of that center line to the outside corners.

CONE

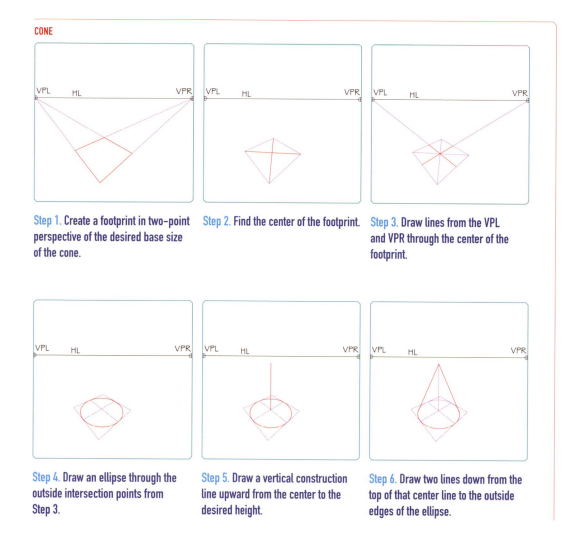

Step 1. Create a footprint in two-point perspective of the desired base size of the cone.

Step 2. Find the center of the footprint.

Step 3. Draw lines from the VPL and VPR through the center of the footprint.

Step 4. Draw an ellipse through the outside intersection points from Step 3.

Step 5. Draw a vertical construction line upward from the center to the desired height.

Step 6. Draw two lines down from the top of that center line to the outside edges of the ellipse.

CYLINDER

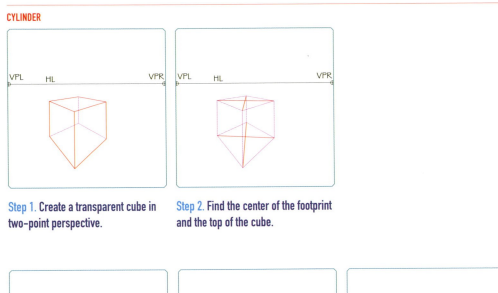

Step 1. Create a transparent cube in two-point perspective.

Step 2. Find the center of the footprint and the top of the cube.

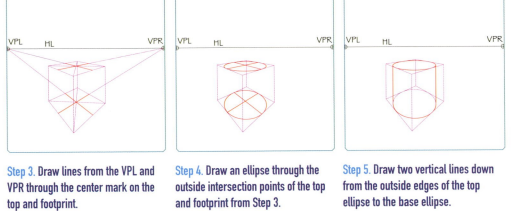

Step 3. Draw lines from the VPL and VPR through the center mark on the top and footprint.

Step 4. Draw an ellipse through the outside intersection points of the top and footprint from Step 3.

Step 5. Draw two vertical lines down from the outside edges of the top ellipse to the base ellipse.

Project 2.1 DRAWING GEOMETRIC FORMS IN ONE-POINT PERSPECTIVE

Create the following geometric objects on 14" × 17' paper.

1. Draw two solid and two transparent cubes varying in shape and size *above* the horizon line.
2. Draw two solid and two transparent cubes varying in shape and size *below* the horizon line.
3. Draw two solid and two transparent cubes varying in shape and size *on* the horizon line.
4. On the same sheet of paper, draw one pyramid, cone, and cylinder.

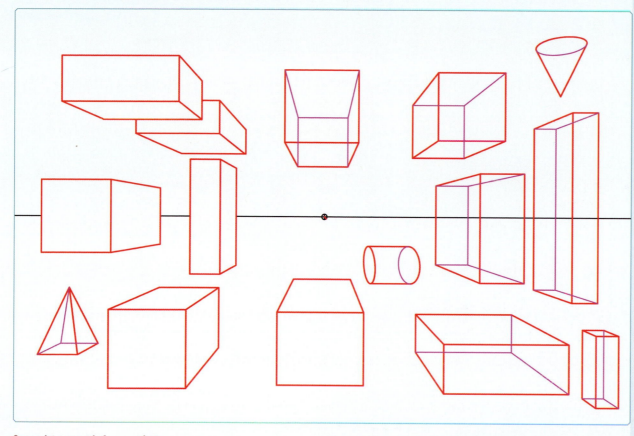

One-point geometric forms project.

GETTING STARTED

1. Use drafting tools (T-square, triangle, and ruler).
2. Lay out your drawing in pencil, preferably with an HB pencil.
3. Create a ½-inch line border all around, creating a 13" × 16" image area.
4. Ink exterior object lines with a .05 thickness, and use .01 thickness for interior transparent lines.

NOTE

Construction lines in pencil do not need to be erased (they can be lightly drawn but visible). The horizon line should also be inked; you will not see the horizon line through solid cubes. The horizon line does not need to be drawn in the center of the picture plane; it may be offset.

Project 2.2 DRAWING GEOMETRIC FORMS IN TWO-POINT PERSPECTIVE

Create the following geometric objects on 14" × 17' paper.

1. Draw two solid and two transparent cubes varying in shape and size *above* the horizon line.
2. Draw two solid and two transparent cubes varying in shape and size *below* the horizon line.
3. Draw two solid and two transparent cubes varying in shape and size *on* the horizon line.
4. Experiment by altering these objects, such as adding holes through the cubes or creating angled surface planes.

GETTING STARTED

1. Use drafting tools (T-square, triangle, and ruler).
2. Lay out your drawing in pencil, preferably with an HB pencil.
3. Create a ½-inch line border all around, creating a 13" × 16" image area.
4. Ink exterior object lines with a .05 thickness, and use .01 thickness for interior transparent lines.

NOTE

Construction lines in pencil do not need to be erased (they can be lightly drawn but visible). The horizon line should also be inked; you will not see the horizon line through solid cubes. The horizon line does not need to be drawn in the center of the picture plane; it may be offset.

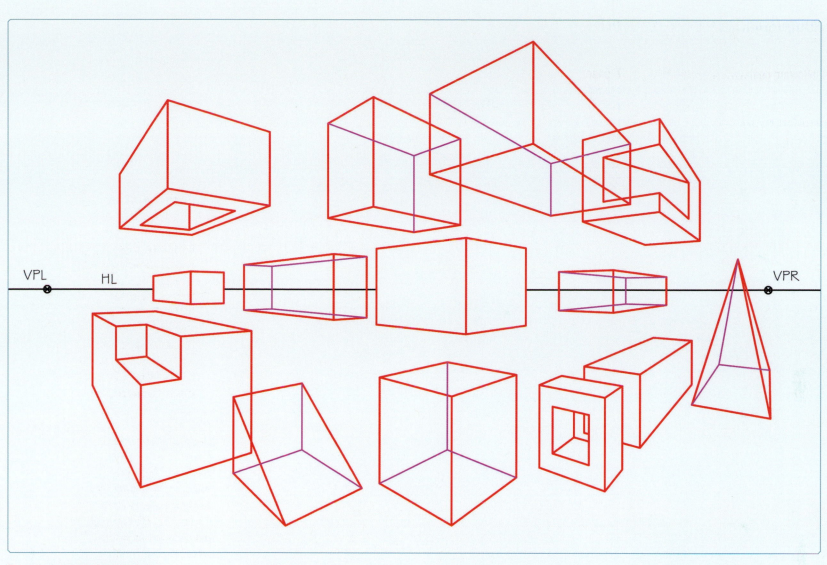

VPL

HL

VPR

Two-point geometric forms project.

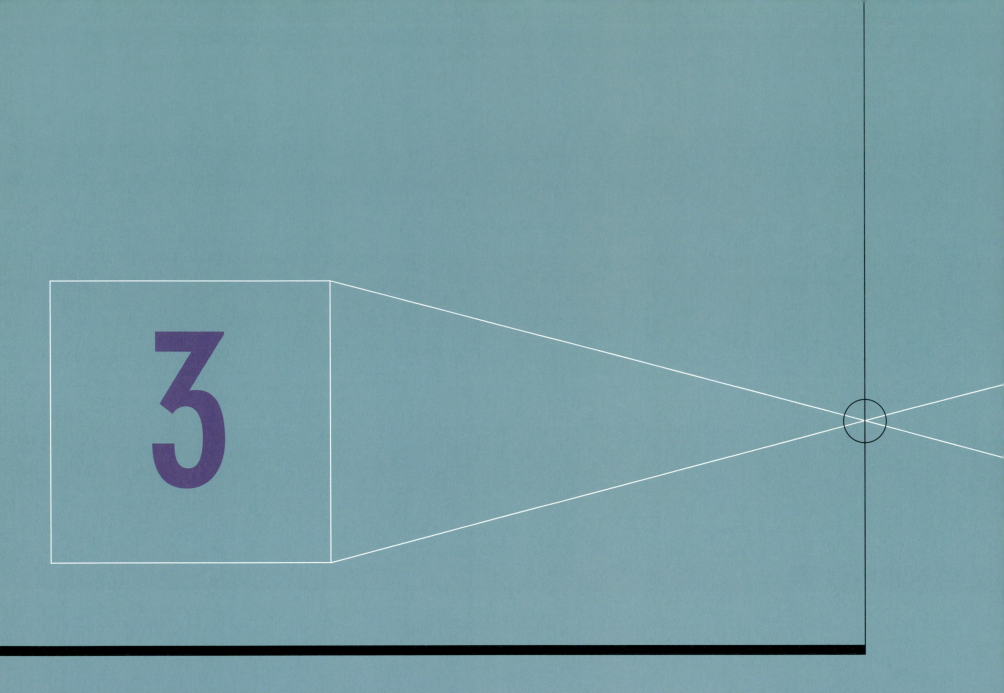

3

Drawing Furniture and Interior Spaces in One-Point Perspective

As covered in Chapter 2, the one-point perspective drawing portrays an object or room so that the placement shows the front of the object or back of the room is flat to the viewer. These types of drawings have only one vanishing point.

This chapter shows how to divide space to create equally sized images as well as how to use a cube to create furniture. It also shows how to create a grid in order to use the correct proportions and scale for a room and the furniture in that room. Finally, the chapter illustrates how to create details in a room and add dimension to those details, and how to draw a room from an aerial or floor plan view. By the end of this chapter you will be able to divide space and take the basic cube form and develop it into different types of furniture. You will also be able to lay out a grid system to create the correct proportion of architectural elements and freestanding objects in an interior space. The final goal of this chapter is to create a three-dimensional space from a floor plan.

TERMS FOR ONE-POINT PERSPECTIVE

This chapter introduce two new terms. The first is the **station point (SP)**, which represents the placement of the view in relationship to the object or the room. The second is the **45-degree vanishing point**, which is a point created by dividing the one-point footprint diagonally and extending the line until it reaches the horizon line. Dividing the footprint on each side creates two 45-degree lines, which can be used to draw objects in two-point perspective. The following terms covered in the previous chapter are also used:

- **Eye level (EL)**
- **Horizon line (HL)**
- **Vanishing point (VP)**
- **Below eye level**
- **Above eye level**
- **Eye-level view**

As a review from Chapter 2, set up the one-point perspective by first creating the eye level line (EL). There is one vanishing point (VP) in these drawings, which is placed anywhere on the EL. *Note: There is an exception to this rule.* There is not an eye-level line when viewing a floor plan because the vanishing point is placed on the floor area. (This type of drawing is covered at the end of this chapter.) The VP cannot be moved after it is placed. Think of a photograph—the vanishing point represents what the viewer or camera was aiming at in the photo. When the picture is taken, that picture is frozen in time and cannot be changed. The same principle applies to a one-point perspective. All objects drawn in the one-point perspective have lines that converge to that point.

MEASURING AND DIVIDING SPACE

Dividing up space to created the correct proportion to an object typically starts with finding the center of the surface plane that is to be divided or detail to be added. Finding the correct thickness for table legs, for example, starts with creating the front legs and then transferring that dimension to the back legs. This thickness is smaller than in the front because it is farther from the viewer. The following example shows a cube and how to reproduce the same object with the same proportions back in the picture plane.

CUBE IN PICTURE PLANE

Step 1. Create the object or detail to reproduce.

Step 2. Draw guidelines from the top and bottom of the object to the vanishing point, and then draw the front vertical line of the second object between those lines.

Step 3. Find center between the front object and the back line.

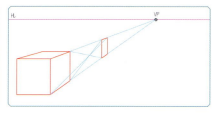

Step 4. Draw a guideline from the bottom corner of the front object through center until it crosses the top guideline. Draw a vertical line down from that intersection to create the back line of the back object.

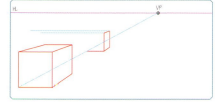

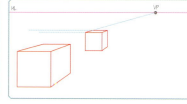

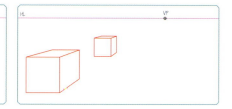

Step 5. Draw a guideline from the bottom front object to the vanishing point, and then draw a horizontal line across from the back surface plane. The object's width is created where these two bottom lines intersect.

Step 6. Draw a vertical line upward from the intersection in Step 5, and then draw a line back to the vanishing point from the top intersection point.

Step 7. Erase any construction lines.

TRANSFORMING A CUBE INTO FURNITURE

The same process as outlined in the previous steps can be used to create furniture details such as table leg proportions or placement of windows in a space, both of which are shown in later examples.

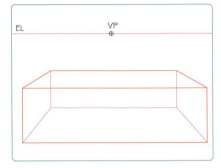

Step 1. Create a transparent cube to represent the total volume of the table.

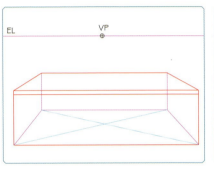

Step 2. Create the thickness of the top across the front edge and transfer to the vanishing point on the side. Also, find the center along the footprint of the table; this helps create the same proportions on each side of the table.

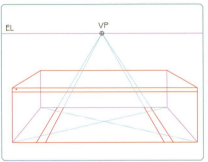

Step 3. Add the thickness for the legs with two vertical lines on each side.

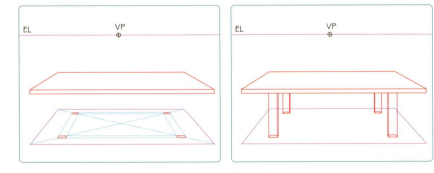

Step 4. Draw horizontal lines where the lines from Step 3 intersect the diagonal lines. This creates the footprint for the legs.

Step 5. Draw vertical lines upward from the footprints to complete the basic dining table with an overhanging top.

GIVING STRUCTURE TO THE TABLE

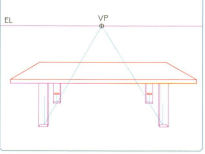

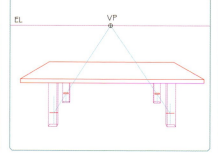

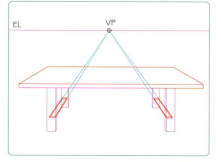

Step 1. Start with a basic table. Draw guidelines from the vanishing point through the centers of the legs, and guidelines upward to the desired height for the stretchers. Create footprints on the back legs for the stretchers.

Step 2. Transfer the stretcher height to the front legs with guidelines.

Step 3. Use the vanishing point to connect the legs with the stretchers.

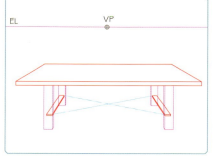

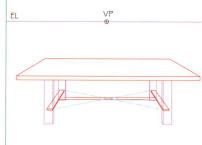

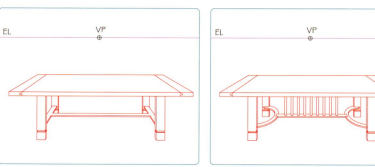

Step 4. To connect the stretchers horizontally, start by finding center between the side stretchers.

Step 5. Draw a line across in front of the center line and in back of the center line. Also draw the thickness across to complete the center stretcher.

BASIC SOFA

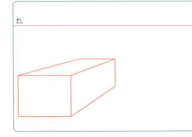

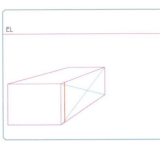

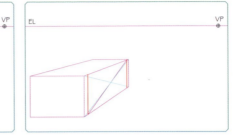

Step 1. Create a cube based on the total size of the sofa.

Step 2. Find center on the front surface and then add the thickness for the front edge.

Step 3. From the base of the front edge, draw a line through center until it intersects the top line. Draw a vertical line down from that intersection to create the correct thickness of the back edge.

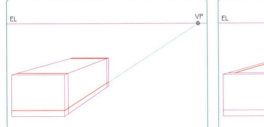

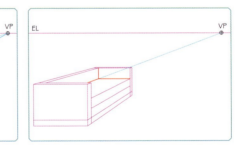

Step 4. Draw a line from the vanishing point across the front surface plane to create the height of the foot and transfer that line horizontally across the front surface plane. Also draw horizontal lines across the top from the side edges.

Step 5. Draw lines from the vanishing point between the side edges at the desired sizes to create the back and seat edges.

Step 6. Create the interior seat space by drawing a vertical line down from the back inside corner and a line horizontally from the back inside edge until they converge. Then draw a line from the vanishing point through that intersection point to create the back edge.

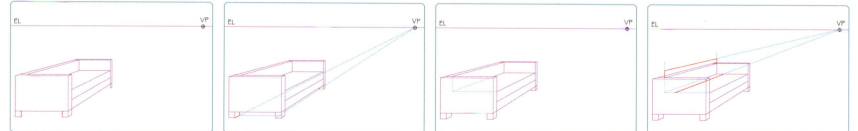

Step 7. Create the desired thickness of the front feet.

Step 8. Transfer those dimensions to the back leg with the vanishing point, and transfer the thickness of the legs across. Draw vertical lines upward where these lines intersect.

Step 9. To angle the seat back, start by extending the seat and back surface planes as construction lines to see the total volume.

Step 10. Extend the seat back upward to the desired height and connect with a top line from the vanishing point. Also draw another line from the vanishing point to make the front of the seat back.

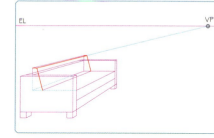

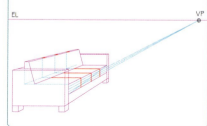

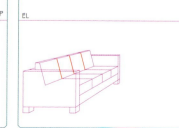

Step 11. Draw two lines horizontally from the top of the seat back and then draw a line from the vanishing point to create the top front of the seat back. Connect those intersection points to the bottom front line. These two lines will be angled.

Step 12. Divide up the seat cushion by first creating equally spaced marks on the front vertical line of the cushion. Draw guidelines to the vanishing point and then draw a diagonal guideline from corner to opposite corner on the front surface plane of the cushion. Draw vertical lines for the divisions at the intersections on the diagonal line, and transfer those marks horizontally across the seat.

Step 13. Transfer the division lines from the seat to the back of the sofa.

ONE-POINT ROOM FROM A GRID

The purpose of making a grid is to ensure the scale and proportions of the space and the objects in that space. Because items appear smaller in the background and larger in the foreground, it's important to create a system to ensure the proper scale of those items. One way to do this is by creating a grid. This means creating a standard unit of measure for the space. Two basic measuring units to use are the 12" grid and the 30" grid based from a scale factor, such as $\frac{1}{2}$" unit in the drawing is equal to 12" in reality. Both systems are set up in the exact same way, but the 30" grid is faster because it uses fewer lines for the grid. When the grid is created, a second sheet of paper is used to overlay the grid for the perspective drawing. This way the grid is used as a guide and does not need to be erased.

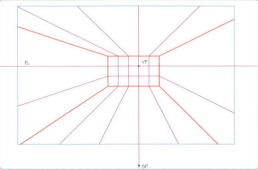

Step 1. Create the back wall with a 30" scaled grid on that back wall. Use the scale ruler at $\frac{1}{2}$" scale for smaller rooms and $\frac{1}{4}$" scale for larger spaces. Add an eye-level line and vanishing point.

NOTE The outside border line represents the edge of the paper in these grid images.

Step 2. Draw lines from the vanishing point outward through the outside edge of the grid. Add the station point vertically down from the vanishing point. This point represents where the person is standing in the space, so place it at the bottom or off the paper.

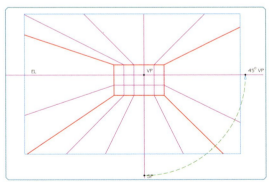

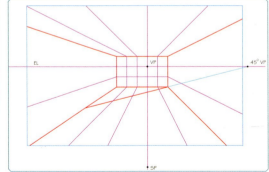

Step 3. Create the 45-degree vanishing point by measuring the distance between the vanishing point and the station point, and then transfer the dimension on the eye-level line to the right or left of the vanishing point.

Step 4. Draw a line from the 45-degree vanishing point through the bottom corner of the back wall across the floor.

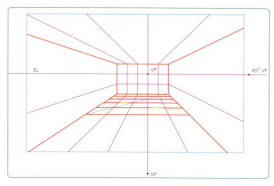

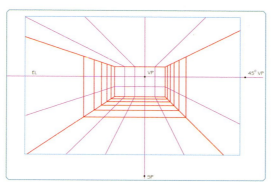

Step 5. Draw horizontal lines across the floor where the diagonal line crossed the grid line.

Step 6. Draw vertical lines up both sides of the walls from the horizontal lines on the floor.

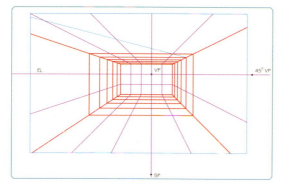

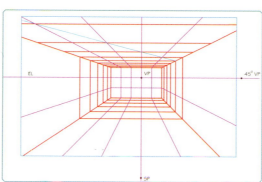

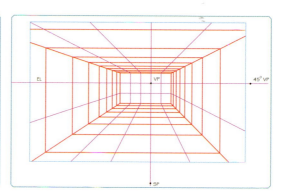

Step 7. Connect the vertical lines across the ceiling.

Step 8. If the grid does not continue to the edge of the paper, extend it by drawing a diagonal line from corner to opposite corner of any grid square and continue it outward. Then draw horizontal (floor or ceiling) and vertical lines (walls) across the surface plane.

Step 9. Connect those extra lines to complete the grid.

Project 3.1 DRAWING FURNITURE IN ONE-POINT PERSPECTIVE

Create a piece of furniture in one-point perspective. Start by creating the object in cube form to define the total volume first. Use 14" × 17" marker paper in vertical format and drafting tools (T-square, triangle, and ruler). Lay out your drawing in pencil, preferably an HB pencil.

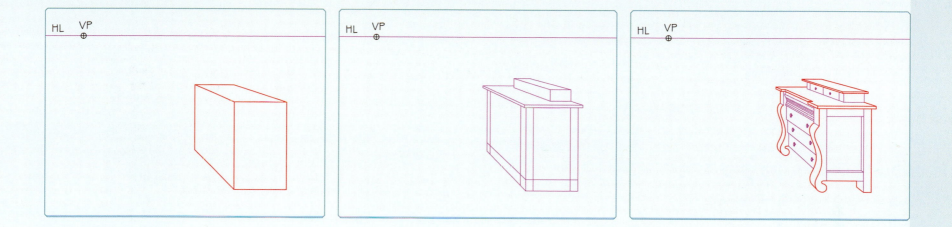

GETTING STARTED

1. Start by creating the correct proportions of the object as a cube.

2. Develop the cube into the furniture as shown in this chapter.

3. Ink exterior object lines with a .05 thickness, and use .01 thickness for the details of the furniture.

Project 3.2 DRAWING A ROOM IN ONE-POINT PERSPECTIVE USING THE GRID

Create a one-point room from a grid on 14" × 17" marker or vellum paper. Use drafting tools (T-square, triangle, and ruler).

1. Create a grid sheet on sketch paper, as shown in this chapter. Include the grid worksheet along with the final art.
2. Lay out your drawing in HB pencil on marker paper, using the grid sheet underneath.
3. Create a ½" line border all around, creating a 13" × 16" image area.
4. Design a room in one-point perspective using the techniques covered in this chapter.
5. Add details to walls and ceiling, such as doors, windows, and lighting fixtures.
6. Add at least three pieces of furniture in one-point perspective.
7. Ink all images and erase any construction lines.

Example of one-point grid.

Example of a completed drawing, overlaid with marker paper and freehand sketched.

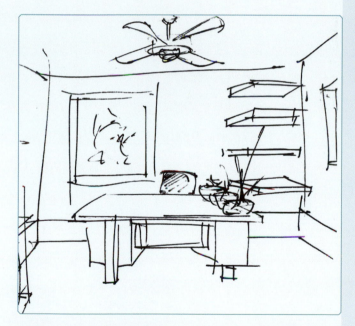

A developmental thumbnail sketch to help with placement in the final drawing.

Note
The horizon line does not need to be drawn in the center of the picture plane; it may be offset.

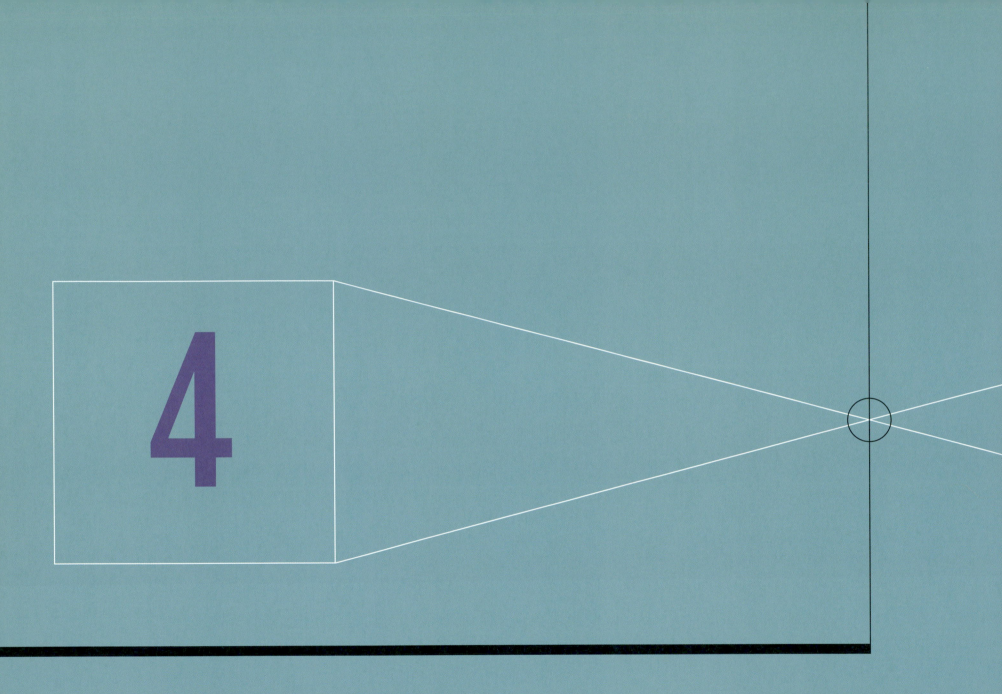

4

Drawing Furniture and Interior Spaces in Two-Point Perspective

As covered in Chapter 2, two-point perspective portrays an object so that the placement shows the front corner of that object to be closest to the viewer. In a room drawing, the back corner would be the furthest from the viewer; it would be like spinning the one-point object to a 45-degree angle. These types of drawings will have two vanishing points—a vanishing point left and vanishing point right.

TWO-POINT PERSPECTIVE

This chapter starts by showing how to divide space to create equally sized images, and then shows how to create and use an alternate vanishing point. It explains how to use the cube as a starting point to develop furniture. Finally, it shows how to create a grid in two-point perspective to create the correct proportions and scale to a room and the furniture in that room. By the end you will be able to take the basic cube and turn it into different types of furniture. Just like the previous chapter you will be able to draw a grid to create correct proportion inside the space as well as objects in that space in two-point perspective. This chapter uses the following terms:

- **Eye level (EL)**
- **Horizon line (HL)**
- **Vanishing point left (VPL)**
- **Vanishing point right (VPR)**
- **Station point (SP)**
- **Ground line (GL) 45-degree vanishing points below eye level**
- **Above eye level**
- **Eye-level view**

TERMS FOR TWO-POINT PERSPECTIVE

This chapter also introduces the following terms:

- **Alternative vanishing point (AVP):** This vanishing point is created for surface areas that are angled, such as a pitched roof or interior vaulted ceiling.
- **Measuring points left and right (MPL and MPR):** These points provide the ability to use standard units to develop measured volume in the perspective.
- **Cone of vision:** This is a 60-degree cone that equates to the limits of

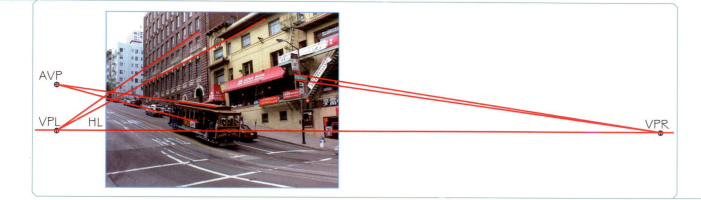

AVP

VPL HL

VPR

An example showing the vanishing point left by drawing the edge of the building toward the left and the vanishing point right by drawing the edge of the sign toward the right. The alternate vanishing point is found by drawing the edges of the trolley car outward until they intersect.

the human eye. In a perspective drawing, items outside this cone can be distorted because they are in the eye's peripheral vision.

- **Center axis of vision:** This refers to the center of the cone of vision. The center will have a 30-degree angle on each side making up the cone of vision.

As a review from Chapter 2, set up the one-point perspective by first creating the eye-level line (EL). To set up the two-point perspective, start the same way as the one-point by creat-ing the EL. There will be two vanishing points—a vanishing point left (VPL) and a vanishing point right (VPR). These vanishing points are placed on the EL; after the points are placed, they cannot be moved. They create the angle of the object or room for that drawing. All objects drawn in two-point perspective have lines that converge to either the VPL or VPR in order to show depth. Also just like one-point perspec-tive, there are three ways to view an object—above, below, and at eye level.

MEASURING AND DIVIDING SPACE

The purpose of dividing space is to cre-ate the same size and proportion of an object or detail as it travels back in the picture plane or gets closer to the vanishing point. Because the object is drawn in perspective, it cannot be measured with a ruler and transferred backwards toward the vanishing point. Instead, a reference point and a cen-ter point are created. The center point allows the measurement to be trans-ferred while being proportionate to the original image.

Step 1. Create the basic object; in this case, it is a simple cube.

Step 2. Draw guidelines to the vanishing point where the object is going to be re-created, and create a vertical line that represents the front corner of the object.

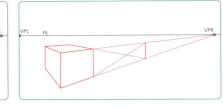

Step 3. Find center between the back line and the object.

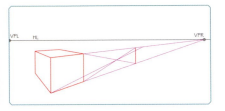

Step 4. Draw a new guideline from the bottom front of the surface plane through the center mark to the top of the guideline from Step 2.

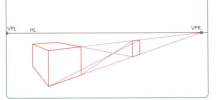

Step 5. Draw a vertical line down from the top intersection point to create the back of the object.

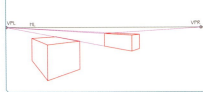

Step 6. Draw guidelines from the back surface plane to the other vanishing point. Then draw a guideline from the front object bottom inside corner to the vanishing point right. The depth of the back object is where these lines intersect.

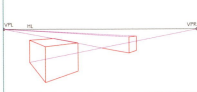

Step 7. Draw a vertical line upward from the back bottom line until it intersects the front top line, and then transfer back to the vanishing point to complete the back object.

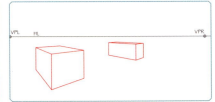

Complete drawing with correct proportions of the rear object and the spacing between the objects.

CREATING AN ALTERNATE VANISHING POINT

The alternate vanishing point is created for a surface area that is angled, such as a pitched roof or interior vaulted ceiling. This example shows the basic fundamentals of creating the alternate vanishing point. It starts with a tilted lid and then repeats the lid on the back box.

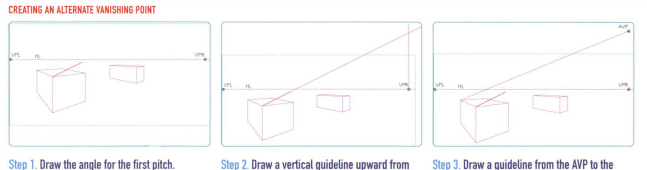

CREATING AN ALTERNATE VANISHING POINT

Step 1. Draw the angle for the first pitch.

Step 2. Draw a vertical guideline upward from the vanishing point, and extend the angle drawn in Step 1 until it intersects with the vertical line. This intersection point is the alternate vanishing point (AVP) for that angle.

Step 3. Draw a guideline from the AVP to the back part of the box.

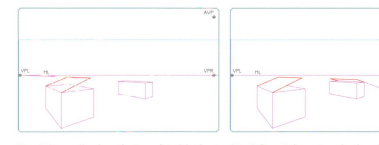

Step 4. Draw a line from the top point of the front angle to the vanishing point left to complete the angled surface plane.

Step 5. Repeat these steps for the other lid.

NOTE Because it is a different angle, a new alternate vanishing point is created, but it still lines up vertically with the vanishing point right.

TRANSFORMING A CUBE INTO FURNITURE IN TWO-POINT PERSPECTIVE

These steps show how to use a transparent cube to define the total volume of an object and then develop the details and proportions to turn it into a piece of furniture. The first step is to create a transparent cube whose dimensions and proportions match the proportions of the final object; for example, a coffee table is a shorter, smaller cube than a dining table.

BASIC TABLE

Step 1. Draw a transparent cube.

Step 2. Mark the desired top thickness on the front edge and then draw lines from that mark to both of the vanishing points (VPL and VPR).

Step 3. Draw vertical lines to the left and right of the front edge from the bottom of the top to the bottom line of the cube. (The distance from the front edge determines the leg thickness.)

Step 4. Find center on the right front vertical surface plane of the cube by drawing lines from corner to opposite corner.

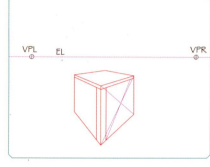

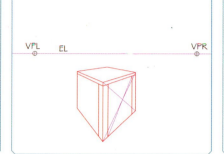

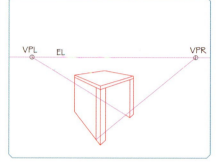

Step 5. Draw a line from the bottom right front leg through center until it intersects with the top edge.

Step 6. Draw a vertical line down from the top intersection point in Step 5.

Step 7. From the bottom of the right back leg, draw a line from the front edge to the VPL. Then from the front leg, transfer the thickness by drawing a line from the left side to the VPR.

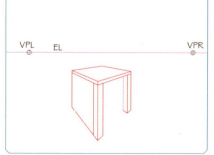

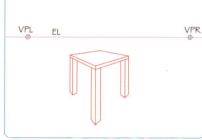

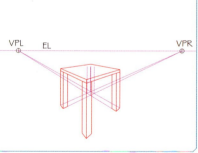

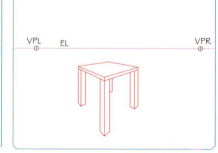

Step 8. Draw a vertical line upward where the lines intersect in Step 7.

Step 9. Repeat Steps 4–8 on the left side.

Step 10. Depending on the angle and proportion, the far back leg may not be seen. To find the back leg, draw lines from the base of both side legs to the VPL and VPR. Where the lines intersect is the footprint of the back leg. Draw lines upward from the footprint.

Step 11. Erase any construction lines.

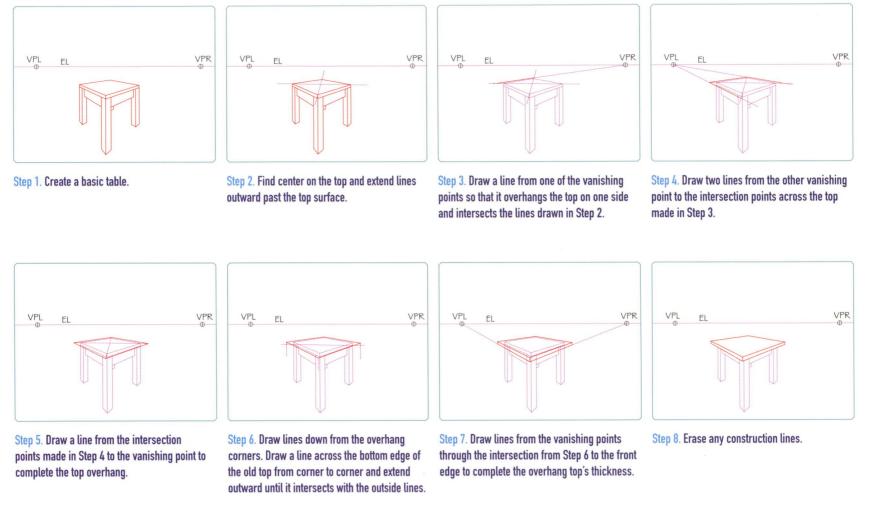

Step 1. Create a basic table.

Step 2. Find center on the top and extend lines outward past the top surface.

Step 3. Draw a line from one of the vanishing points so that it overhangs the top on one side and intersects the lines drawn in Step 2.

Step 4. Draw two lines from the other vanishing point to the intersection points across the top made in Step 3.

Step 5. Draw a line from the intersection points made in Step 4 to the vanishing point to complete the top overhang.

Step 6. Draw lines down from the overhang corners. Draw a line across the bottom edge of the old top from corner to corner and extend outward until it intersects with the outside lines.

Step 7. Draw lines from the vanishing points through the intersection from Step 6 to the front edge to complete the overhang top's thickness.

Step 8. Erase any construction lines.

TABLE WITH TURNED LEGS

Step 1. Create a basic table; the table shown has a top that overhangs.

Step 2. Draw in the footprint at the base of each leg to be able to see the volume of the legs.

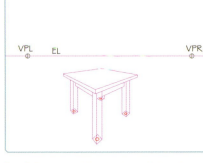

Step 3. Create an ellipse inside each footprint. This will be the base of the turned legs.

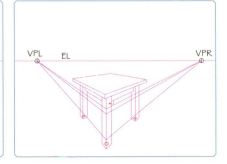

Step 4. Draw guidelines from the vanishing points to divide up the legs' proportions.

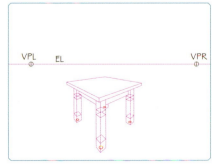

Step 5. Draw guidelines around each leg where the proportions were divided in Step 4. This will create a three-dimensional footprint at each division on the leg.

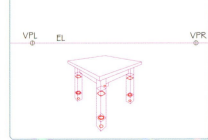

Step 6. Draw an ellipse of the desired size in each division.

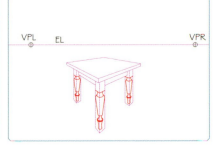

Step 7. Connect the outside edges of the ellipses to form the legs.

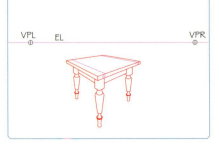

Step 8. Erase construction lines. An extra breadboard edge has been added to this final drawing.

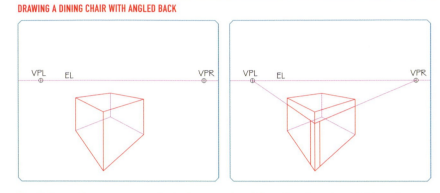

Step 1. Start with a transparent cube for the seat of the chair.

Step 2. Draw lines from the vanishing points to create the thickness of the seat and add vertical lines to provide the dimension of the front legs.

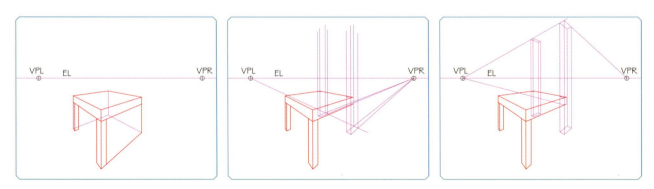

Step 3. Create a deeper dimension for the back legs and extend them upward.

Step 4. Draw lines from the vanishing points to intersect the back legs at the desired height.

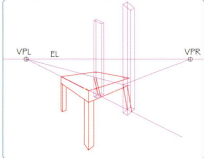

Step 5. Draw an angle line for the base of the back leg. Use the vanishing point to transfer to the other back leg.

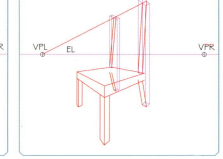

Step 6. Draw an angled line for the seat back. Use the vanishing point to transfer to the other back edge.

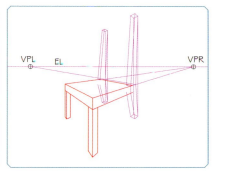

Step 7. Repeat Steps 5 and 6 to create thickness for the back legs.

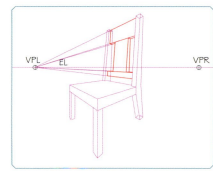

Step 8. Use the vanishing points to add detail to the seat back.

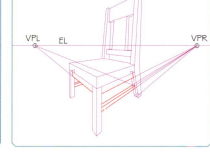

Step 9. Use the vanishing points to add structural detail to the base of the chair.

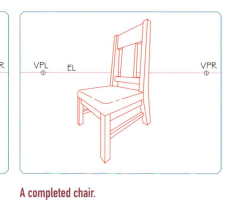

A completed chair.

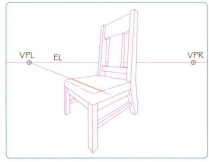

Step 1. Create the chair, and add a guideline from the vanishing point across the seat for the placement of the arms.

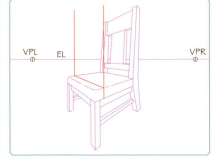

Step 2. Draw vertical lines upward where the guideline intersects the outside edge of the seat.

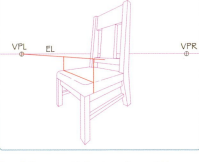

Step 3. Draw a guideline from the vanishing point to the desired height for the arm.

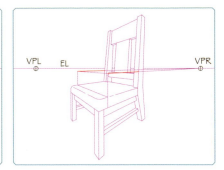

Step 4. Draw guidelines from the intersection points in Step 3 to the other vanishing point.

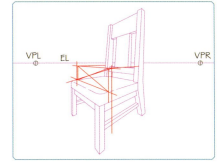

Step 5. Add dimension to the arms by first finding center between the vertical lines of the two arms. Draw a vertical line to create the desired thickness of one of the arms. Draw a line from the top of that line through the center mark to find the other arm dimension, and draw a vertical line at that intersection point.

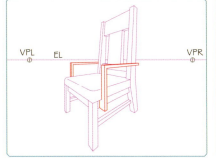

Step 6. When the dimension is made on the front part of the arms in Step 5, use the vanishing points to attach the front of the arms to the seat back. Also add depth to the arms using the vanishing points.

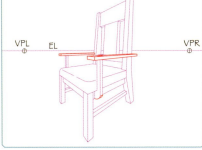

Step 7. With the arm proportions completed, use the vanishing points to add detail.

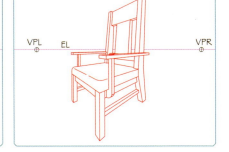

A completed armchair.

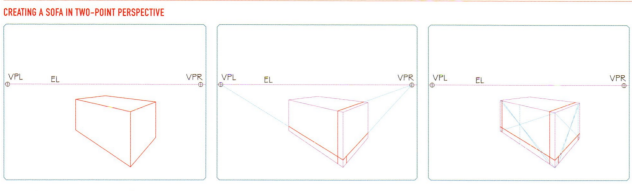

Step 1. Create the total dimension of the sofa in cube form.

Step 2. Draw a vertical line to create the thickness of the front arm and then draw a line from the top of the vertical line to the vanishing point. Also create the desired height for the legs by drawing lines from the vanishing points to the front edge of the cube.

Step 3. Find center on both vertical surface planes and then reproduce front arm spacing by drawing a guideline from the bottom of the leg through center to the top edge of the cube. Draw a vertical line downward from the intersection point to reproduce the spacing.

NOTE A vertical guideline is drawn through center, which will be used later.

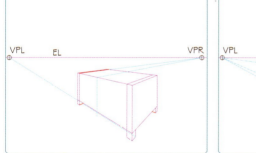

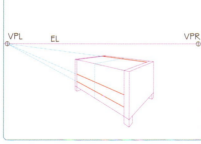

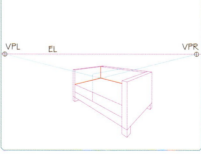

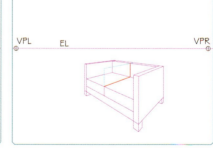

Step 4. Add dimension to the feet by drawing lines to the vanishing points and erasing the bottom line of the cube that is not used. Also draw the thickness of the back arm to the vanishing point.

Step 5. Draw lines from the vanishing point to create the desired spacing for the base structure, seat cushion, and back cushion.

Step 6. Draw a line from the back top edge of the seat cushion to the vanishing point and then draw a vertical line down from the back edge of the seat back. Draw a third line from the other vanishing point through the intersection point to create the back of the seat.

NOTE The center line is used to divide the cushion into two pieces.

Step 7. Draw a line from the center cushion vertical line to the vanishing point and then draw a vertical line upward to create the back center line.

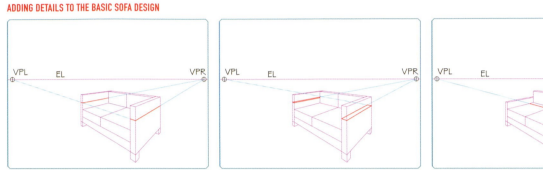

Step 1. Pick a desired height for the arm on the front edge, and draw lines back to the vanishing points.

Step 2. Transfer the height around the arms to create the new top surface planes of the arms.

Step 3. Draw through the front arm to temporarily provide the complete seat and back to the piece. Draw a line from the vanishing point to create the bottom of the seat back. This creates an angle to the back seat cushion.

Step 4. Angle the seat back by drawing lines that connect the seat top to the base.

NOTE: This example has curved lines to help soften the sofa.

Erase construction lines to complete the sofa.

CREATING ACCESSORIES DETAILS TO AN OBJECT—SIDE TABLE AND LAMP

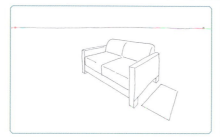

Step 1. Start with the placement of the footprint for a side table.

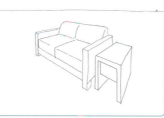

Step 2. Develop that footprint into a side table while using the sofa as scale for the table.

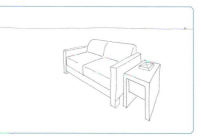

Step 3. To add a lamp on the table, create the base on the table top.

NOTE This does not need to be centered. This image shows the base closer to the back of the table.

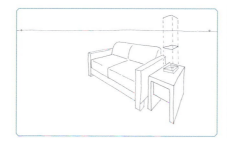

Step 4. Extend lines upward to desired height for the lamp shade. Also create guidelines for the bottom of the lamp shade.

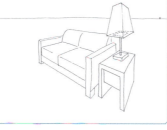

Step 5. Use the bottom of the shade as a guide, and draw lines around the bottom to create the final size of the lamp shade bottom. Connect the new bottom and top of the shade.

TWO-POINT PERSPECTIVE ROOM FROM A GRID

The purpose of making a grid is the same for a two-point perspective as it is for the one-point—to ensure scale and proportions for the space and the objects in that space. The process of setting up a grid is completely different for two-point perspective, but the end result produces a drawing that allows items to be placed in the environment so that they appear smaller in the background and larger in the foreground. The standard unit of measure can be one of two basic units—a 12" grid or a 30" grid—which are based on a scale factor. Both systems are set up in exactly the same way, but the 30" grid is faster because it uses fewer lines for the grid. When the grid is created, a second sheet of paper is used to overlay the grid for the perspective drawing, just like for the one-point grid. This way the grid is used as a guide and does not need to be erased.

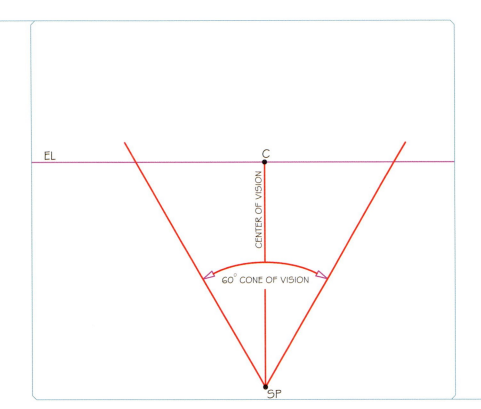

PART 1: CONE OF VISION — CREATING THE 12-INCH GRID

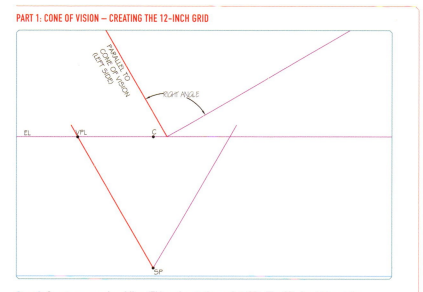

Step 1. Create an eye-level line (EL) and a station point (SP). The SP should be at the bottom of the page, but does not need to be center.

Step 2. Draw a vertical line from the SP up to the EL to create the center of vision.

Step 3. Draw two lines at a 30-degree angle on each side of the center. This creates the complete 60-degree cone of vision.

PART 2: CREATING THE ANGLE OF THE ROOM

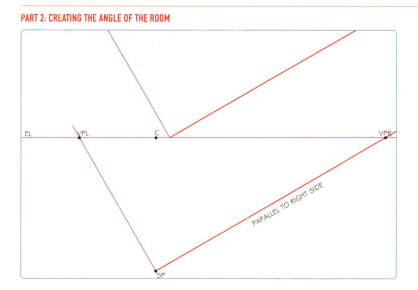

Step 1. Choose the intersection of the right or left cone of vision line as one of the vanishing points. This example uses the left line intersection point as the vanishing point left (VPL).

Step 2. Draw two guidelines as the angle of the space on the eye-level line (EL). The first line is parallel to the cone of vision line with the vanishing point on it. The second guideline is drawn at a right angle to the first.

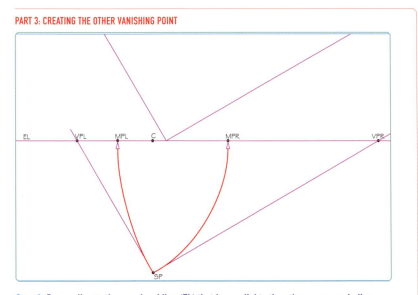

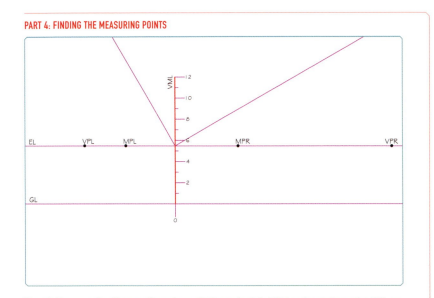

Step 1. Draw a line to the eye-level line (EL) that is parallel to the other room angle line.

Step 2. Add the other vanishing point where the lines intersect from Step 1. This example shows the vanishing point right (VPR).

Step 1. Measure the distance from the vanishing point left (VPL) to the station point (SP), or use a compass and transfer that distance to the eye-level line (EL) to create the measuring point right (MPR).

Step 2. Measure the distance from the vanishing point right (VPR) to the SP, or use a compass and transfer that distance to the horizon line (HL) to create the measuring point left (MPL).

PART 5: STARTING THE UNITS OF MEASURE

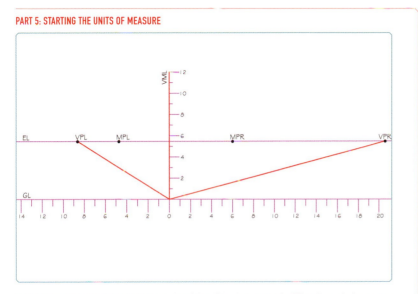

Step 1. From the angle above the eye–level line (EL), draw a vertical line through the center above and below the EL.

Step 2. Create a unit of measure by marking the vertical line; make sure the units are equal to one another. The example shows a 12" unit with the horizon line at 5' 6", so the mark at the EL should be between 5' and 6' for someone standing viewing the space.

Step 3. Draw a line parallel to the EL from the bottom of the vertical line, which is at zero, to create the ground line (GL).

PART 6: CREATING THE ANGLE OF THE ROOM

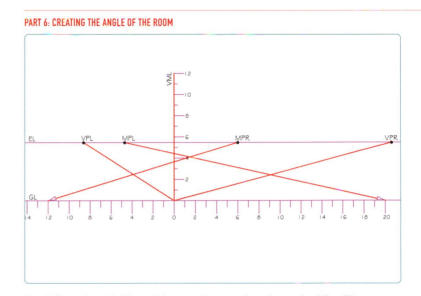

Step 1. Erase the angled lines of the room that were above the eye–level line (EL).

Step 2. Add the same unit of measure to the ground line (GL).

NOTE Start at the zero mark and count up in both directions.

Step 3. Draw two lines from the vanishing points to the zero mark, which is where the vertical line intersects with the GL.

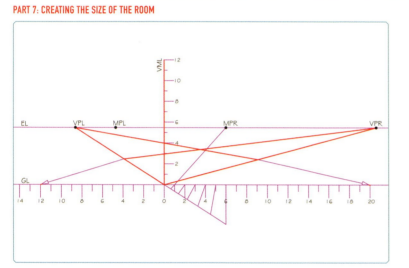

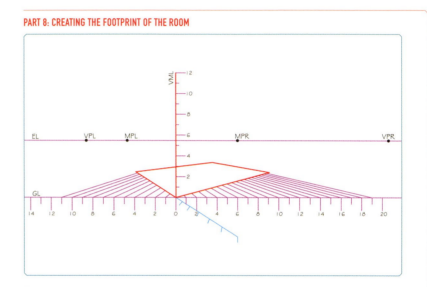

Step 1. Draw a guideline from the measuring point left (MPL) to the desired size on the ground and mark where it crosses the line from the vanishing point right (VPR). In this example it is at the 20' mark.

Step 2. Draw a guideline from the measuring point right (MPR) to the desired size on the ground and mark where it crosses the line from the vanishing point left (VPL). In this example it is at the 12' mark.

NOTE This will create a 12' × 20' room in perspective.

Step 1. Draw a line from the intersection on the right side line to the vanishing point left (VPL).

Step 2. Draw a line from the intersection on the left side line to the vanishing point right (VPR). This completes the footprint or floor of the room.

NOTE If you are unsure of the room size when Step 2 is complete, extend one or both of the lines from the vanishing points through the zero mark; then draw the mark from the measuring points through the ground line (GL) units to the extended line or lines and leave it for now.

PART 9: TRANSFERRING THE UNIT MARKS

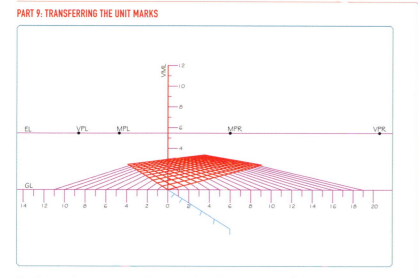

Step 1. Draw lines from each of the ground line (GL) unit marks *left* of zero to the measuring point right (MPR) until they intersect the front line of the room.

Step 2. Draw lines from each of the GL unit marks *right* of zero to the measuring point left (MPL) until they intersect the front line of the room.

PART 10: CREATING THE FLOOR GRID

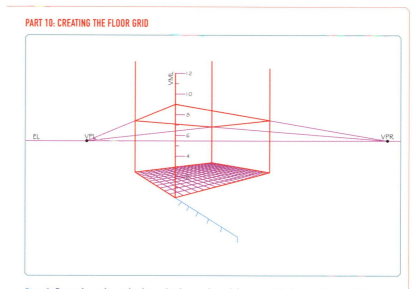

Step 1. Draw the unit marks from the front edge of the *left* side floor to the vanishing point right (VPR). Stop the line when it intersects the back edge of the floor.

Step 2. Draw the unit marks from the front edge of the *right* side floor to the vanishing point left (VPL). Stop the line when it intersects the back edge of the floor.

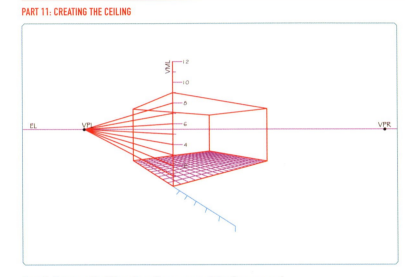

Step 1. Draw vertical lines from the corners of the floor upward.

Step 2. Draw lines to both vanishing points from the desired height of the front line. Stop the lines when they intersect the outside vertical lines from Step 1.

NOTE The example shows a 9' ceiling.

Step 3. Draw lines from the intersection points on the outside verticals from Step 2 to the opposite vanishing points until they intersect with one another and the back vertical line.

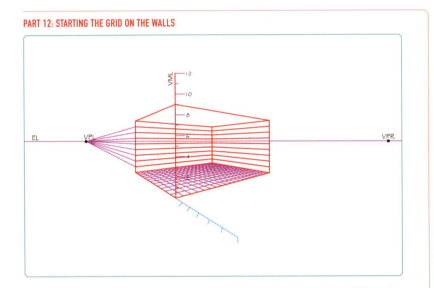

Step 1. Draw guidelines from the unit marks on the front vertical line to the vanishing point left (VPL), and mark the left vertical line where they intersect.

PART 13: TRANSFERRING THE GRID TO THE OTHER WALLS

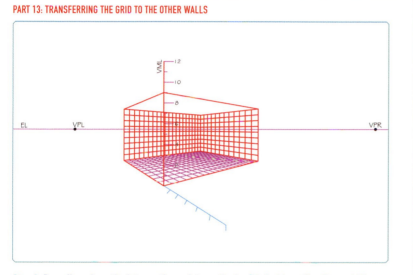

Step 1. Draw lines from the intersection points on the back left side wall to the vanishing point right (VPR). Stop the lines when they intersect the back vertical line.

Step 2. Draw lines from the vanishing point left (VPL) through the intersection points on the back vertical line to the right vertical line.

PART 14: COMPLETING THE WALL GRID

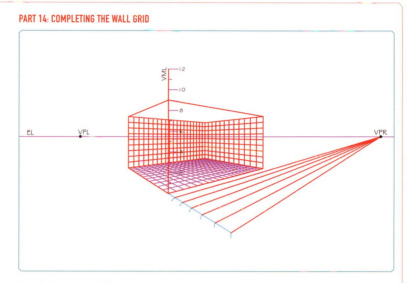

Step 1. Draw vertical lines upward from where the floor grid intersects the back walls. Continue the lines until they intersect the ceiling.

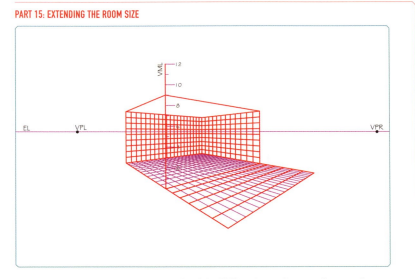

Step 1. Draw lines from the vanishing point right (VPR) to the marks extending past the ground line (GL) from Part 8.

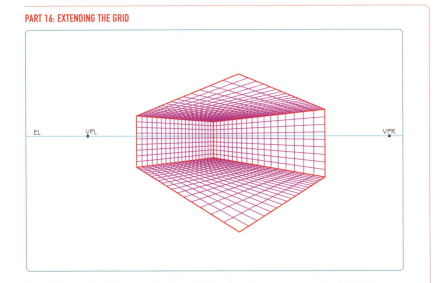

Step 1. Extend the grid by drawing the grid lines from the vanishing point left (VPL) to intersect the front line from Part 15.

OVERLAY TO CREATE A ROOM

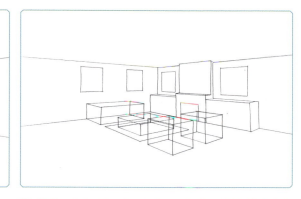

Step 1. Start by using marker paper or vellum to overlay the grid. Using a semitransparent paper helps you see the grid in order to create the space.

NOTE Make sure the two vanishing points are still visible on the grid sheet. They will be used to create the details of the interior space.

Step 2. With the grid underneath, draw out the floor, walls, and ceiling; then draw doors, windows, hallways, and a fireplace in the room while using the grid as a guide for correct proportion.

NOTE The grid sheet shown in Step 1 was drawn in 12" units; therefore, a 7' doorway would be seven grid units tall.

Step 3. Draw in furniture in cube form, starting with the footprint of those pieces, to create the correct proportions of the furniture and the spacing between those pieces; then draw lines upward from the corners of the footprints to create the transparent cubes. Also add the volume of pieces against the walls.

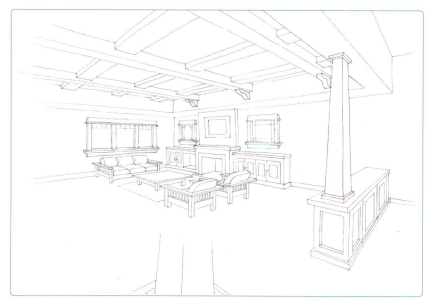

Step 4. Detail the furniture from the transparent cubes, and add dimension to the doors and windows. Also add molding, lighting fixtures, and artwork to complete the space. This example shows an Arts and Crafts space with a fireplace and ceiling detail.

NOTE The front architectural post starts as a solid form and then ends to show the room layout.

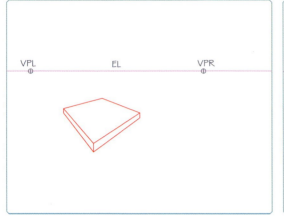

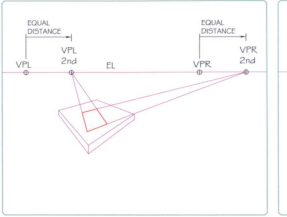

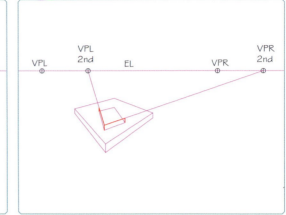

Step 1. Set up a standard two-point perspective drawing with an eye-level line and the vanishing point left and right; then create a surface plane from those vanishing points. This surface can be a cube or tabletop, but make it large enough for other objects to fit on top of it.

Step 2. Create the second set of vanishing points by moving the original points in the same direction. The points must also be moved the same distance, so that the two distances are equal to each another. Use the second set of vanishing points to create the footprint of the next object.

NOTE This second set is for the second object only; make sure not to confuse the first set of vanishing points with the second.

Step 3. Develop the thickness of the second object by drawing a vertical line on the front edge upward, and transfer that line to the second set of vanishing points. Also draw vertical lines upward from the outside corners.

Step 4. Draw lines from the outside top corners to the second set of vanishing points to complete the second shape.

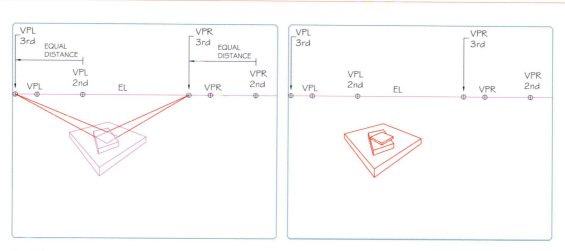

Step 5. To create a third object, repeat Step 2.

NOTE In this example, the third set of vanishing points was moved to the left. This spins the object in the opposite direction from the second object.

Step 6. Add thickness to the third object by repeating Steps 3 and 4.

Step 7. Add detail to the objects.

NOTE Detail for the table is from the original vanishing points. All detail to the second object (book) was drawn from the second set of vanishing points, and for the third object (compact disc) was drawn to the third set of vanishing points.

Project 4.1 DRAWING A ROOM IN TWO-POINT PERSPECTIVE FROM A GRID

Create a two-point room from a grid on 14" × 17" marker or vellum paper. Use drafting tools (T-square, triangle and ruler).

1. Create a grid sheet on sketch paper, as shown in this chapter. Include the grid worksheet along with the final art.
2. Lay out your drawing in HB pencil on marker paper, using the grid sheet underneath.
3. Create a ½" line border all around, creating a 13" × 16" image area.
4. Design a room in two-point perspective using techniques covered in this chapter.
5. Add details to the walls and ceiling, such as doors, windows, and lighting fixtures.
6. Add at least three pieces of furniture in two-point perspective.
7. Ink all images and erase any construction lines.

The eye-level line does not need to be drawn in the center of the picture plane; it may be offset.

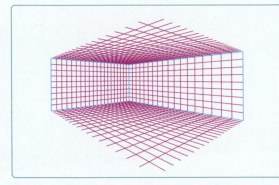

The grid and the room layout with furniture in cube form drawn from that grid. These are the beginning stages of Project 4.1.

Example of Project 4.1 showing the detail added to the space and the cubes developed into furniture.

Project 4.2 DRAWING A FURNITURE GROUPING IN TWO-POINT PERSPECTIVE

Create a two-point furniture grouping. Eye level does not need to be placed through the center of the paper. Vanishing points can be placed off the paper or outside the frame of reference.

1. Use images of furniture as a reference and arrange them to create a simple grouping.
2. Develop objects in cube form to determine correct size and proportions.
3. Overlay and hand sketch the final drawing.

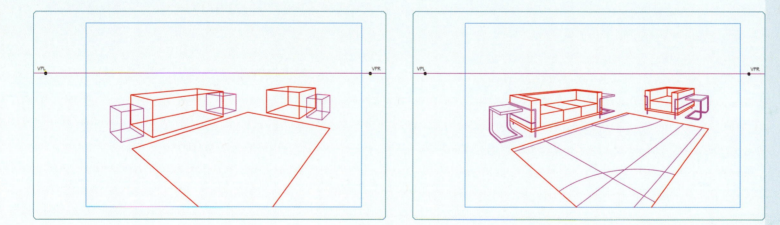

Example of Project 4.2. The image on the left shows development in cube form; the image on the right shows the completed line drawing.

5

Sketching Furniture and Interior Spaces in One- or Two-Point Perspective

Sketching is a skill that can be learned. Think of sketching or hand drawing as just another way to communicate, like learning a foreign language. When learning a new language you may struggle and it might take time at first, but with practice you will improve. Sketching is the same way; sure, some people seem to have been born with that gift because it comes easy for them, but don't become discouraged. When you understand the basic fundamentals of one- and two-point perspective from Chapters 2 through 4, sketching will become easier. By the end of this chapter you will be able to sketch different types of furniture and their details as well as sketching complete interior spaces in one and two-point. Also you will be able to develop volume to objects by adding tone and shading.

You don't use a ruler when you sketch, which makes the process faster. This is why sketching is a great way to develop many ideas quickly or to show clients what a space will look like. These drawings should be done quickly and show a basic idea for an interior space. They can also be used to show details of an object or to show how something is fabricated.

When drawing small objects such as furniture, the vanishing points can be implied; but when you draw full interior spaces you can create reference points. This chapter first shows how to sketch smaller objects, such as furniture, in one- and two-point perspective. It then helps you develop those skills to draw complete interior spaces from different views. The last part of the chapter shows how to redesign existing interior spaces by using photos. This process shows how to find the vanishing points from a photograph and use those vanishing points to change the space.

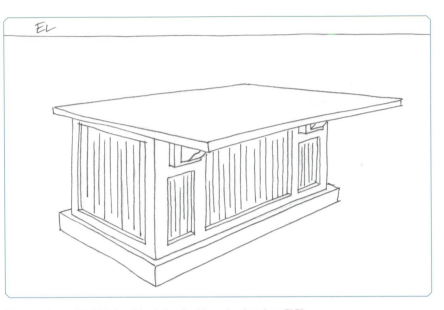

Example of completed kitchen island sketch with eye level at about 5' 5".

EYE LEVEL WHEN SKETCHING

One way to change the appearance of an object or space is to raise or lower the eye level. Doing this creates a different vantage point and changes the angle of the object. The example shown here is of a kitchen island. The first sketch is drawn with the eye level at about 5' 5", which is a typical adult height. At this height, two sides and the top can be seen. The second sketch is of the same island, but the eye level has been changed to about 2' 0", which could be a small child's height. At this height the two sides and the underside of the top can be seen.

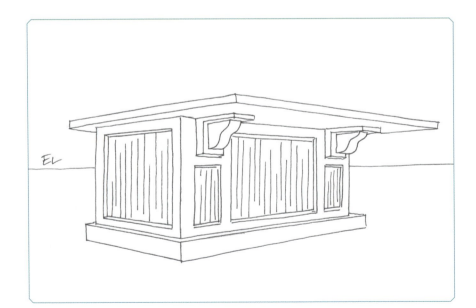

Example of completed kitchen island sketch with eye level at about 2' 0".

SKETCHING FURNITURE

One of the best ways to start sketching furniture is to create the total volume in cube form. This lightly drawn cube starts the sketch with the correct proportions. For example, a coffee table would be a short wide cube, whereas a barstool would be a tall slender cube.

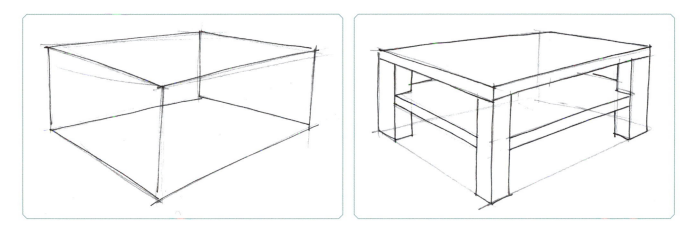

Step 1. Start with a basic cube form for the total volume of the final object. This example will be a barstool.

Step 2. Using this cube, draw the seat height based on the total height of the cube.

Step 3. With the seat height created, draw the leg details to the barstool. This example also shows the aprons connecting the legs just below the seat.

Step 4. Finish the back of the barstool by drawing the back legs up through the seat. Connect the tops of the back legs to create the backrest. This example also shows the bottom rails on the front and sides of the barstool.

TABLE EXAMPLE

Step 1. Draw a solid or transparent cube in order to see the total volume of the object. To create depth, draw lines to implied vanishing points.

NOTE These points are implied, so they do not exist. This example is in two-point perspective with an implied point on each side. The cube should be drawn so that the surface plane is smaller in the back.

Step 2. Draw light lines, like in a gesture drawing, to create the basic form of the object. This example shows the thickness of the top and all four legs.

Step 3. Define the object by adding other types of details such as molding, turned legs, or as in this example, bottom and center stretchers.

Step 4. The sketch can be finalized by darkening the lines of the completed object with pencil or ink. Do not use an eraser to delete lines; simply adjust the line by drawing a darker line over it. This example shows hatching along the right vertical side surfaces.

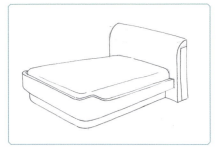

Step 1. Start with the total volume of the mattress set, including the mattress, box spring, and spacing from the floor.

NOTE Different mattress sizes will change the overall proportions. This example is a queen-sized bed.

Step 2. After the mattress dimension is done, create the headboard proportion based on the mattress size. This example is an Art Deco–style bed, so the headboard is drawn much wider than the mattress.

Step 3. Develop the footboard and rail dimensions.

NOTE The original mattress lines were erased, and the edges of the mattress have been curved to soften its appearance.

Step 4. Start developing the object's details. Because this is an Art Deco style, the top of the headboard is rounded, as are the sides of the footboard. The rails are curved and lowered.

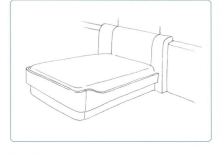

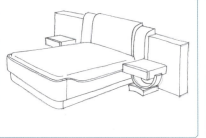

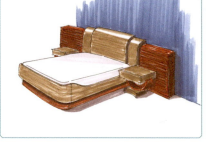

Step 5. To add other elements, start by creating the space for these elements and extrude them outward.

Step 6. Add dimension to the curves and the side and finish with vertical lines to create the desired proportions.

CURVILINEAR FURNITURE SKETCHING

If the furniture is not a square or box form, it will probably be quicker to create the image using a different process. Create a gesture sketch by using forms that are closely related to the forms of the object and then adjust those forms into the object. One example of this is drawing an Eero Saarinen "Tulip Chair" as an independent sketch or in an interior space. The following sketches show the development of that tulip chair. The process starts by defining the geometric proportions, then adding the detail.

BARSTOOL EXAMPLE

Step 1. Start with a ball; then add a pedestal under it, rather than creating a cube. This is done by creating an appropriately sized ball and then drawing a tube from the underside of the chair to an ellipse.

NOTE In this sketch we draw through the details to see the total volume of the chair's parts.

Step 2. Re–form the top part of the chair inside that ball form. Try to see the depth when drawing this part. Also, curve the walls of the tube inward for the base of the chair.

Step 3. When the chair form is drawn, erase any construction lines. At this point, the proportion can be adjusted by refining the forms of the chair.

FURNITURE DETAILS

It can be easier to create an enlarged detail of a piece than to try to add that detail to a small drawing. Typically, the detail drawing accompanies the complete sketch, so the basic idea is shown along with an interesting element or detail. Another type of drawing is the exploded view drawing. This type of drawing shows the piece disassembled, so the client or fabricator understands the connection process. Again, it is typically easier and faster to create a small detail than the complete piece. These sketches can help a furniture builder understand how you think the piece should be assembled or can show a client important details.

SKETCHING ROOMS IN ONE-POINT PERSPECTIVE

When sketching in one-point perspective, the most important step is the first one: defining the dimensional foundation. The proportions of objects and details from other steps are based on this foundation.

CREATING A SMALL SPACE

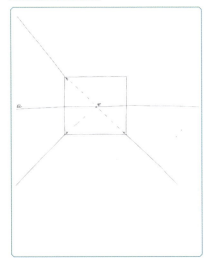

Step 1. Start by creating the back wall and then draw the eye-level (EL) line. This example shows a wall with a 10' ceiling: EL is running along the center of the back wall, making it 5' from the ground. Place the vanishing point (VP) on the eye-level line and inside the back wall. Draw construction lines from the VP through the corners of the back wall outward.

NOTE The VP is a reference point to help line up angles that are to be drawn outward. You should not use a ruler to line things up perfectly. The drawing should be done freehand. Remember, it's a sketch.

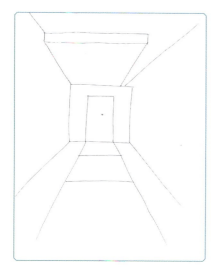

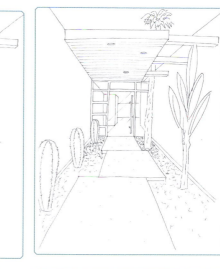

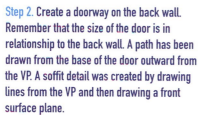

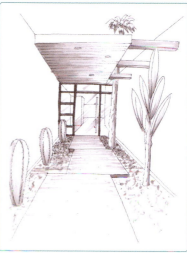

Step 2. Create a doorway on the back wall. Remember that the size of the door is in relationship to the back wall. A path has been drawn from the base of the door outward from the VP. A soffit detail was created by drawing lines from the VP and then drawing a front surface plane.

Step 3. Add details to the back wall. Adjust the front path using lines from the VP.

NOTE Beams were added to the ceiling; because they are above eye level, only the front and bottom surface planes are visible.

Step 4. Add interior details by drawing lines from the corners of the back wall to the VP. Draw vertical lines to create the end of those walls and horizontal lines to create the far interior back wall. This creates the illusion of framed-in glass windows and a glass door.

NOTE Thickness has been added to the path and location spots for vegetation were added to the ground.

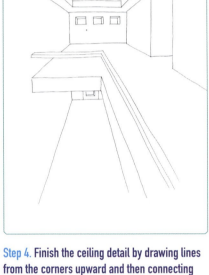

Step 1. This step starts the same way as a small space—by creating the back wall first and then adding an eye level line. The eye level line has been drawn across the center of the wall. If this wall represents 8', then eye level has been drawn at 4'. Add a vanishing point on the eye-level line inside the back wall. Draw lines from the vanishing point through the corners of that back wall outward to create the side walls, floor, and ceiling.

Step 2. Create a hallway to the right side by drawing vertical lines on the wall from floor to ceiling and then drawing horizontal lines at the floor and ceiling to create the hallway.

Divide the floor by drawing a horizontal line from the left side to the desired size and then using the vanishing point to draw the opening forward. Add thickness by drawing vertical lines down from the corners and connecting them with a horizontal line and a line from the vanishing point drawn forward.

Step 3. Create the ground floor by extending the left back wall line downward to the desired size and then draw a horizontal line across. Draw a line from the vanishing point through the corner of the ground floor forward. In this drawing, a ceiling detail has been started as well as windows on the back wall.

NOTE The original back wall is 8' tall; therefore, the ground floor is about 12' tall in this example.

Step 4. Finish the ceiling detail by drawing lines from the corners upward and then connecting those lines with a horizontal line at the desired height. Then draw lines from the VP through the top corners forward to create the sides. Add window dimension by drawing lines from the corners of the windows to the vanishing point and then draw lines for the top and side edges. In this drawing, a door was added to the ground floor's back wall and a railing has been added.

NOTE The scale is important for the height of the railing. This is based on the scale of the left wall where it attaches.

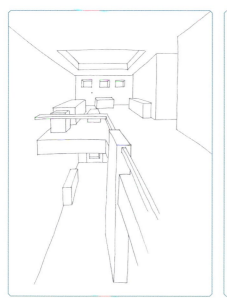 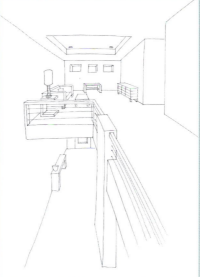 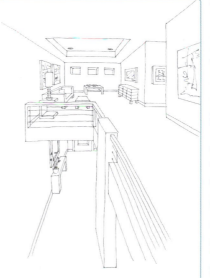 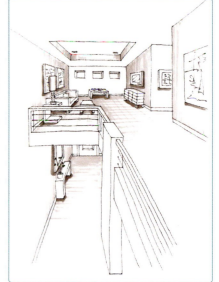

Step 5. Draw the furniture in cube form to start. This helps to show the total proportion of each piece and the space between the pieces. Add a wall partition from the ground floor to the second-floor railing.

Step 6. Define the furniture inside the cube forms from Step 5. In this drawing, a lamp has been added to the end table and a cable system has been added to the railing.

NOTE The bottom of the lampshade is below the eye-level line and extends above it, so only the front curve is visible.

SKETCHING ROOMS IN TWO-POINT PERSPECTIVE

As with a one-point sketch, in a two-point sketch the most important step is the first one because it is the foundation to the entire drawing. Remember that the vanishing points are reference points to help keep surface angles correct. As with the one-point sketches, you should not use a ruler.

CREATING A SMALL INTERIOR SPACE

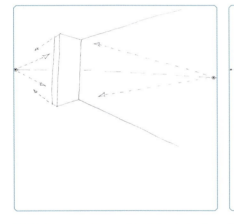

Step 1. Create a vertical wall height, and add the eye-level line with vanishing points at each side. Extend the walls outward from the vanishing points. Use other vertical lines to define other wall planes.

Step 2. Create a footprint of an object against the wall and on the floor; then develop the volume in cube form. This example is a vanity, so the cube has been divided into three parts, which will represent three different cabinets.

Step 3. Divide up space on the cube. This image shows the doors, top thickness, and base molding.

NOTE To find center for the doors, draw guidelines from corner to opposite corner. In this example, vertical lines have been drawn up the walls to define the space for the mirrors.

Step 4. Develop the spacing into forms or surface elements. In this example, the center cabinet and the side tops have been expanded. The mirrors have been completed by drawing lines from the left vanishing point.

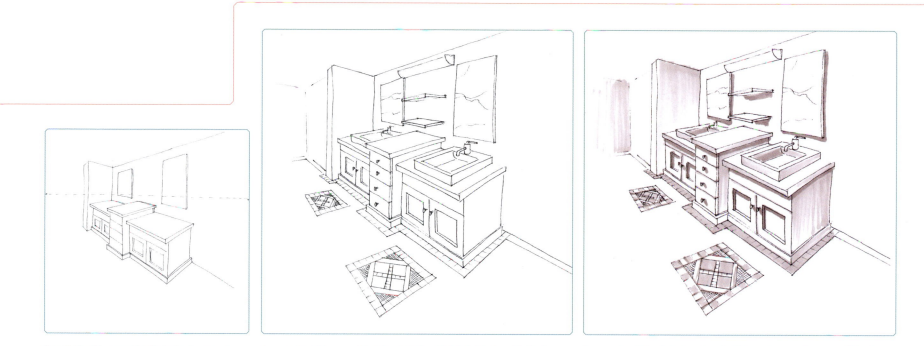

Step 5. Provide more details in the doors and molding around the cabinet. The center top also has been added, and thickness provided for the mirrors.

An example of the completed line sketch with finish details added to the floor and wall. Sinks and fixtures also have been added.

An example of the sketch rendered with gray tone markers to add depth to the drawing.

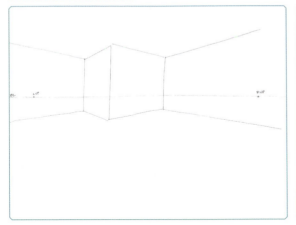

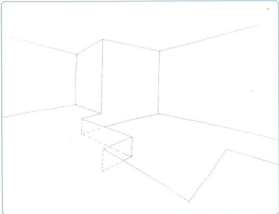

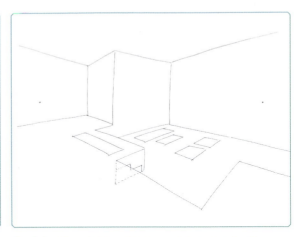

Step 1. Create a vertical wall height and add the eye-level line. Add the left and right vanishing points on the eye-level line. Create the walls by drawing lines from the vanishing points outward from the top and bottom of the vertical line. This example shows eye level at 5', which makes the total ceiling height around 18'.

Step 2. Create a lowered floor by extending the back wall line lower and using the vanishing points to bring the floor through the space.

NOTE A dashed line shows the depth on the front edge.

Step 3. Use the vanishing points to create the footprints of the furniture on the floor. On this example the side wall footprint of the stairs has been added. The dashed line helps with the proportions of the stairs.

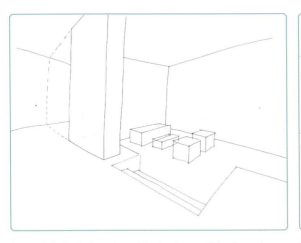

Step 4. Cube in the footprints of the furniture to show the total volume of those pieces. In this example, a front partition also has been cubed in and the stairs have been completed.

Step 5. Finish the details of the furniture using the cubes to help with proportion.

Step 6. Add details to the back walls. This example shows floor-to-ceiling windows.

NOTE The right side windows' proportions are smaller because the front partition blocks where the wall surface plane changes direction.

An example of the completed line drawing, with front partition details added as well as exterior views.

NOTE When drawing large windows it's a good idea to show exterior details because the view will be the major selling point of the space.

An example of the line drawing rendered with gray tone markers, which add depth and detail to surfaces.

SKETCHING INTERIOR SPACES FROM A PHOTOGRAPH

A three-dimensional space is flattened when it is photographed; this creates a perspective image. The angle from which the photo was taken will determine whether it is a one-, two-, or three-point perspective. When the photo is taken, it can be used to create perspective drawings. For interior design, this comes in handy when the project calls for a redesign or remodeling of a space, so there will be a demolition and rebuild. The photo can be taken before the demolition starts and used as the foundation. After printed to a large scale it can be used to find the vanishing points and horizon line. It can then be overlaid with marker paper to start the new drawing.

CREATING ONE-POINT PERSPECTIVE FROM A PHOTO

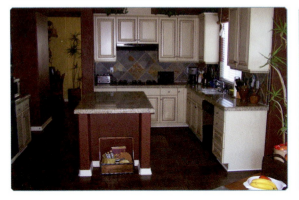

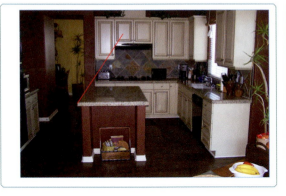

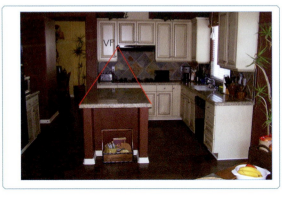

Step 1. Take a photograph of the space that is to be redesigned.

NOTE This photo needs to be taken in a one-point perspective view.

Step 2. Find the vanishing point (VP) by drawing one line from the edge of a surface plane in the photo backwards in the drawing.

NOTE This example uses the edge of the kitchen island.

Step 3. Draw a second line from a different surface plane backwards in the drawing until it intersects the line from Step 2. This intersection point is the one-point VP.

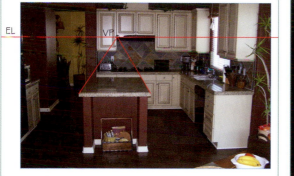

Step 4. Draw the eye–level line from the VP across the paper. This is eye level based on the photograph and will be eye level for the drawing.

Step 5. Enlarge the photo with a computer scanner or copier and then overlay it with marker paper.

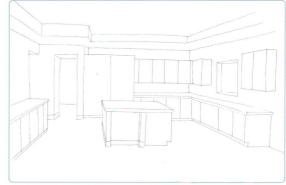

Step 6. Create a rough line drawing of the space on the marker paper.

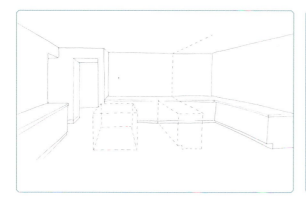

Step 7. Starting with the walls and floor, alter the image to create the new volume of the space.

NOTE For this example the old wall and cabinet lines are dashed.

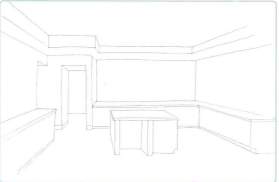

Step 8. Add objects to the space. This example shows the soffit added to the ceiling and the island enlarged and moved slightly to the right.

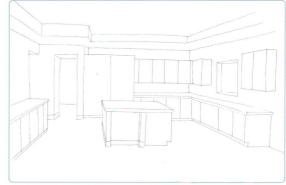

Step 9. Define the volume by adding objects to the room. This example shows the spacing of the cabinets and window.

Step 10. Complete the line drawing with final details to the space. This example shows crown molding, window treatment, refrigerator, double oven, and lighting.

Example with gray-tone markers.

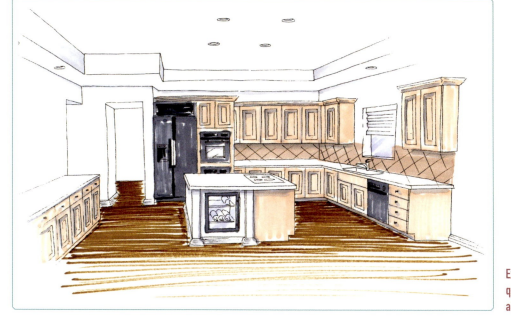

Example with quick color added.

CREATING TWO-POINT PERSPECTIVE FROM A PHOTO

The example used in this process shows a kitchen with a small living room space. The back wall is going to be redesigned to create a larger overall space with a dining room on the other side.

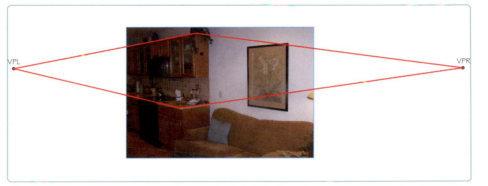

Step 1. Take a photograph of the space that is to be redesigned. Enlarge the photo with a computer scanner or copier.

NOTE This photo needs to be taken in a two-point view.

Step 2. Find the vanishing point left (VPL) by drawing a line from the edge of an object's surface plane to the left side. Then draw a second line from a different surface plane toward the left side. Where the two lines intersect creates the VPL.

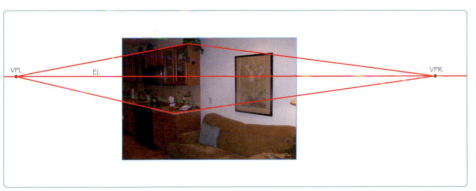

Step 3. Draw the eye level line (EL) from the VPL across the paper. This is eye level based on the photograph, and will be eye level for the drawing.

Step 4. Overlay with marker paper to start final drawing.

Step 5. Start altering the image based on the photo. This example shows the wall being altered from solid to a walk-through to create space for a dining room. All of the lines are drawn as a standard two-point perspective drawing.

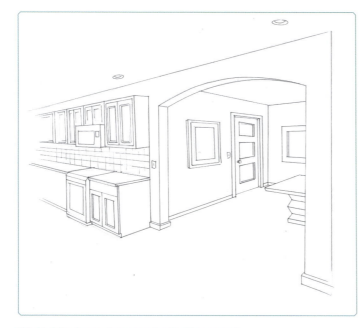

This final line image shows construction lines erased.

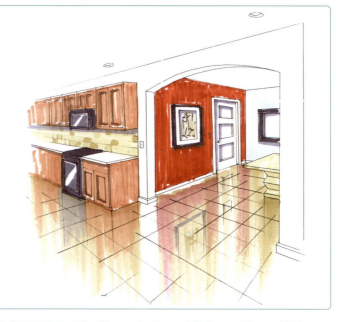

This final marker-rendered image shows materials that would be used in the space.

HATCHING AND CROSS-HATCHING

Hatching and cross-hatching are used to provide shadow and depth for a piece of furniture or an interior space. Hatching is the use of parallel lines to create tone lines; they are drawn closer together to create a darker image or spaced further apart to create a lighter one. Cross-hatching uses parallel and perpendicular lines in the same way as hatching to create different shades. They can be created in pencil or ink pen, but are typically done in ink drawing because the pencil can be blended differently than a pen. Both hatching and cross-hatching are a good way to quickly show a client volume in a sketch without having to render the image. The following example shows a step-by-step process to create a chair and then shows that chair with hatching and cross-hatching.

HATCHING AND CROSS-HATCHING

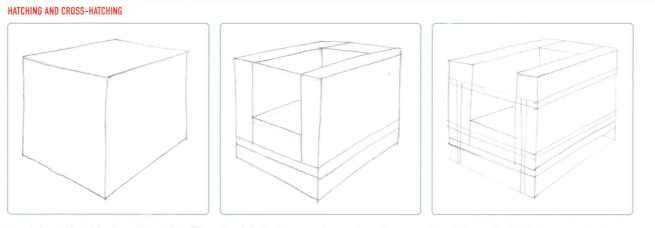

Step 1. **Create the total volume of the object. This piece will be a Le Corbusier LC3 chair.**

Step 2. **Define the proportions, such as the arms, seat, and back.**

Step 3. **Create the details. This example shows the development of the steel frame.**

NOTE **Drawing through the front of the chair can help line up the proportions and angle of the frame.**

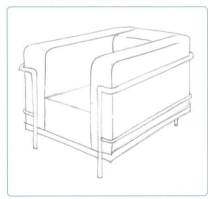 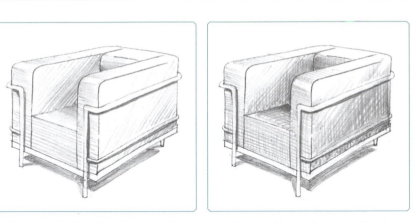

Step 4. Define the complete object. Because this example is an upholstered piece, the edges of the chair have been rounded off and the steel frame completed.

The first example shows the value scale of hatching, and the second image shows cross-hatching. Both were created in pencil.

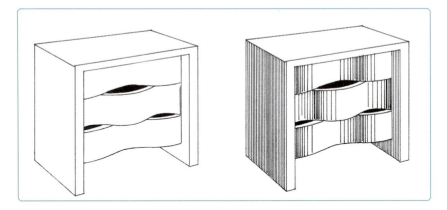

This example shows a pen sketch of a nightstand with some quick hatching to show the shape and depth of the front drawers.

NOTE: The hatching shows where the light hits the drawers by creating a shadow in value and creating the highlight left in white.

Project 5.1 SKETCHING FURNITURE IN ONE- AND TWO-POINT PERSPECTIVES

Sketch a piece of furniture in three views on the same sheet of paper.
1. The first view is a front one-point perspective.
2. The second view is a front/side view in two-point perspective.
3. The third view is a back/side view in two-point perspective.
4. Draw a total of five different types of furniture.

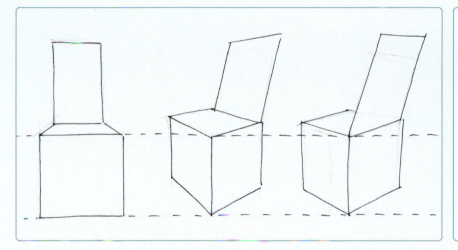

This image shows the development of the basic volume of a chair.

This image shows the completed sketches of the chair.

Project 5.2 SKETCHING FURNITURE AND DETAILS

Sketch a single piece of furniture as well as a detail of that piece. Create a total of three pieces of furniture.

1. Start by sketching a cube to represent the total volume of the piece of furniture.
2. Develop that cube into the completed piece of furniture.
3. On the same sheet of paper, sketch a detail of that piece—carving, turning, or the like.
4. Finish the sketches by shading the lines with pencil or ink to create a contour drawing. Do not erase construction lines.

This is an example of a sketch of a piece of furniture and a detail.

Project 5.3 SKETCHING ASSEMBLED AND EXPLODED VIEWS OF FURNITURE

On one sheet of paper, sketch a piece of furniture; then provide assembled and exploded views. Create a total of three pieces of furniture.

1. Start by sketching a cube to represent the total volume of the piece of furniture.
2. Develop that cube into the completed piece of furniture.
3. On the same sheet of paper, sketch an assembled detail of that piece.
4. On the same sheet of paper, sketch an exploded detail of that piece.

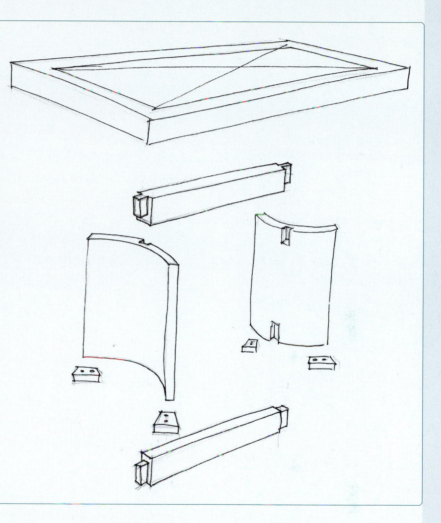

This is an example of a piece of furniture assembled and exploded.

Project 5.4 SKETCHING A FURNITURE GROUPING IN A ROOM IN TWO-POINT PERSPECTIVE

Sketch an interior space with a small furniture grouping in a two-point view.

1. Start by drawing the back vertical corner of the wall.
2. Draw wall surface planes to implied vanishing points.
3. Use the back wall to eyeball the size and proportions of the items in the room.
4. Start the furniture in cube form and then detail it into furniture.
5. Sketch a complete room, including furniture, light fixtures, window treatments, molding, and so on.

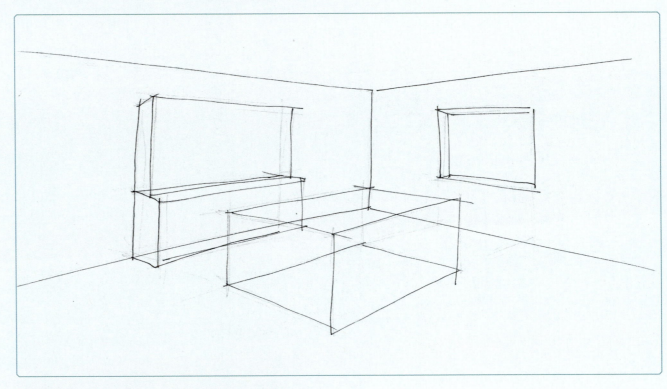

Example of how to lay out the two-point perspective room sketch.

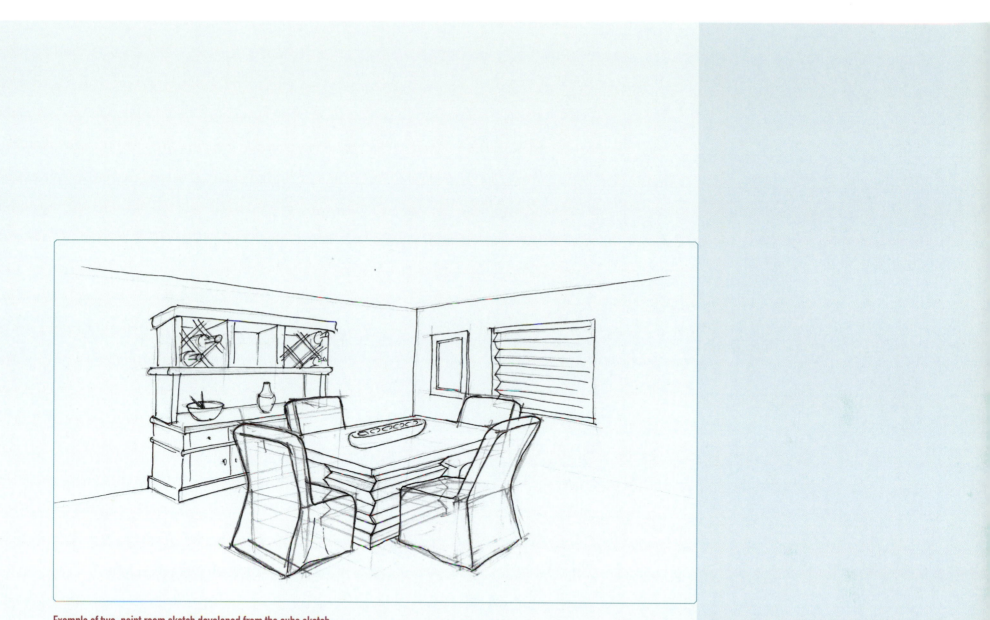

Example of two-point room sketch developed from the cube sketch.

6

Using Plan and Elevation Views for One-Point Perspective

This chapter covers one-point perspective drawings and shows how to use the plan and elevation views together to create the perspective. It starts with furniture in one-point perspective. Using the same basic process for drawing furniture, the chapter illustrates how to use the plan and elevation views to create complete interior spaces in one-point perspective. This is a great way to take an AutoCAD project from a flat two-dimensional view into a three-dimensional space. By the end of this chapter you will be able to take any plan and elevation view of an individual object or complete space and turn it into a perspective. This chapter shows you how to create the correct proportion from one-point perspectives without creating a grid.

ORTHOGRAPHIC PROJECTION

An orthographic projection is a drawing of a three-dimensional object that has been drawn into three separate two-dimensional views: a top or plan view, a front elevation view, and a side elevation view. The correct format for these views is to have the plan view above and lined up with the front elevation and the side view to the right and also lined up with the front elevation. The purpose of having the orthographic drawing for perspective is that you can start with this scaled object, furniture, or room, and create a perfectly proportioned perspective drawing without a grid. Therefore, it is possible to use orthographic AutoCAD drawings and develop them into a perspective.

BASIC RULES FOR USING A PLAN AND ELEVATION

This section shows one method of creating a piece of furniture or a room with perfect proportions without measuring or using a grid. This method saves time because a grid does not need to be produced first. These drawings use two views from an orthographic drawing. The plan view must be used as well as one elevation. These views can be created in AutoCAD and then printed and taped to the paper for the perspective drawing. The setup for a piece of furniture, which is discussed first, is slightly different than that for a room.

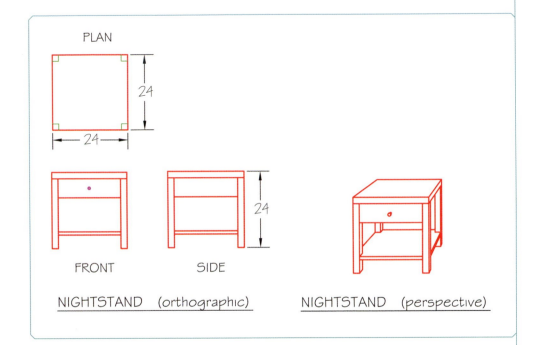

An orthographic drawing of a nightstand on the left and a perspective of the same nightstand on the right.

FURNITURE IN ONE-POINT PERSPECTIVE

The following examples show how to create a one-point perspective draw- ing of a piece of furniture while using a scaled plan and an elevation view.

SETUP IN ONE-POINT PERSPECTIVE FOR A PIECE OF FURNITURE

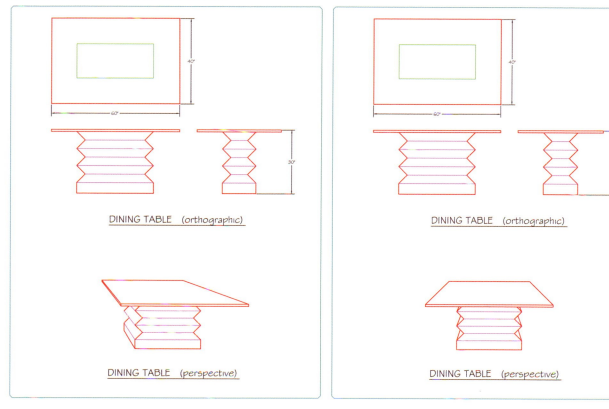

DINING TABLE (orthographic)

DINING TABLE (orthographic)

DINING TABLE (perspective)

DINING TABLE (perspective)

Step 1. Start with the orthographic projection drawing of the piece of furniture. The drawing must use the plan view and one elevation view. It does not matter if it's the front or side view.

Step 2. Set up the perspective using the paper in vertical format. Draw a ground line (GL) close to the bottom of the paper. Draw a picture plane overhead (PPO) close to the top of the paper.

Step 3. Place the elevation on the GL and to the right of the paper. Place the plan view above and on the PPO. A one-point perspective will have the front edge touching the PPO, and the plan view will be parallel to the PPO.

Step 4. Draw the eye-level line parallel to the PPO and GL. Remember that the eye level is in relationship to the elevation.

Step 5. Add a station point (SP). This represents the distance of the person from the plan view.

Step 6. Draw a guideline down from the SP until it intersects the eye-level line. The intersection point is the vanishing point (VP).

Step 7. Start creating the one-point perspective.

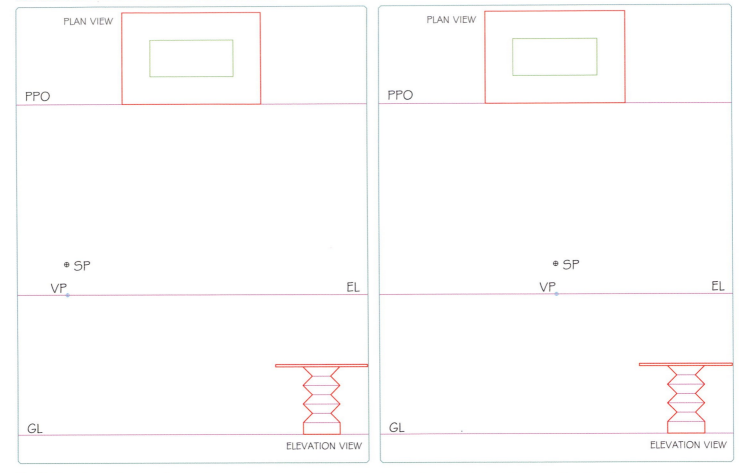

Step 1. After setting up the perspective, draw lines down from the outside edges of the plan view. Also draw a horizontal line across those lines from the top of the elevation.

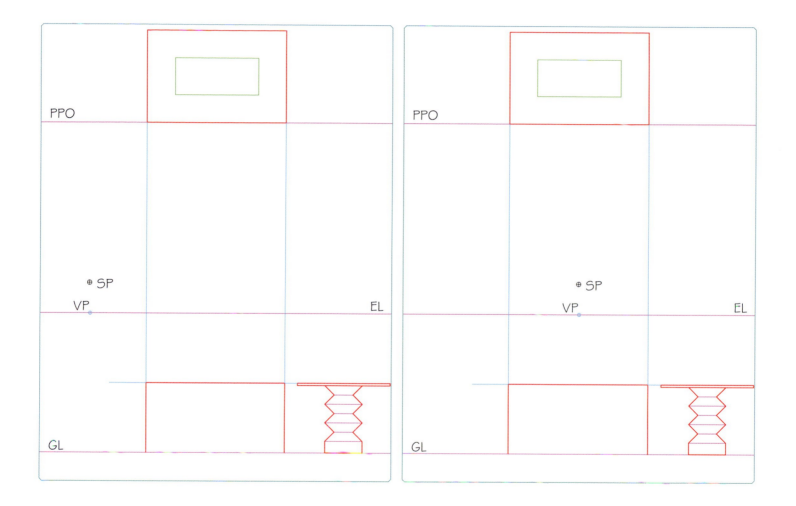

PPO

⊕ SP

VP EL

GL

PPO

⊕ SP

VP EL

GL

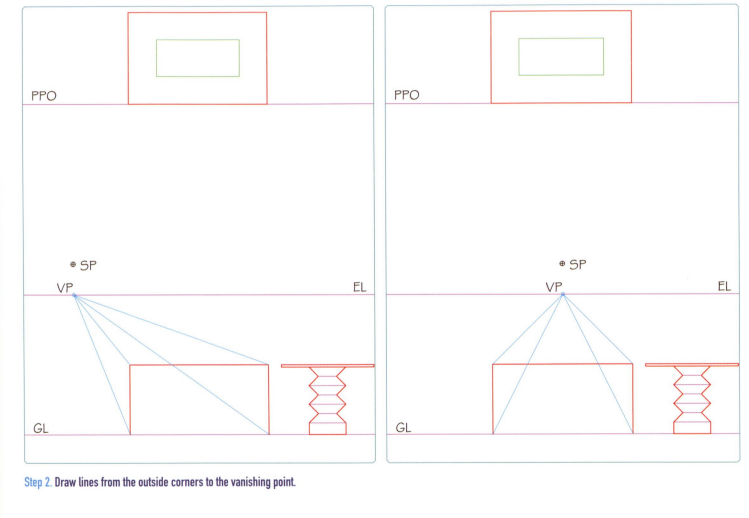

Step 2. Draw lines from the outside corners to the vanishing point.

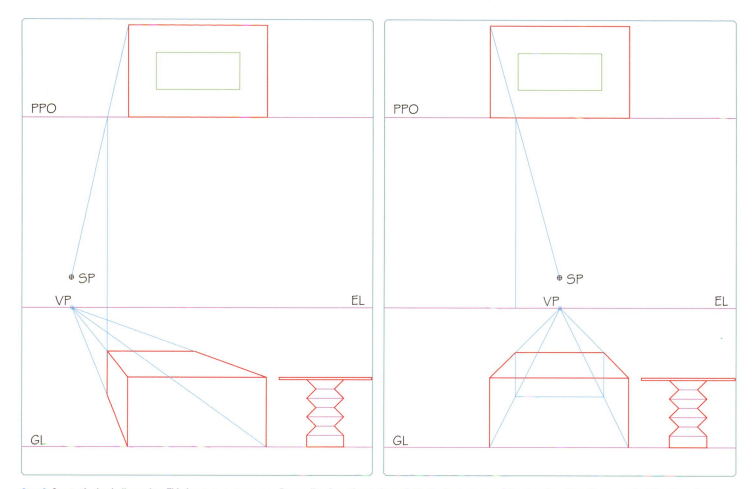

Step 3. Create the back dimension. This is a two-part process: Draw a line from the station point to the back corner of the plan view; then draw a vertical line down from where the first line intersects with the picture plan overhead. This line creates the back of the object.

Step 4. Make the solid cube transparent to see the total volume of the object.

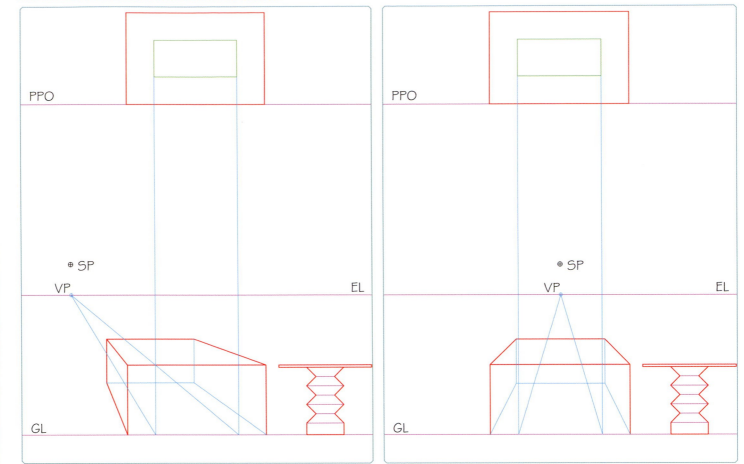

Step 5. After the cube is created, repeat the same step to create the detail of the object. Start the footprint for the pedestal by bringing the lines down from the plan view to the ground line (GL). Then transfer those lines back to the vanishing point.

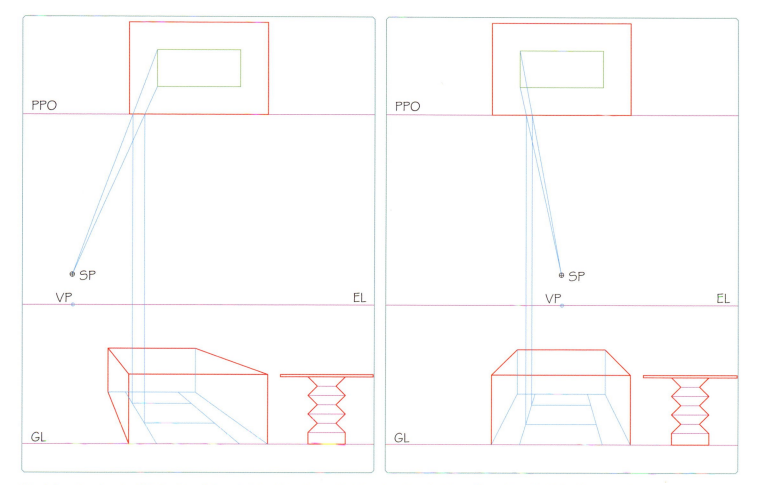

Step 6. Draw lines from the SP to the sides of the pedestal and then draw vertical lines down from the intersection points on the PPO to the perspective.

Step 7. Draw horizontal lines for the front and back lines where the lines from Step 6 intersect to create the footprint of the pedestal.

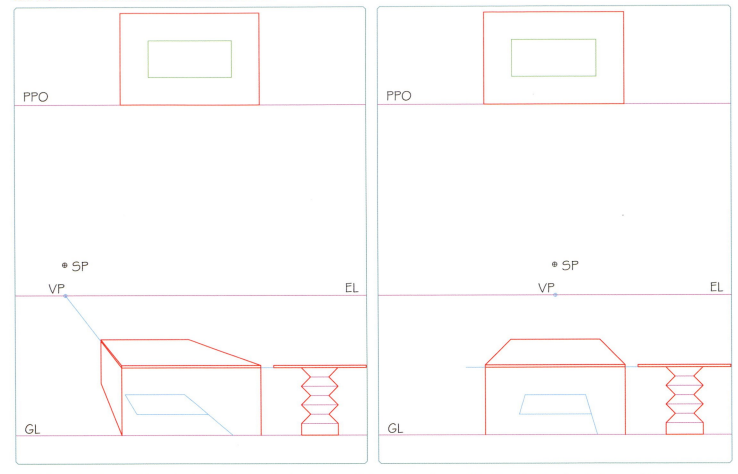

Step 8. Create the thickness of the top by drawing a line from the elevation across the front surface plane, and then draw a line from the edge to the vanishing point.

NOTE A guideline is left from the footprint to the front edge; this is for the base.

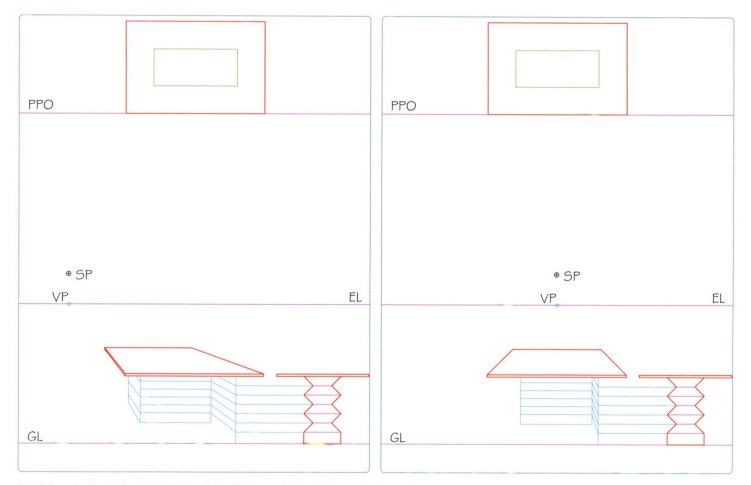

Step 9. Draw detail guidelines from the elevation to the front vertical guideline and then to the object.

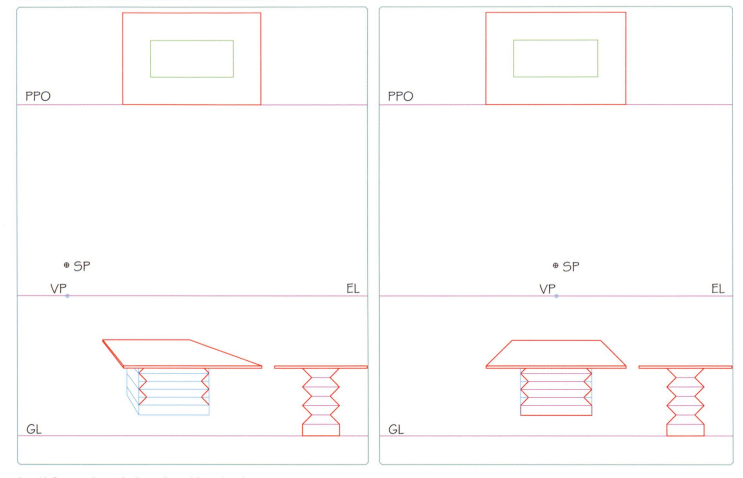

Step 10. Draw angles on the front edges of the pedestal.

PLAN VIEW

PPO

⊕ SP

VP EL

GL

ELEVATION VIEW

PPO

⊕ SP

VP EL

GL

Step 11. Erase the construction lines to show the finished piece of furniture.

ONE-POINT ROOM USING PLAN AND ELEVATION VIEWS

Step 1. Start with the orthographic projection drawing of the interior space. The drawing must use the plan view and one elevation view. It does not matter if it's the front or side view.

Step 2. Set up the perspective using the paper in vertical format. Draw a picture plane overhead (PPO) close to the top of the paper.

NOTE The room setup will not use a ground line (GL).

Step 3. Place the elevation to the right or left of the paper. Place the plan view *below* and inside the back wall on the PPO.

NOTE Two-point perspective, which is covered later in this chapter, will have the inside corner of the back wall touching the PPO and the plan view at an angle to the PPO.

Step 4. Draw the eye-level line parallel to the PPO. Remember that the eye level is in relationship to the elevation; therefore, the eye-level line should run through the elevation.

Step 5. Add a station point (SP). This represents the distance of the person from the plan view.

Step 6. Find the vanishing point. With one-point perspective, draw a line downward from the SP to the eye-level line (EL). This line should be perpendicular to the PPO. The vanishing point is where these two lines intersect. Start creating the one-point perspective.

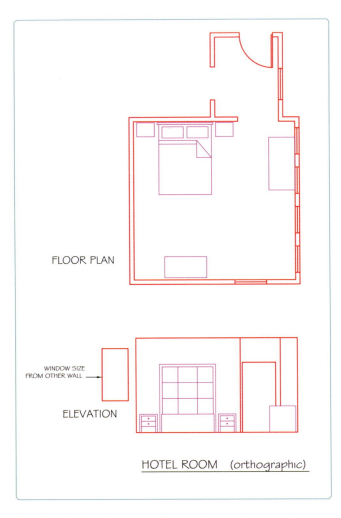

FLOOR PLAN

WINDOW SIZE FROM OTHER WALL

ELEVATION

HOTEL ROOM (orthographic)

Example of the floor plan and elevation used to create the one-point perspective.

PART 1: CREATING THE BACK WALL

Step 1. Draw a vertical guideline down from the station point to the eye–level line. This intersection point is the vanishing point.

Step 2. Draw the inside walls' lines from the plan view down.

Step 3. Draw the ground and ceiling lines from the elevation across. Where they intersect the lines from Step 2 is where the back wall is created.

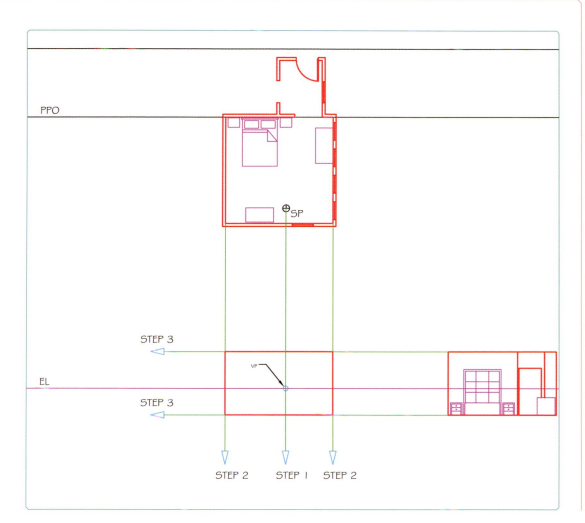

PPO

STEP 3

STEP 3

EL

VP

SP

STEP 2 STEP 1 STEP 2

Step 1. Draw lines from the vanishing point through the corners of the back wall outward to create the side walls, ceiling, and floor.

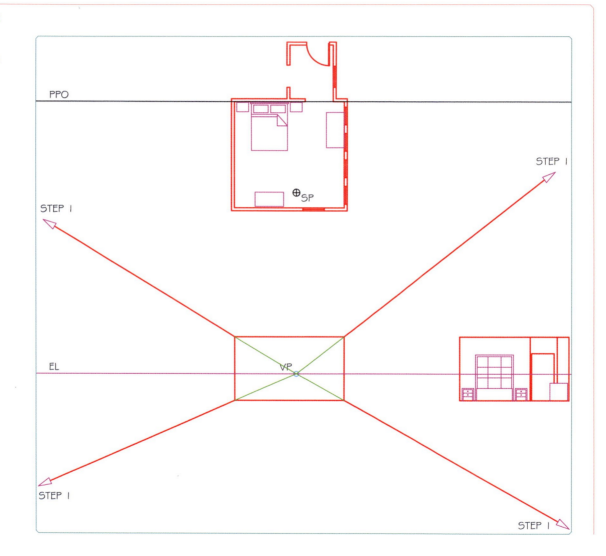

PART 3: STARTING A HALLWAY FROM THE BACK WALL

Step 1. Draw vertical lines down from the hallway to the back wall of the perspective.

Step 2. Draw a height line from the elevation across. The hallway is created where the line intersects from Step 1.

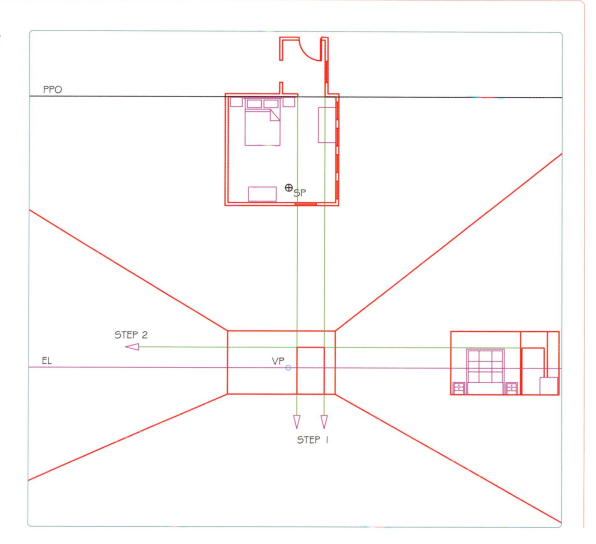

Step 1. Draw a guideline from the station point to the back corner of the wall.

Step 2. Draw a vertical line down from the intersection point from the line in Step 1 and the picture plane overhead.

Step 3. Draw a line from the top line and bottom corner of the hallway to the vanishing point.

Step 4. Draw a horizontal line to make the back wall of the hallway where the lines from Steps 2 and 3 intersect.

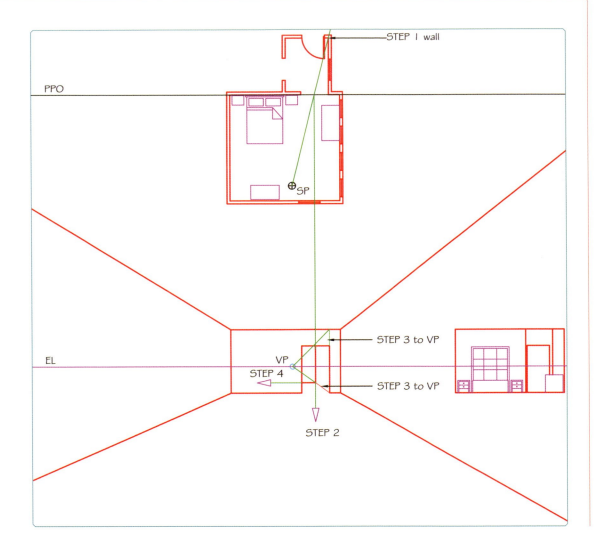

PART 5: CREATING THE BACK DOOR

Step 1. Draw a line from the station point to the edge of the door in the plan view.

Step 2. Draw a vertical line down to the perspective from the picture plane overhead intersection to create the vertical line of the door.

Step 3. Draw a guideline from the top corner of the doorway to the vanishing point.

Step 4. Draw a horizontal line from where the line in Step 3 intersects with the far wall to create the top of the door.

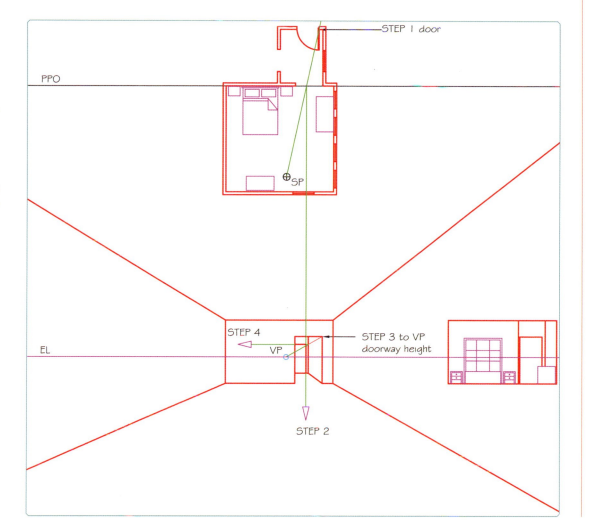

Step 1. Draw vertical lines down from the outside edges of the bed in the plan view to the back wall of the perspective.

Step 2. Draw horizontal lines from the elevation to create the headboard and mattress heights.

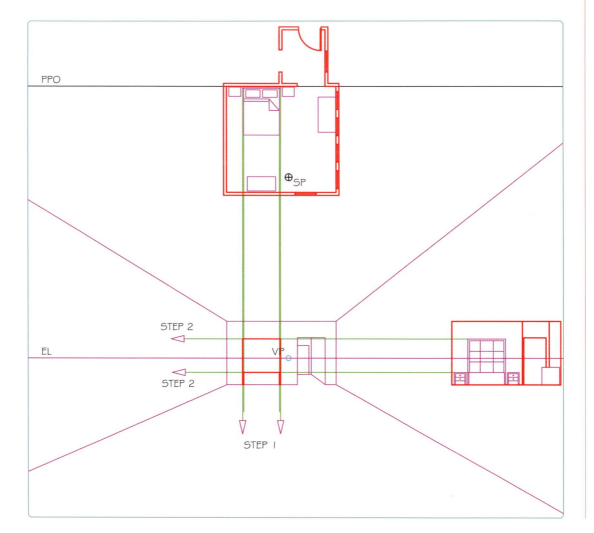

PART 7: CREATING THE NIGHTSTANDS ON THE BACK WALL

Step 1. Draw vertical lines down from the outside edges of the nightstands in the plan view to the back wall of the perspective.

Step 2. Draw a horizontal line from the elevation to create the nightstands' height.

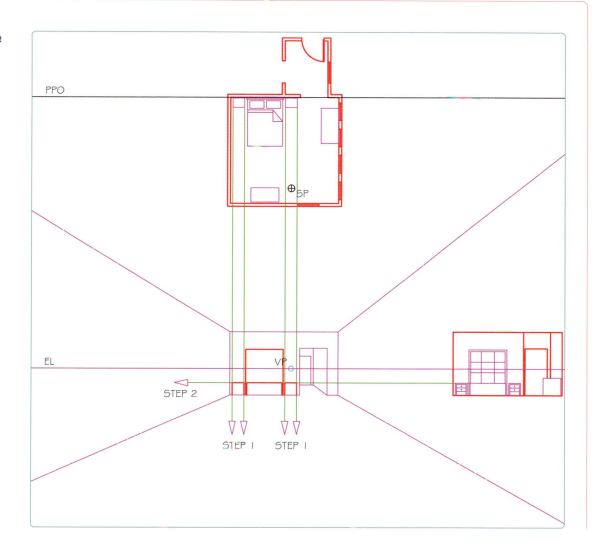

Step 1. Draw lines from the vanishing point through the baselines of the bed and nightstands outward across the floor.

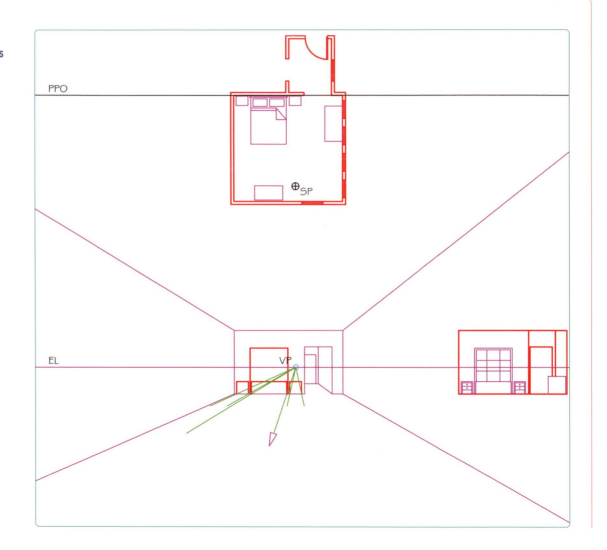

PART 9: CREATING THE SIZE OF THE BED

Step 1. Draw a guideline from the station point through one of the front corners of the bed to the picture plane overhead.

Step 2. Draw a vertical line down from the intersection point of the picture plane overhead to the guideline of the bed drawn in Part 8.

Step 3. Draw a horizontal line from the intersection point in Step 2 across to the other bed line. This completes the footprint for the bed.

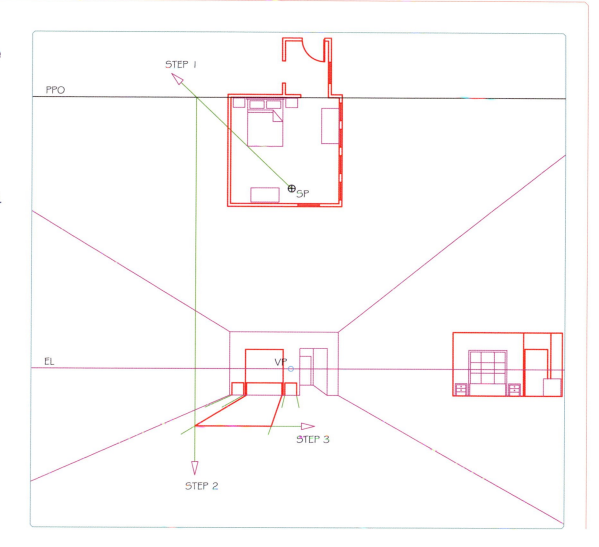

PART 10: CREATING THE SIZE OF THE NIGHTSTANDS

Step 1. Draw a guideline from the station point through one of the front corners of the nightstands to the picture plane overhead.

Step 2. Draw a vertical line down from the intersection point of the picture plane overhead to the guideline of the nightstand drawn in Part 8.

Step 3. Draw a horizontal line from the intersection point in Step 2 across to the other nightstand lines. This completes both footprints for the nightstands.

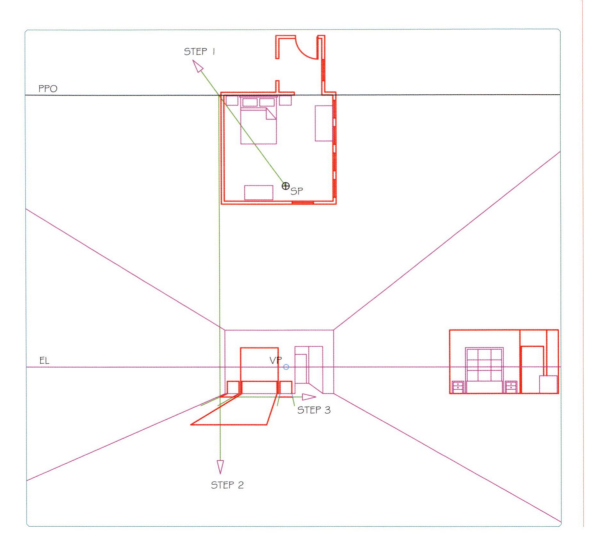

PART 11: CREATING DIMENSION FOR THE BED AND NIGHTSTANDS

Step 1. Draw vertical lines upward from the two front corners of the bed.

Step 2. Draw lines from the vanishing point through the bed mattress height on the back wall until they intersect with the lines from Step 1.

Step 3. Draw a horizontal line from the front intersection point created in Step 2 to create the top front of the bed.

Step 4. Repeat Steps 1 through 3 for the nightstands.

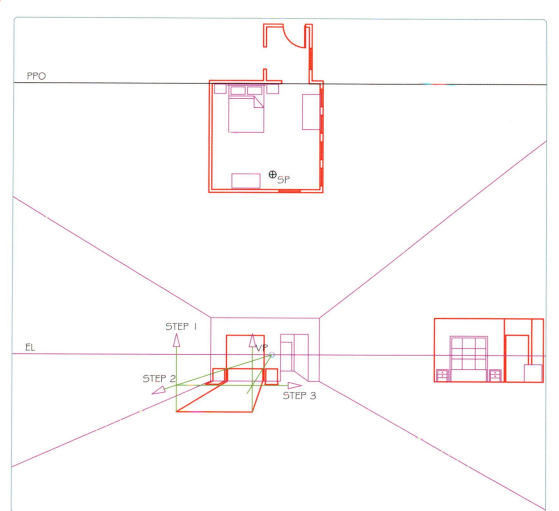

Step 1. Draw guidelines from the station point through the front and back corners of the desk where it touches the wall.

Step 2. Draw vertical guidelines down from the intersection points on the picture plane overhead to the base of the side wall.

Step 3. Draw guidelines across the floor where the vertical lines in Step 2 intersect the floor.

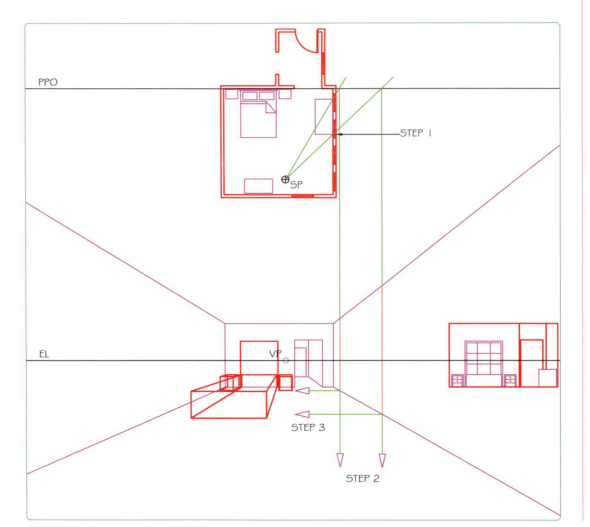

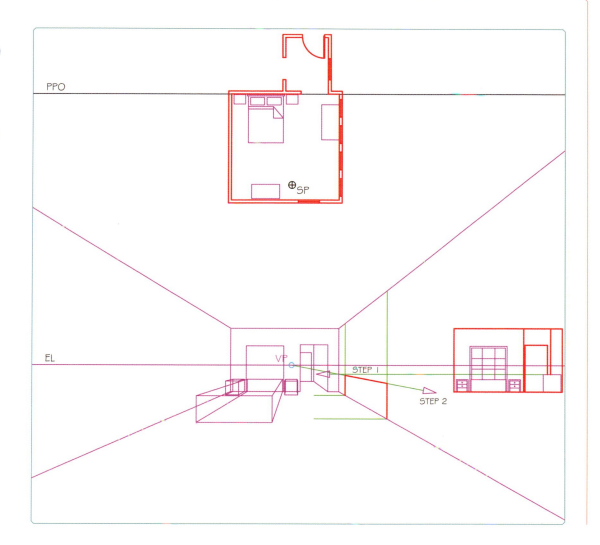

PART 13: CREATING THE HEIGHT TO THE DESK

Step 1. Draw a guideline from the object height in the elevation across until it intersects with the corner of the back wall.

Step 2. Draw a line from the vanishing point through the intersection point from Step 1 outward until it intersects with the vertical lines of the desk against the wall.

PPO

⊕SP

EL

VP

STEP 1

STEP 2

Step 1. Draw a guideline from the station point through the front corner of the desk to the picture plane overhead.

Step 2. Draw a vertical guideline down from the intersection point on the picture plane overhead to the front horizontal guideline on the floor.

Step 3. Draw a line from the vanishing point to the intersection point created in Step 2.

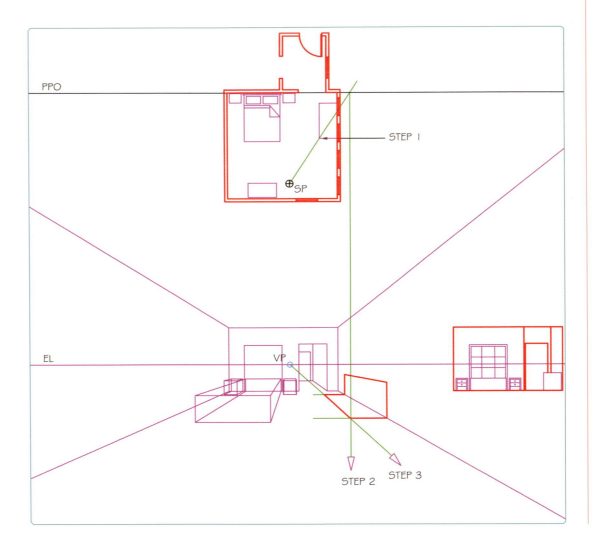

PART 15: CREATING THE TOTAL VOLUME OF THE DESK

Step 1. Draw vertical lines up from the front and back corners along the floor.

Step 2. Draw horizontal lines across from the front and back corners along the wall until they intersect the lines in Step 1.

Step 3. Connect the intersection points with a line from the vanishing point to complete the cube.

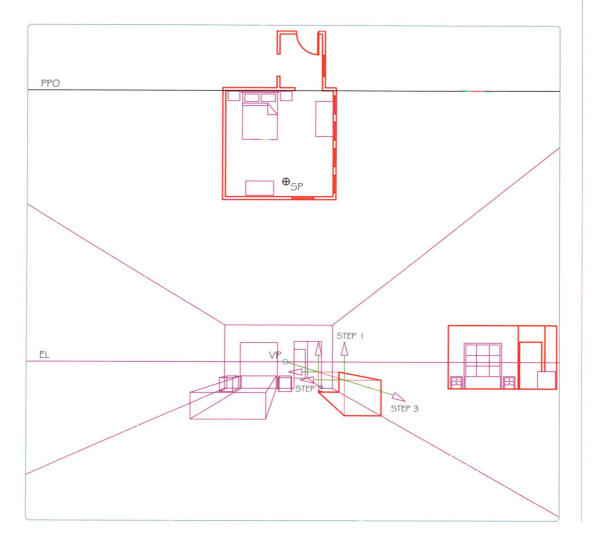

PART 16: CREATING THE FIRST WINDOW

Step 1. Draw guidelines from the station point through the far window edges to the picture plane overhead.

Step 2. Draw vertical lines down from the picture plane overhead intersection points to the side wall of the perspective.

Step 3. Draw the height of the windowsill and top from the elevation across the back wall to intersect with the right side wall.

NOTE The elevation window was added to the side of the elevation drawing because it is not part of the back wall elevation. It was added at the same scale as the elevation drawing.

Step 4. Draw guidelines from the vanishing point through the top and bottom intersection marks from Step 3. They cross the vertical lines in Step 2 where the far window is created.

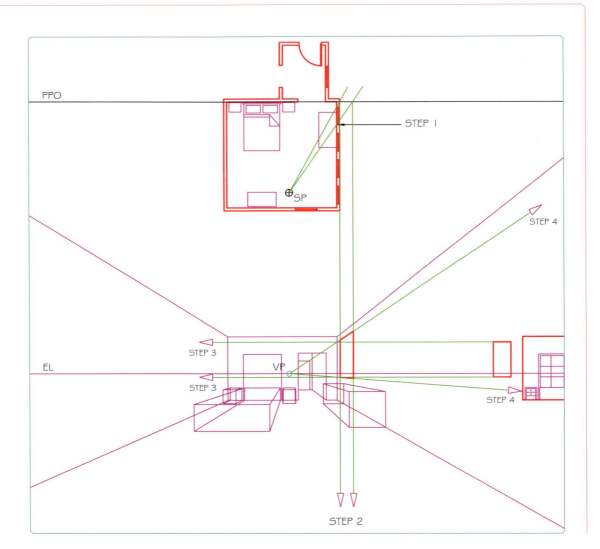

PART 17: ADDING THE REST OF THE WINDOWS

Step 1. Draw a guideline from the station point through the rest of the window edges to the picture plane overhead.

Step 2. Draw vertical lines down from the picture plane overhead intersection points to the side wall of the perspective. This creates the complete window spacing where the vertical lines cross the top and bottom window lines from Part 16.

NOTE The elevation drawing was removed because it's not needed for the rest of the drawing.

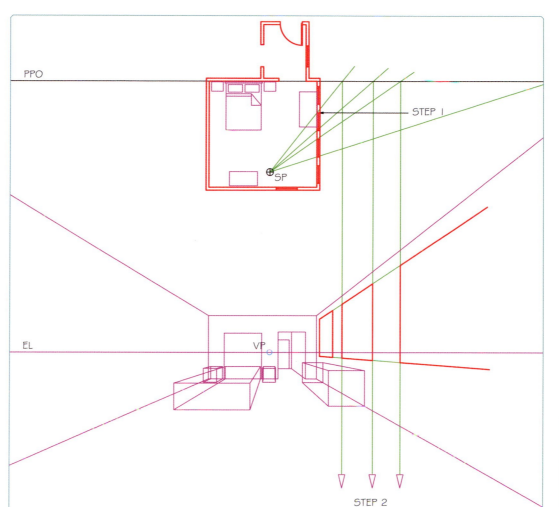

Step 1. Draw a guideline from the station point through the depth of the far window edge to the picture plane overhead.

Step 2. Draw a vertical line down from the intersection point on the picture plane overhead.

Step 3. Draw horizontal lines from the top and bottom of the back window until they intersect with the vertical line in Step 2.

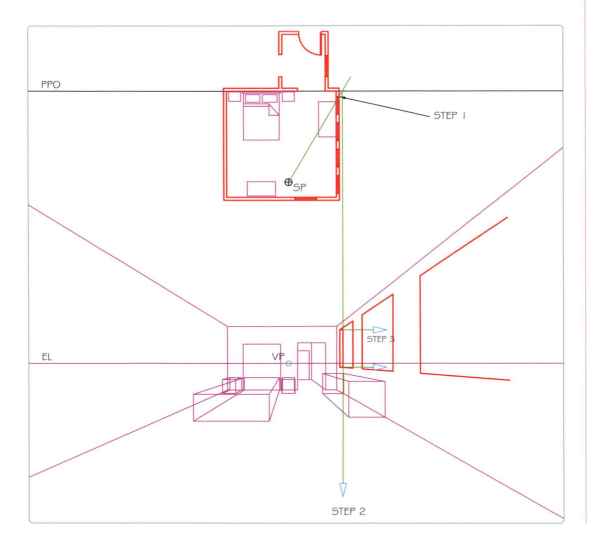

PART 19: ADDING DIMENSION TO THE REST OF THE WINDOWS

Step 1. Draw horizontal lines from the other window corners.

Step 2. Draw two lines from the vanishing point through the back window thickness, top and bottom, and continue through the other windows.

Step 3. Draw vertical lines from the intersection points in Steps 1 and 2 to complete the thickness.

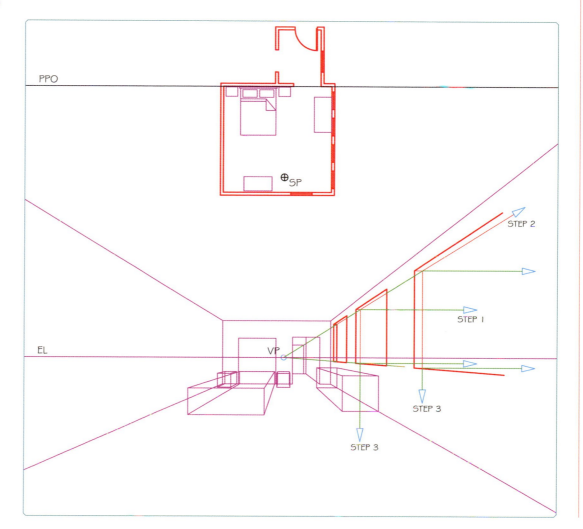

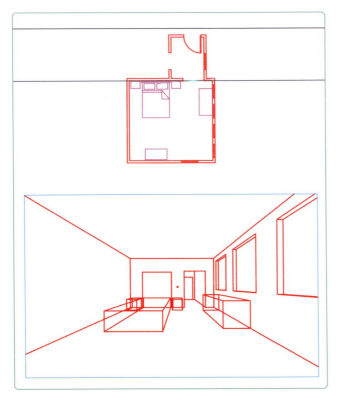

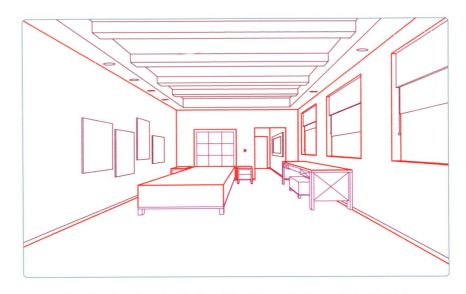

Completed line drawing with window shades, soffit and beams structure, and artwork added.

The basic room with the total volume of the furniture cropped to final frame of reference size.

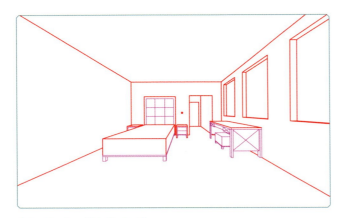

Cubes developed into the furniture.

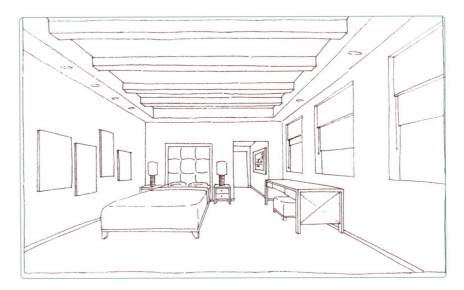

Completed drawing after being overlaid with marker paper and sketched to soften some of the edges and add other details.

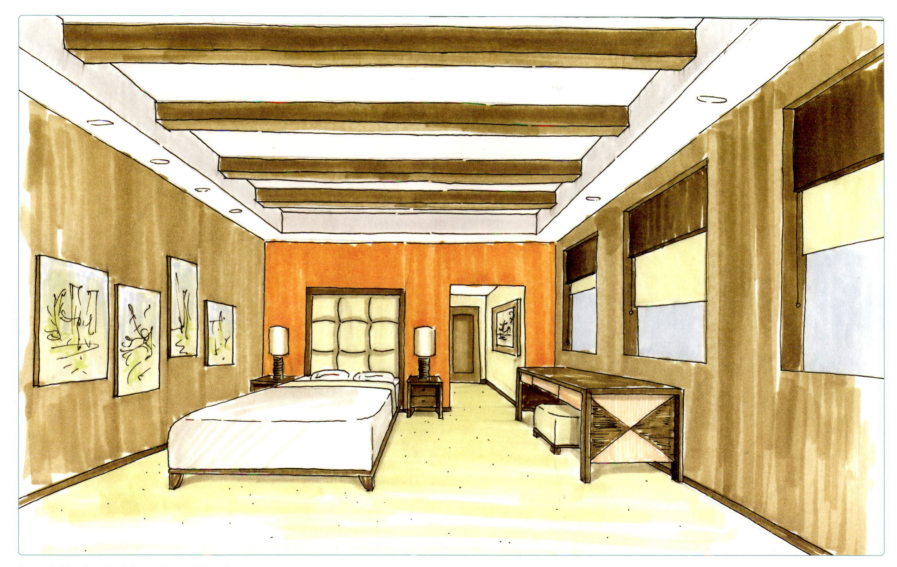

Completed drawing after being rendered with markers.

CREATING A PERSPECTIVE
FROM A FLOOR PLAN

This is an easy way to show depth in a floor plan drawing. It's a good solution for a small space, such as a bathroom where there is not enough depth for the back wall. The main difference is that there is not a horizon line, just the vanishing point placed somewhere in the floor area because the space is being viewed from directly above.

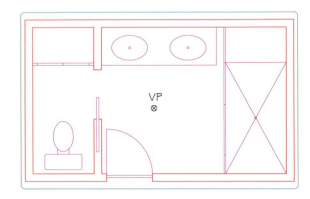

Step 1. Start with a scaled floor plan of the space and add a VP to the interior of the floor plan.

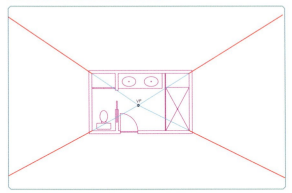

Step 2. Draw lines outward from the VP through the corners of the walls.

Step 3. Pick a desired ceiling height and draw the top ceiling lines parallel to the corresponding floor lines.

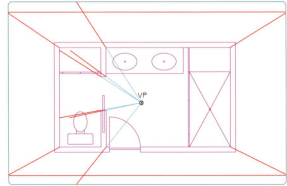

Step 4. Create dimension to objects in the space, such as doors, cabinets, and furniture, by drawing lines from the VP outward through the corners of those objects. This image shows lines from the vanishing point through corners of other walls.

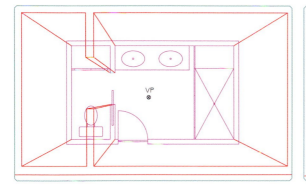

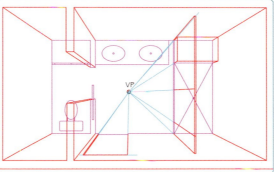

Step 5. Interior walls should be connected to outside wall lines and wall thickness can be added at the top.

Step 6. Add dimension to shower glass wall, shower seat, and doorway.

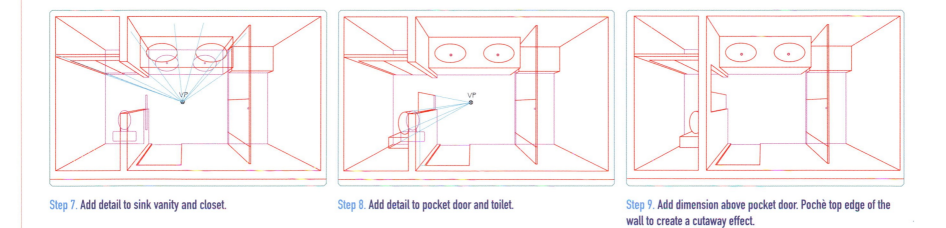

Step 7. Add detail to sink vanity and closet.

Step 8. Add detail to pocket door and toilet.

Step 9. Add dimension above pocket door. Pochè top edge of the wall to create a cutaway effect.

Project 6.1 ONE-POINT PERSPECTIVE FURNITURE FROM A PLAN AND ELEVATION

Create a piece of furniture in one-point perspective. This project is designed to show the basics of using plan and elevation views to create a perspective. Use 14" × 17" marker paper in vertical format and drafting tools (T-square, triangle, and ruler). Lay out your drawing in pencil, preferably an HB pencil.

1. Start with scaled plan and elevation views of the piece of furniture.
2. Create the one-point perspective using the plan and elevation views, as shown in this chapter.

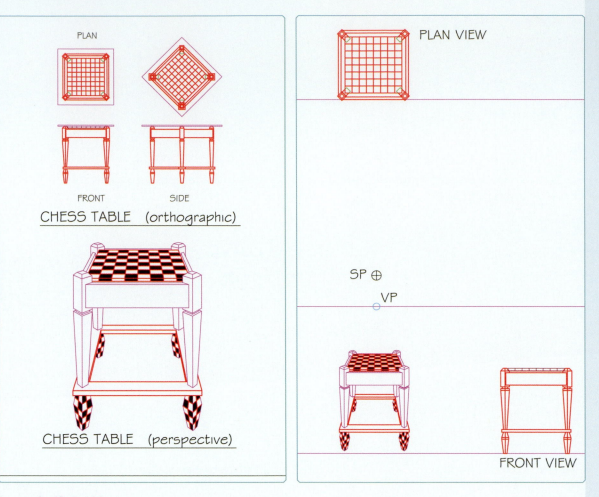

PLAN

FRONT SIDE

CHESS TABLE (orthographic)

CHESS TABLE (perspective)

PLAN VIEW

SP ⊕

VP

FRONT VIEW

An example of Project 6.1.

Project 6.2 ONE-POINT PERSPECTIVE ROOM FROM A PLAN AND ELEVATION

Create a one-point perspective interior space. Use 14" × 17" marker paper and drafting tools (T-square, triangle, and ruler). Lay out your drawing in pencil, preferably an HB pencil.

1. Start with scaled plan and elevation views of the room.
2. Create a perspective view using the plan and elevation views, as shown in this chapter, by starting with the walls.
3. Add details to the walls and ceiling such as doors, windows, and light fixtures.
4. Add furniture to the space.

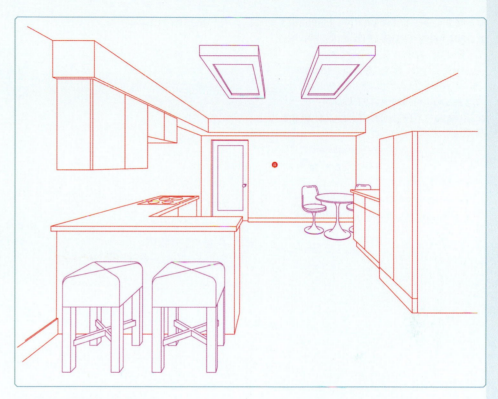

An example of Project 6.2, plan view.

An example of Project 6.2, perspective from the plan view.

Project 6.3 DRAWING A ROOM IN ONE-POINT PERSPECTIVE USING A FLOOR PLAN

Create a one-point room from a floor plan on 14" × 17" marker or vellum paper. Use drafting tools (T-square, triangle, and ruler).

1. Create a scaled floor plan manually or on AutoCAD. (Use a small space at ¼" scale.)
2. Overlay the floor plan with marker or vellum paper. (Place the floor plan in the center of the paper.)
3. Lay out your drawing in HB pencil.
4. Create a ½" line border all around, creating a 13" × 16" image area.
5. Transfer details from the floor plan to the perspective.
6. Ink all images and erase any construction lines.

The vanishing point does not need to be drawn in the center of the floor plan; it may be offset.

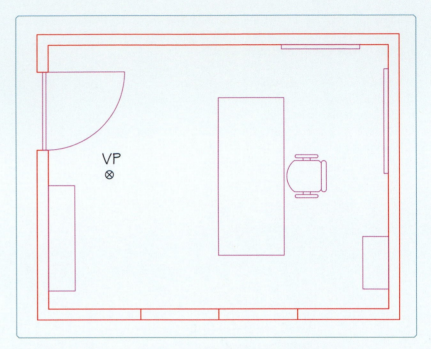

An example of a floor plan and a one-point interior space from that floor plan.

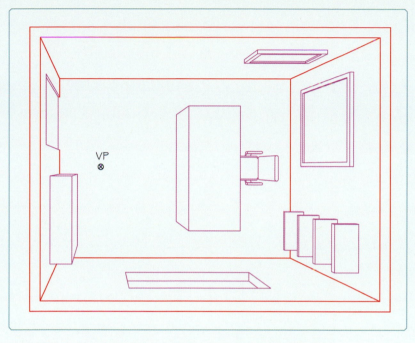

An example of a floor plan and a one-point interior space from that floor plan.

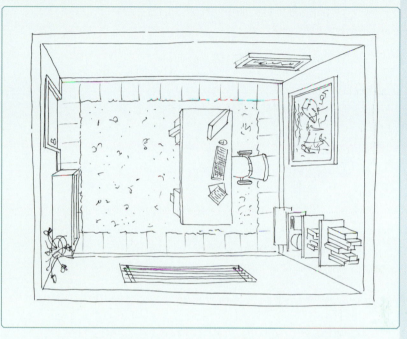

An example of a completed drawing, overlaid with marker paper and freehand sketched.

7

Using Plan and Elevation Views for Two-Point Perspective

This chapter covers two-point perspective drawings and shows how to use the plan and elevation views together to create the perspective. It starts with furniture in two-point perspective using the same basic process for drawing furniture. The chapter illustrates how to use the plan and elevation views to create complete interior spaces in two-point perspective. This is a great way to take an AutoCAD project from a flat two-dimensional view into a three-dimensional space. By the end of this chapter you will be able to take any plan and elevation view of an individual object or complete space and turn it into a perspective. This chapter shows you how to accomplish this in two-point perspectives while being able to create the correct proportion without creating a grid.

ORTHOGRAPHIC PROJECTION

An orthographic projection is a drawing of a three-dimensional object that has been drawn into three separate two-dimensional views: a top or plan view, a front elevation view, and a side elevation view. The correct format for these views is to have the plan view above and lined up with the front elevation and the side view to the right and also lined up with the front elevation. The purpose of having the orthographic drawing for perspective is that you can start with this scaled object, furniture, or room and create a perfectly proportioned perspective drawing without a grid. Therefore, it is possible to use orthographic AutoCAD drawings and develop them into a perspective.

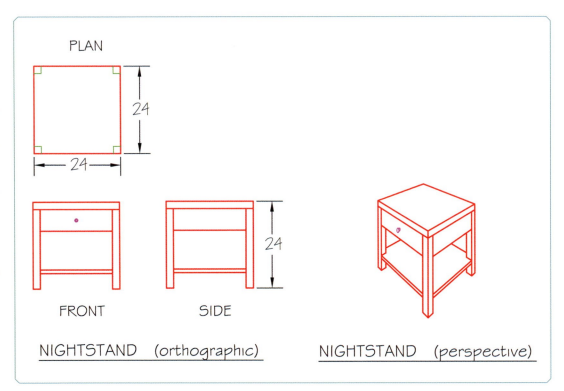

An orthographic drawing of a nightstand on the left and a perspective of the same nightstand on the right.

BASIC RULES FOR USING A PLAN AND ELEVATION

This section shows one method of creating a piece of furniture or a room with perfect proportions without measuring or using a grid. This saves time because a grid does not need to be produced first. These drawings use two views from an orthographic drawing. The plan view must be used as well as one elevation. These views can be created in AutoCAD and then printed and taped to the paper for the perspective drawing. The setup for a piece of furniture, which is discussed first, is slightly different than that for a room.

SETUP: TWO-POINT PERSPECTIVE FOR A PIECE OF FURNITURE

Step 1. Start with the orthographic projection drawing of the furniture. The drawing must use the plan view and one elevation view. It does not matter if it's the front or side view.

Step 2. Set up the perspective using the paper in vertical format. Draw a ground line (GL) close to the bottom of the paper. Draw a picture plane overhead (PPO) close to the top of the paper.

Step 3. Place the elevation on the GL and to the right of the paper. Place the plan view above and on the PPO. Two-point perspective will have the corner touching the PPO and the plan view at an angle to the PPO.

Step 4. Draw the eye-level line parallel to the PPO and GL. Remember that the eye level is in relationship to the elevation.

Step 5. Add a station point (SP). This represents the distance of the person from the plan view.

Step 6. Find the vanishing points. With two-point perspective, first draw a line from the SP parallel to the left side object until it intersects with the PPO; then draw a guideline down from that intersection point to the eye-level line. This creates the vanishing point left (VPL). Repeat the same process to the right side of the object to create the vanishing point right (VPR).

Step 7. Start creating the two-point perspective.

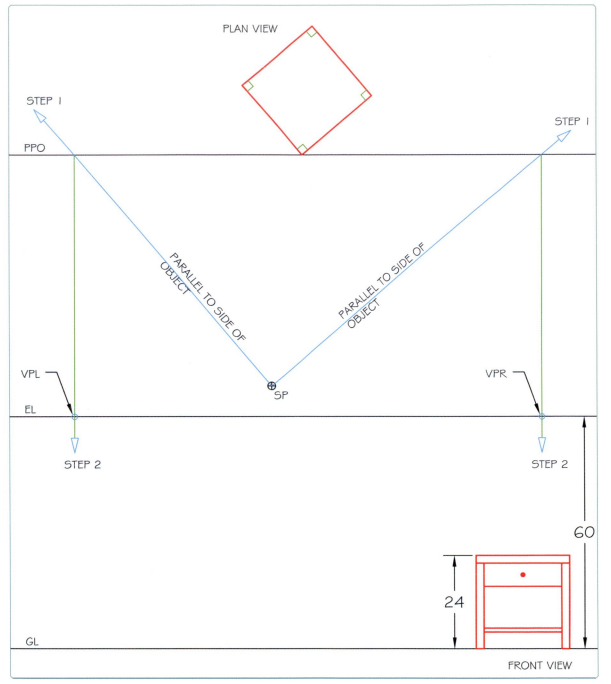

STEP I

STEP I

PPO

PARALLEL TO SIDE OF OBJECT

PARALLEL TO SIDE OF OBJECT

VPL

VPR

EL

SP

STEP 2

STEP 2

60

24

GL

FRONT VIEW

PART 1: CREATING THE FRONT EDGE

Step 1. Draw the front corner from the plan view down to the ground line.

Step 2. Draw the total height over to the front line in step 1 from the elevation.

Step 3. Draw guidelines from the top and bottom of the front line to the vanishing points.

The initial setup of a piece of furniture in two-point perspective.

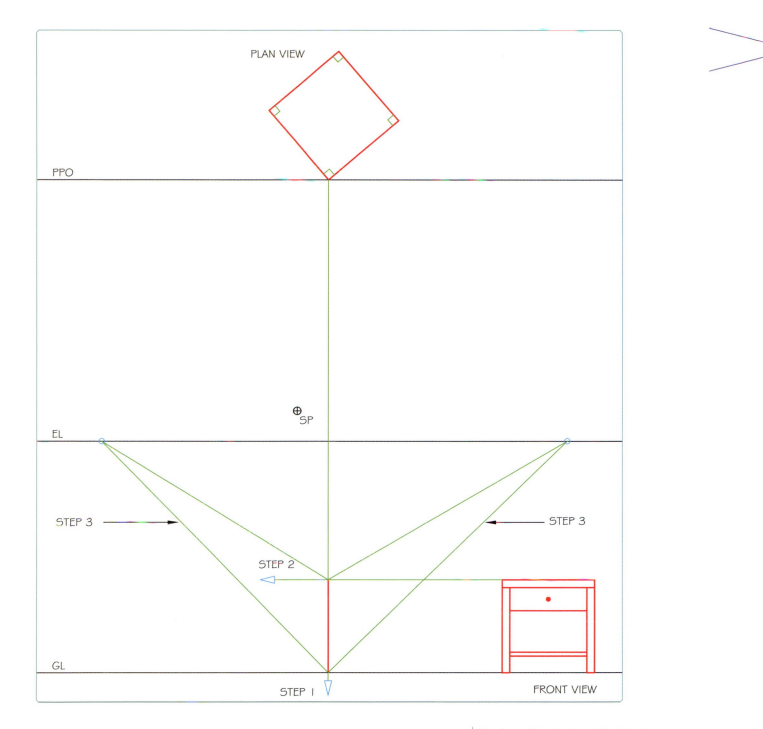

PLAN VIEW

PPO

⊕
SP

EL

STEP 3 →

← STEP 3

STEP 2

STEP I

GL

FRONT VIEW

PART 2: CREATING THE TOTAL VOLUME OF THE OBJECT

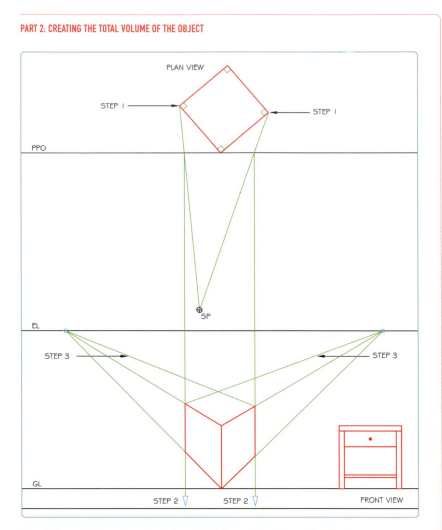

PART 3: CREATING THE LEGS

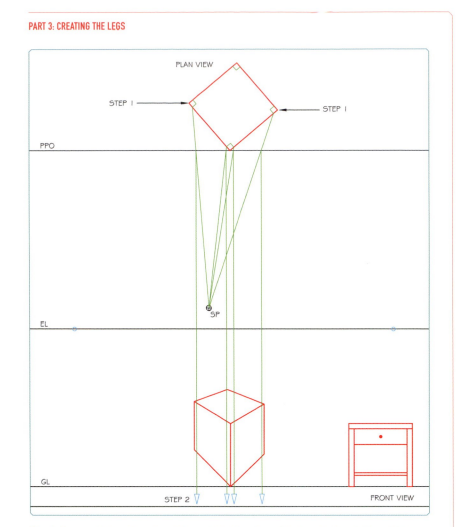

Step 1. Draw guidelines from the station point to the outside edges of the plan view.

Step 2. Draw vertical lines downward from the picture plane overhead intersection points to create the outside edges of the object.

Step 3. Draw guidelines from the top back corners to the vanishing points to complete the total volume of the object.

Step 1. Draw guidelines from the station point to the edges of the legs that touch the outside front surface planes.

Step 2. Draw vertical lines down from the intersection points on the picture plane overhead to create the front surface planes of the legs.

PART 4: CREATING DIMENSION

Step 1. Draw a horizontal guideline from the elevation for the thickness to the front edge.

Step 2. Draw lines from the intersection point on the front edge to the vanishing points to create the top thickness.

Step 3. Draw a guideline from the bottom right leg to the vanishing point left.

Step 4. Transfer the thickness of the front leg to the vanishing point right.

Step 5. Draw a vertical line upward from the intersection point from Steps 3 and 4. Repeat these steps for the left leg.

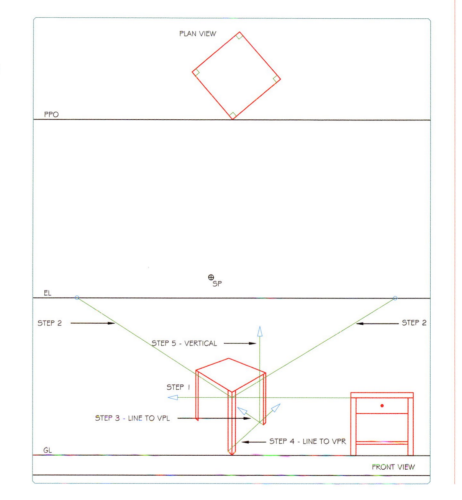

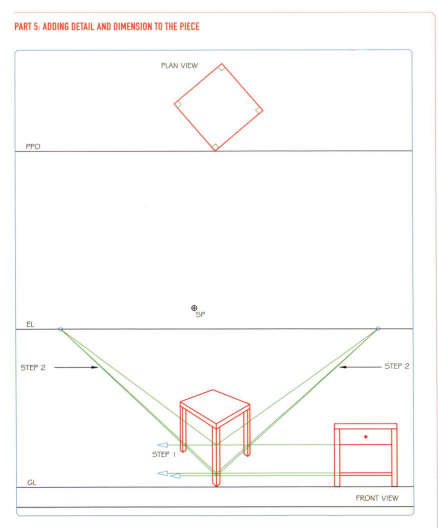

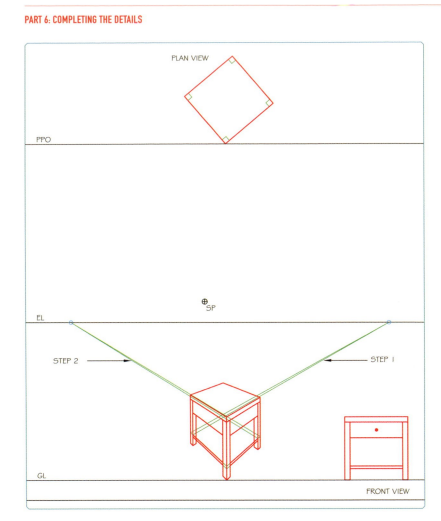

Step 1. Draw horizontal guidelines from the elevation of the drawer and shelf to the front edge of the perspective.

Step 2. Draw lines from the intersection points on the front edge to both vanishing points.

Step 1. Draw lines from the outside edge of the left bottom shelf to the vanishing point right.

Step 2. Draw lines from the outside edge of the right bottom shelf to the vanishing point left.

PART 7: ADDING THE KNOB

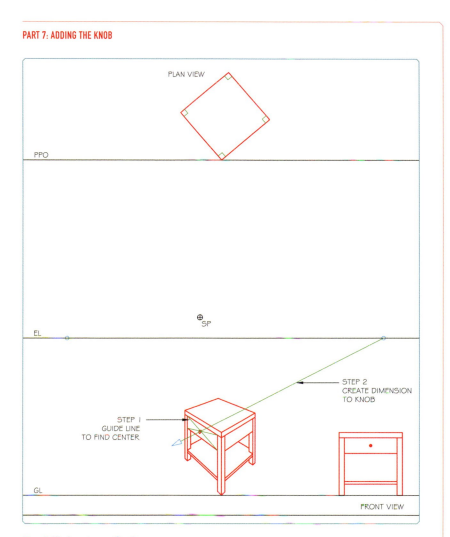

PLAN VIEW

PPO

SP

EL

STEP 2
CREATE DIMENSION
TO KNOB

STEP 1
GUIDE LINE
TO FIND CENTER

GL

FRONT VIEW

Step 1. Find center on the drawer.

Step 2. Use the vanishing point right to create the dimension of the knob outward from the drawer face.

TWO-POINT ROOM USING A PLAN AND ELEVATION VIEWS

Follow the two-point perspective setup directions below. The main difference between a two-point room and a one-point room is that in the two-point room, the plan view is turned at an angle on the picture plane overhead and the vanishing points are created from that angle. This angle is arbitrary, but if the angle is subtle, one of the vanishing points will be far off the paper. For example purposes the same room from the one-point drawing is used in this two-point perspective.

SETUP

Step 1. Start with the orthographic projection drawing of the interior space. The drawing must use the plan view and one elevation view. It does not matter if it's the front or side view.

Step 2. Set up the perspective using the paper in vertical format. Draw a picture plane overhead (PPO) close to the top of the paper.

NOTE The room setup will not use a ground line (GL).

Step 3. Place the elevation to the right or left of the paper. Place the plan view *below* and inside the back wall on the PPO.

Step 4. Draw the eye-level line parallel to the PPO. Remember that the eye level is in relationship to the elevation; therefore, the eye level line should run through the elevation at about 5'-5" for someone standing.

Step 5. Place the floor plan at an angle, so that the inside corner of the back wall is touching the PPO.

Step 6. Add a station point (SP) inside the room. This represents the distance of the person in the plan view.

NOTE This point should be placed away from the PPO. Everything from the SP to the PPO will be seen in the perspective.

Step 7. Find the vanishing points. With two-point perspective, first draw a line from the SP parallel to the left side wall until it intersects with the PPO; then draw a guideline down from that intersection point to the eye-level line. This creates the vanishing point left (VPL). Repeat the same process to the right side wall to create the right vanishing point (VPR).

Step 8. Start creating the two-point perspective.

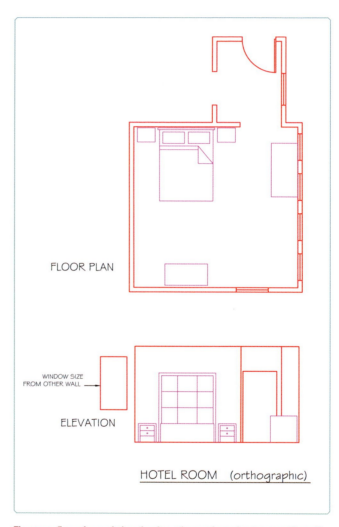

FLOOR PLAN

WINDOW SIZE FROM OTHER WALL →

ELEVATION

HOTEL ROOM (orthographic)

The same floor plan and elevation from the previous chapter; now they will be used to create a two-point perspective.

PART 1: CREATING THE VANISHING POINTS

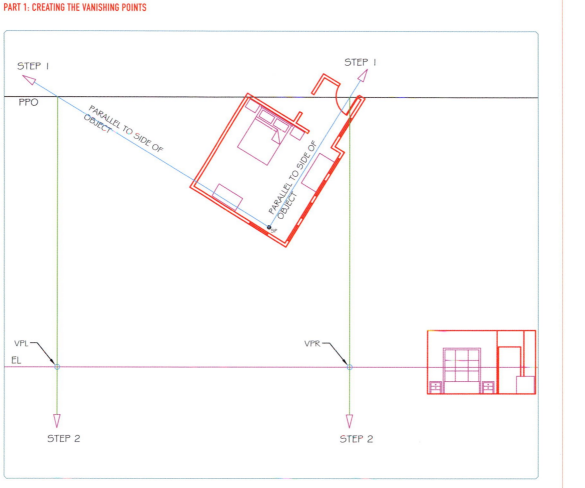

Step 1. Draw two guidelines that are parallel to the walls of the room from the station point (SP) to the picture plane overhead (PPO).

NOTE If these guidelines are not parallel to the wall, the perspective will be wrong from the beginning and cannot be fixed.

Step 2. Draw guidelines down from the intersection point on the PPO to the eye-level line. These intersection points are now the vanishing point left (VPL) and right (VPR).

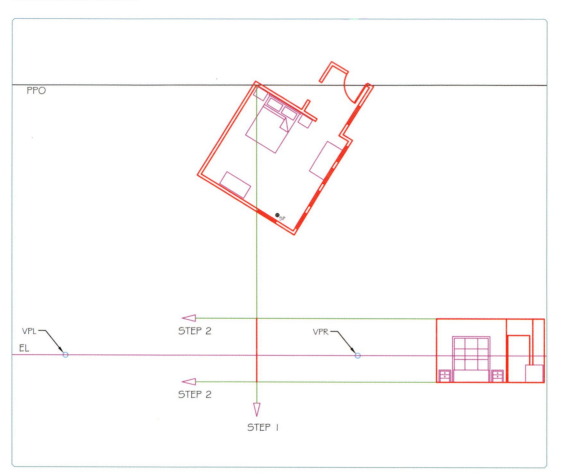

Step 1. Draw a vertical line down from the back corner of the plan view that is on the picture plane overhead.

Step 2. Draw horizontal lines from the floor and ceiling of the elevation until they intersect the vertical line. This creates the height of the back corner.

NOTE These lines are the only part of the drawing that is to scale in the perspective; therefore, all details from the elevation will be drawn to the back vertical line first and then transferred into the perspective.

PART 3: CREATING THE WALLS

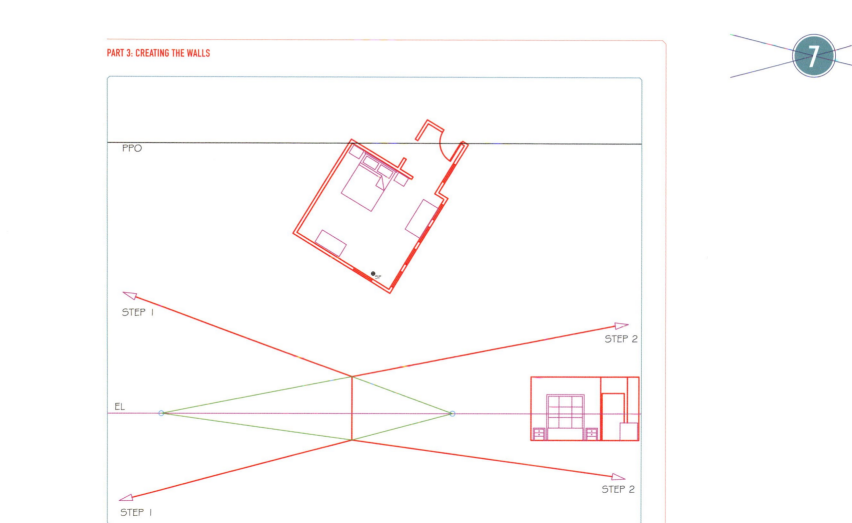

PPO

STEP 1

STEP 2

EL

STEP 2

STEP 1

Step 1. Draw lines from the VPR through the top and bottom of the vertical line outward to create the left side wall.

Step 2. Repeat this step using the VPL to create the right side wall.

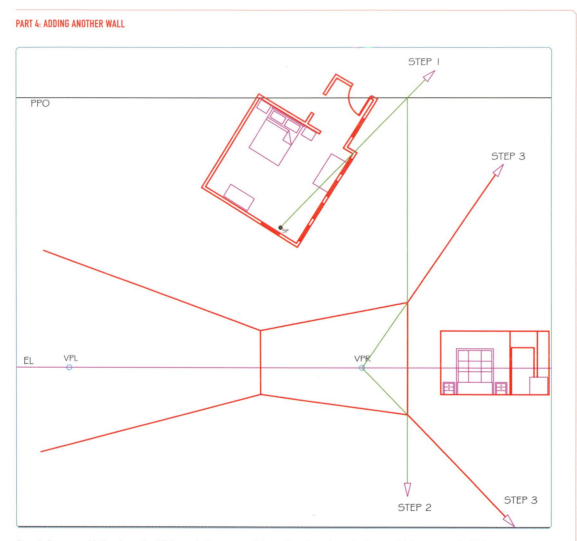

STEP 1

STEP 3

PPO

STEP 3

EL VPL VPR

STEP 2

STEP 3

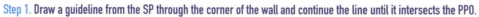

Step 1. Draw a guideline from the SP through the corner of the wall and continue the line until it intersects the PPO.

Step 2. Draw a vertical guideline down from the intersection point on the PPO through the perspective drawing.

Step 3. Draw lines from the VPR through the top and bottom intersection points from the vertical line to create the other wall.

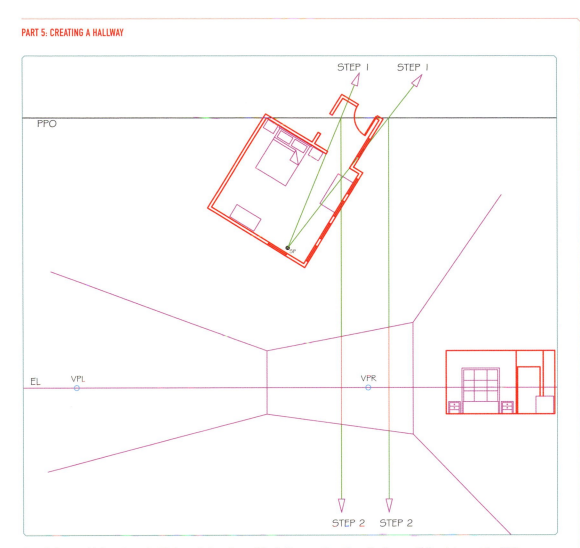

Step 1. Draw guidelines from the SP through the edges of the hallway, and continue the lines until they intersect the PPO.

Step 2. Draw vertical guidelines down from the intersection point on the PPO through the perspective drawing. This creates the vertical spacing of the hallway.

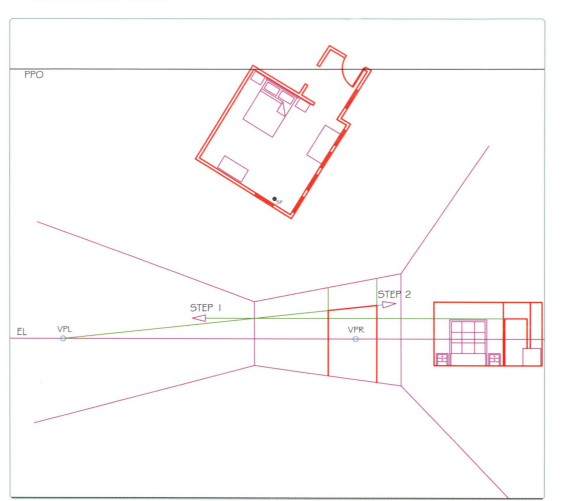

Step 1. Draw a horizontal guideline from the hallway height on the elevation to the back vertical line of the wall.

Step 2. Draw a guideline from the VPL through the height intersection point until it intersects with the vertical lines of the hallway.

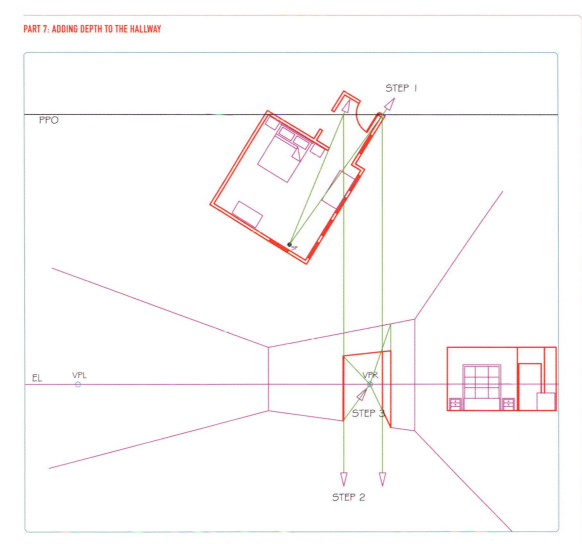

STEP 1

PPO

STEP 2

STEP 3

EL VPL

VPR

SP

Step 1. Draw a guideline from the SP through the back edges of the wall until it intersects the PPO.

Step 2. Draw vertical guidelines down from the intersection point on the PPO to create the placement of the depth.

Step 3. Draw lines from the corners of the hallway to the VPR to create the ceiling and floor lines.

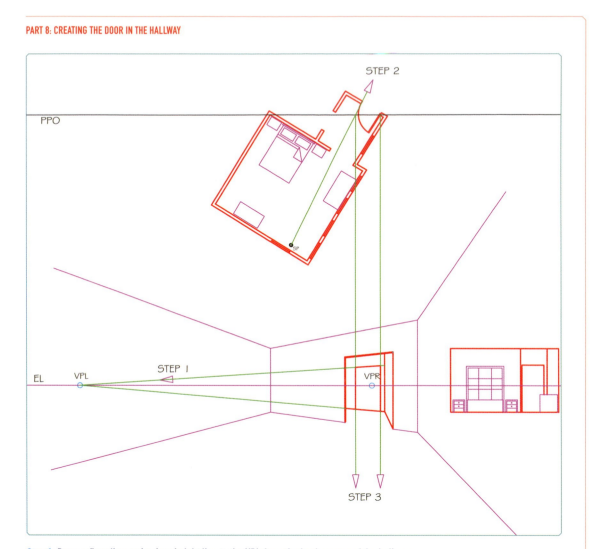

Step 1. Draw a floor line and a door height line to the VPL from the back corner of the hallway.

Step 2. Draw a guideline from the SP through the door edges to the PPO.

Step 3. Draw vertical guidelines down from the intersection point on the picture plane overhead to create the door on the back wall of the hallway.

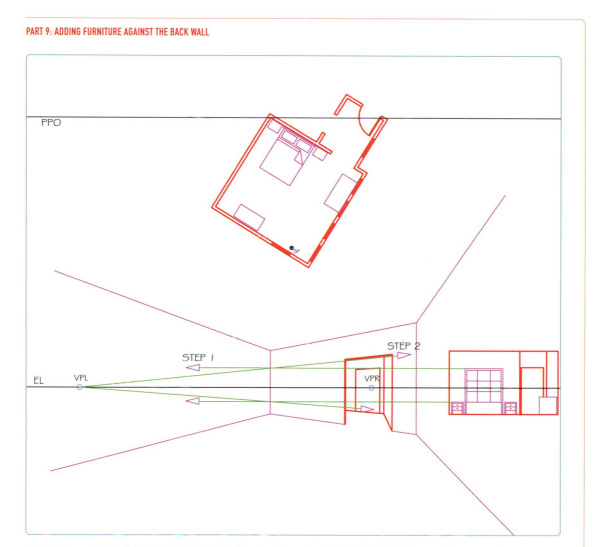

Step 1. Draw guidelines for the height of the bed and mattress from the elevation to the back corner of the perspective.

Step 2. Draw guidelines from the VPL through the intersection points in Step 1 across the back wall.

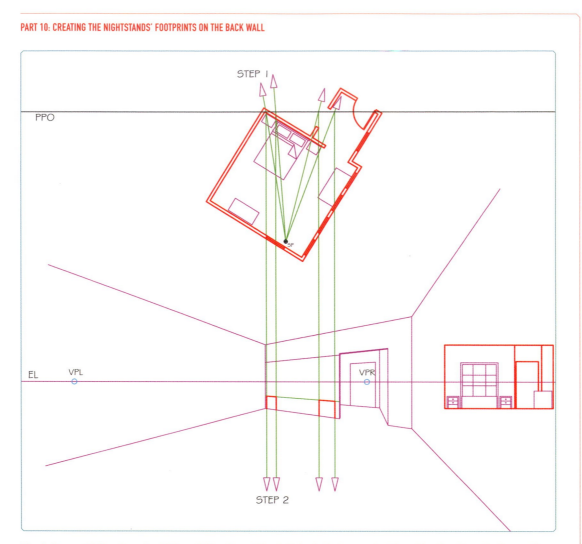

Step 1. Draw guidelines from the SP through the edges of the nightstands that are against the wall and continue the lines until they intersect the PPO.

Step 2. Draw vertical guidelines down from the intersection point on the PPO to the floor line of the back wall to create the nightstands' footprints on that back wall.

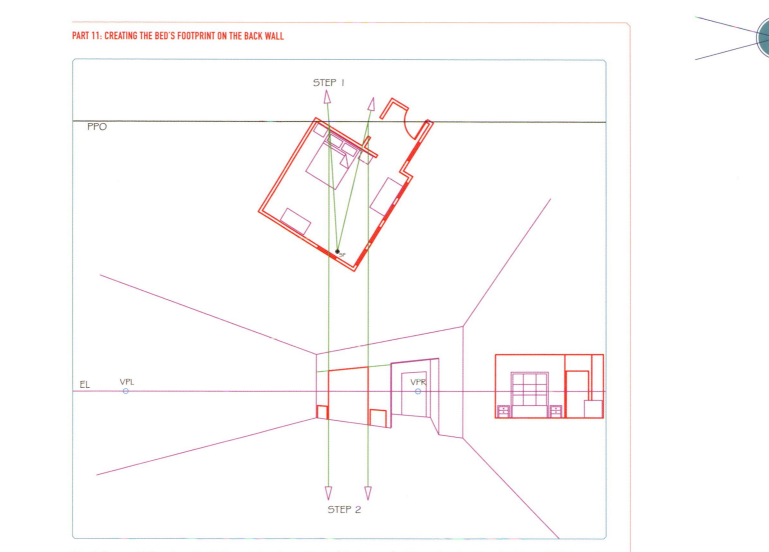

Step 1. Draw guidelines from the SP through the edges of the bed that are against the wall and continue the line until it intersects the PPO.

Step 2. Draw vertical guidelines down from the intersection points on the PPO to the floor line of the back wall to create the bed's footprint on that back wall.

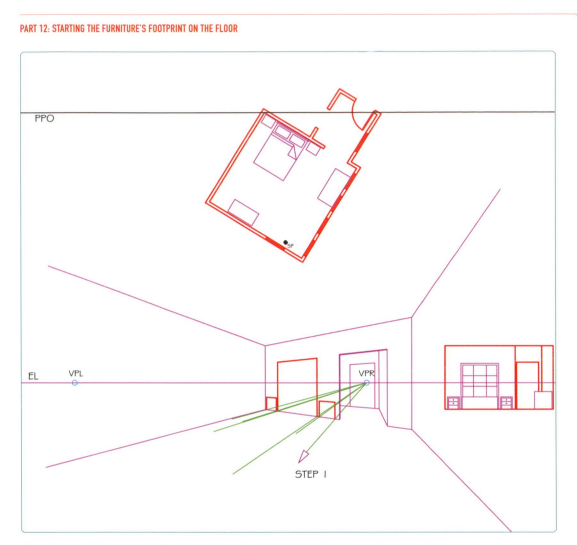

Step 1. Draw guidelines from the VPR outward through the lines of the nightstands and bed where they intersect the floor.

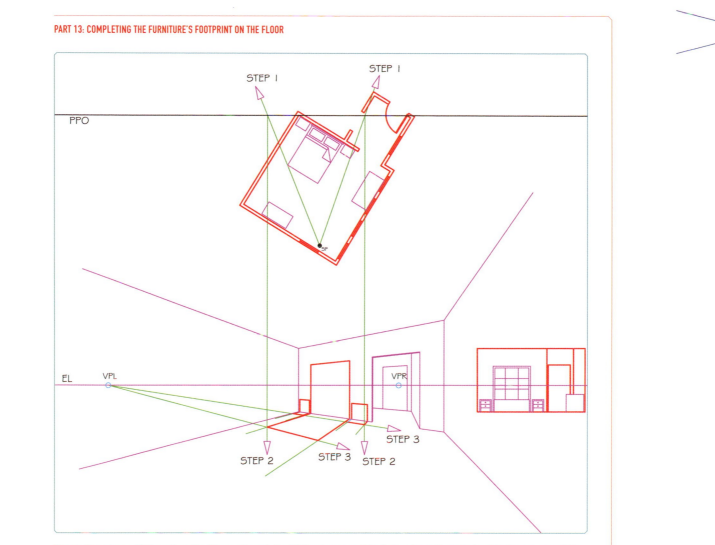

Step 1. Draw two guidelines from the SP, one through the left front corner of the bed and one through the right front corner of the right nightstand. Continue the lines until they intersect the PPO.

Step 2. Draw vertical guidelines down from the intersection point on the PPO to the front corner of the bed and nightstand.

Step 3. Draw guidelines from the VPL through the intersection points from Step 2 to complete the footprints of the bed and nightstands on the floor.

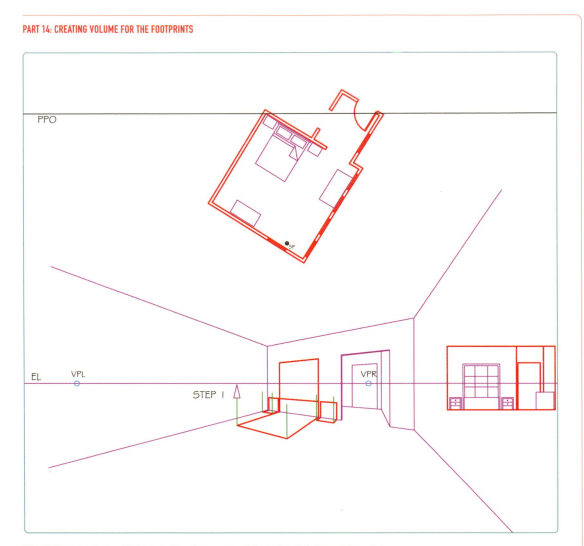

Step 1. Draw vertical guidelines up from the corners of the bed and nightstand footprints.

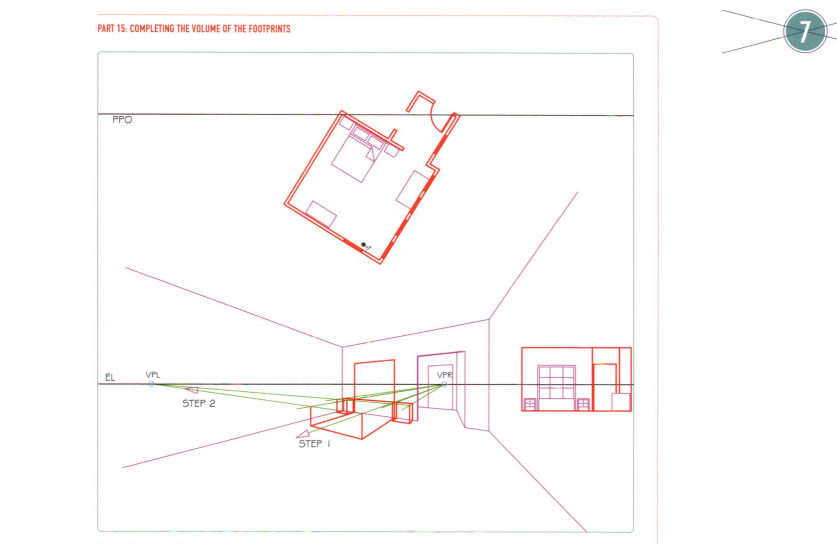

Step 1. Draw guidelines from the VPR through the top corners of the footprints along the back wall until they intersect the vertical lines of the furniture.

Step 2. Draw lines to the intersection points in Step 1 to the VPL to complete the volume.

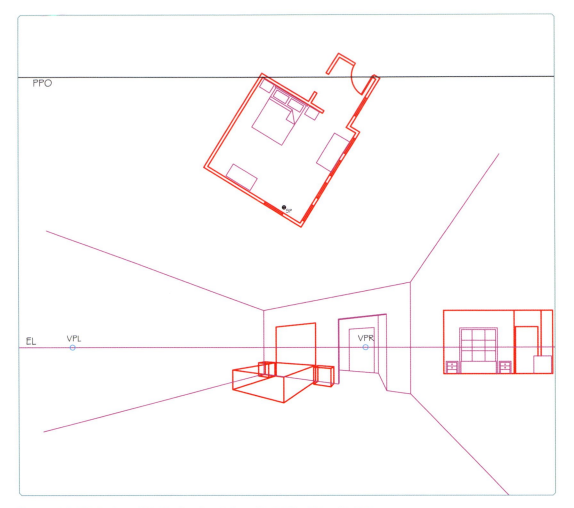

PPO

EL VPL VPR

SP

The completed total volume of the furniture in cube form; the details will be added later.

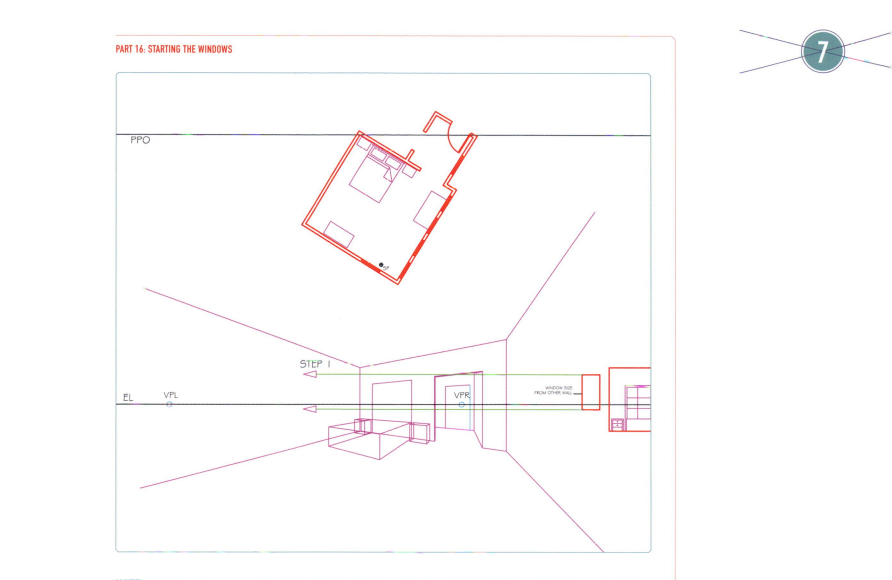

PPO

STEP I

EL VPL VPR

WINDOW SIZE
FROM OTHER WALL

NOTE The window size was created in relationship to the elevation and is placed to the right. This was done because the window does not appear on the back wall elevation and is only used in this step.

Step 1. Draw guidelines from the top and bottom of the window to the back corner of the perspective.

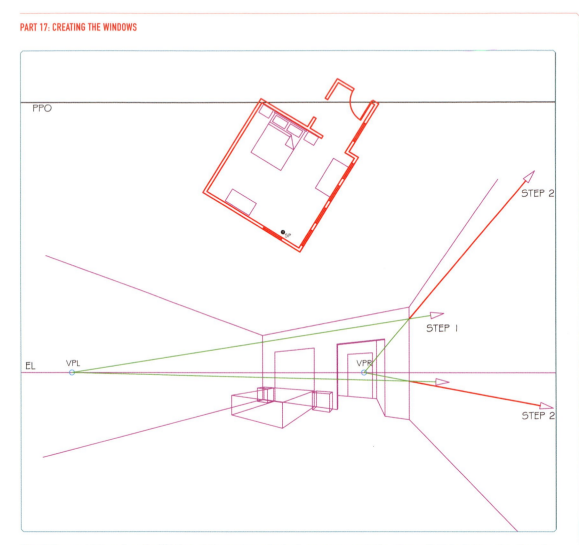

Step 1. Draw guidelines from the VPL through the marks on the back corner across to the other wall. Make light marks where the lines intersect the vertical edge of the wall.

Step 2. Draw lines from the VPR through the intersection marks from Step 1 to create the height lines of the windows.

NOTE The elevation drawing was removed because it's not needed for the rest of the drawing.

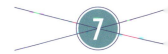

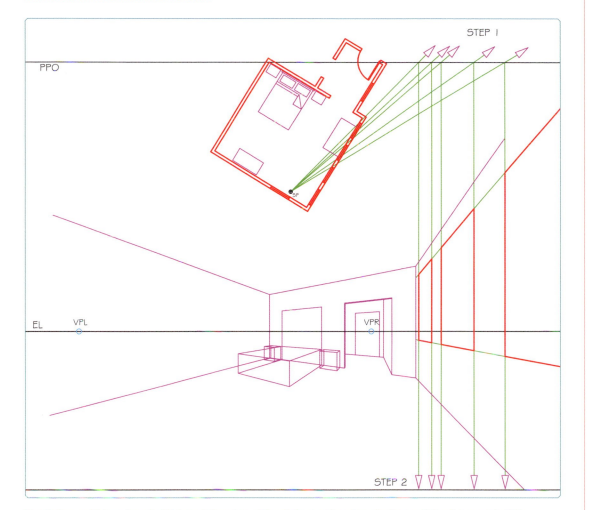

Step 1. Draw guidelines from the SP through the edges of the windows and continue the lines until they intersect the PPO.

Step 2. Draw vertical guidelines down from the intersection points on the PPO through the lines on the right side wall until they intersect the window height lines.

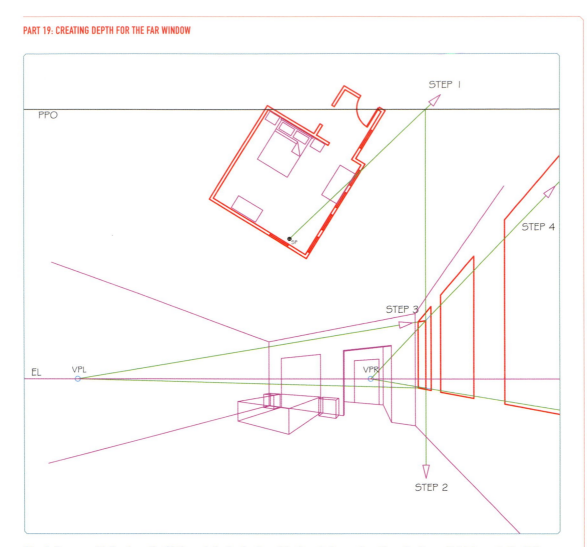

Step 1. Draw a guideline from the SP through the back edge of the far window and continue the line until it intersects the PPO.

Step 2. Draw a vertical guideline down from the intersection point on the PPO through the far window.

Step 3. Draw two lines from the VPL through the top and bottom edges of the far window until they intersect with the vertical line in Step 2.

Step 4. Draw guidelines from the VPR through the top and bottom intersection points from Step 3.

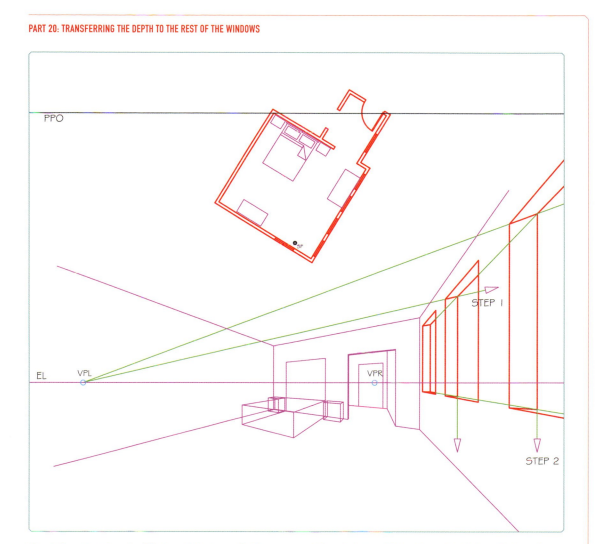

Step 1. Draw lines from the VPL through the top and bottom corners of the windows until they intersect with the guidelines drawn in Part 19.

Step 2. Draw vertical lines where the lines from Step 1 intersect to create the depth in the other windows.

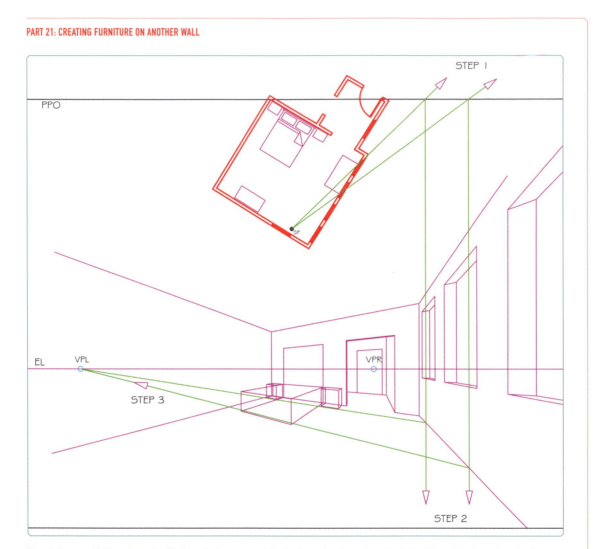

Step 1. Draw guidelines from the SP through the corner of the furniture that is against the right side wall and continue the lines until they intersect the PPO.

Step 2. Draw vertical guidelines down from the intersection point on the PPO to the wall below.

Step 3. Draw guidelines from where the lines in Step 2 intersect the floor to the VPL.

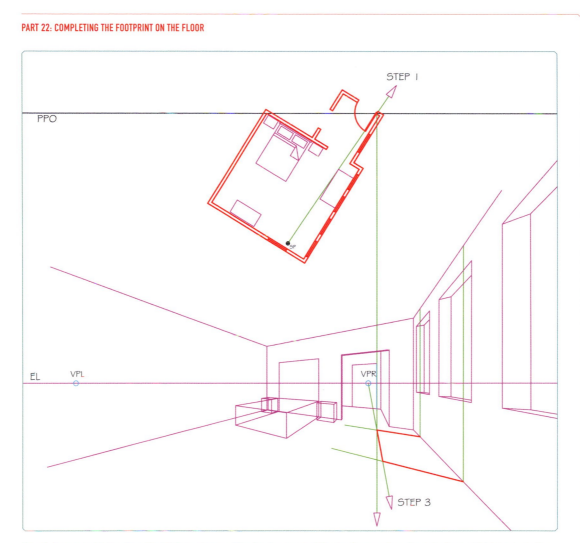

Step 1. Draw a guideline from the SP through one of the front corners of the furniture and continue the line until it intersects the PPO.

Step 2. Draw a vertical guideline down from the intersection point on the PPO until it intersects the line on the floor.

Step 3. Draw a line from the VPR through the intersection in Step 2 to the other floor line to complete the footprint.

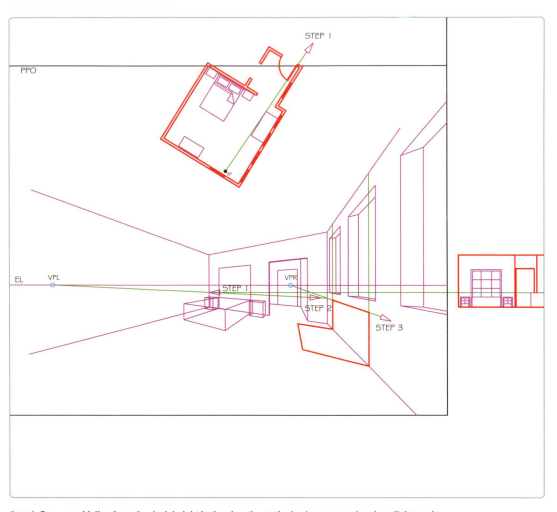

Step 1. Draw a guideline from the desk height in the elevation to the back corner and make a light mark.

Step 2. Draw a guideline from the VPL through the mark on the back corner across to the far right wall.

Step 3. Draw a line from the VPR through the intersection mark in Step 2 until the line intersects the vertical lines of the desk against the wall.

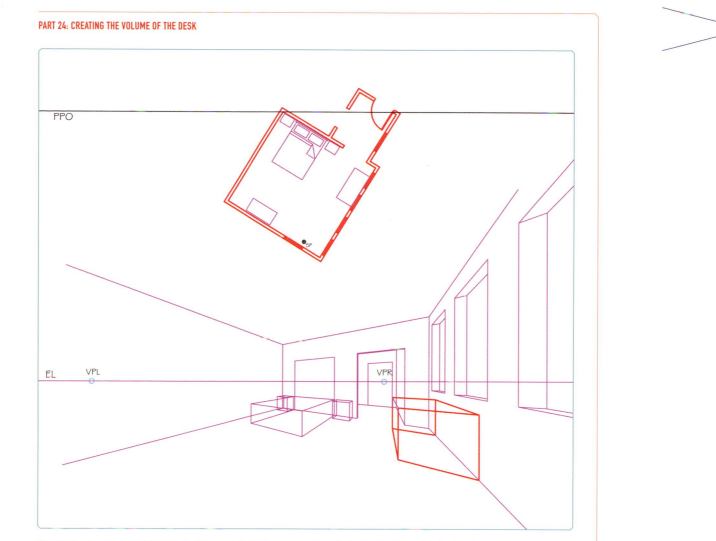

PPO

EL VPL

VPR

Step 1. Develop the footprint of the desk into a cube in the same way as the bed and nightstands, by drawing vertical lines up from the left side corners.

Step 2. Draw lines from the top right side corners to the VPL until they intersect with the vertical lines.

Step 3. Connect the left top edge of the cube by drawing a line from the front corner to the back corner using the VPR.

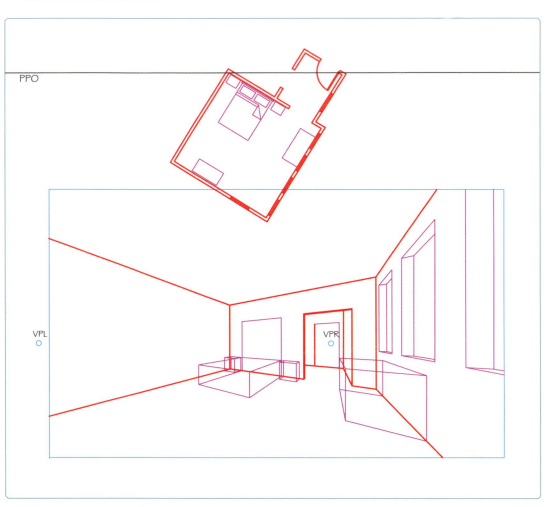

This image shows where the perspective will be cropped when it is transferred onto marker paper. Cropping the perspective helps define the frame of reference and omits unwanted negative space on the paper.

PART 26: DEVELOPING THE FURNITURE

This image develops the cubes into the furniture.

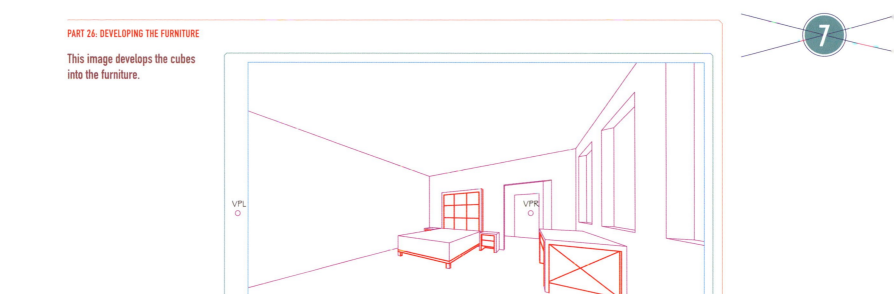

PART 27: ADDING DETAIL TO THE ROOM

This image shows details added to the walls and ceiling. They were not in the plan or elevation views; only the basic room was created with the plan and elevation to ensure correct proportions. The artwork, window blinds, soffit, and beams have been added based on the room's proportions.

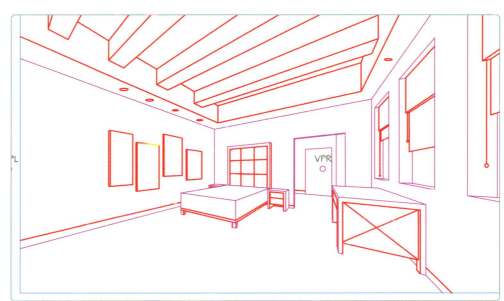

PART 28: FINISHING DETAILS

This image shows details that have been added to the space, such as rounding off the edges of soft materials like the mattress and upholstered headboard.

NOTE: This drawing was retraced over the original without a ruler to give it a hand-sketched look.

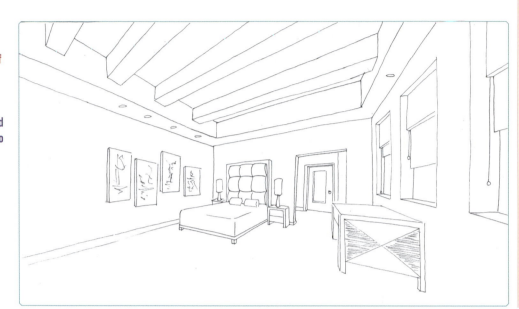

PART 29: ADDING DEPTH WITH MARKERS

This image renders the surfaces with color markers and adds shadows to give weight to the objects and depth to the space.

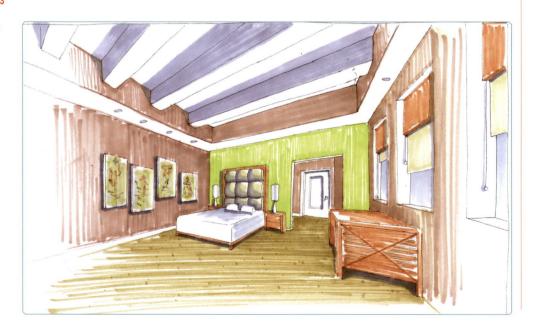

CREATING A VAULTED CEILING

The next set of examples shows how to create a vaulted ceiling using plan and elevation views. The example is in two-point perspective, so the setup is the same as the previous set of drawings. Since the ceiling is going to be vaulted, alternate vanishing points (AVPs) will be added to the perspective. Starting with a quick thumbnail sketch of the space can help with the placement and angle of the drawing.

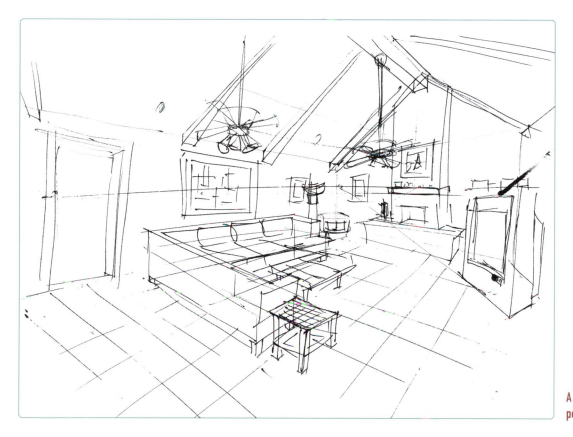

A quick thumbnail sketch; this sketch was done in pen and took about five minutes to create.

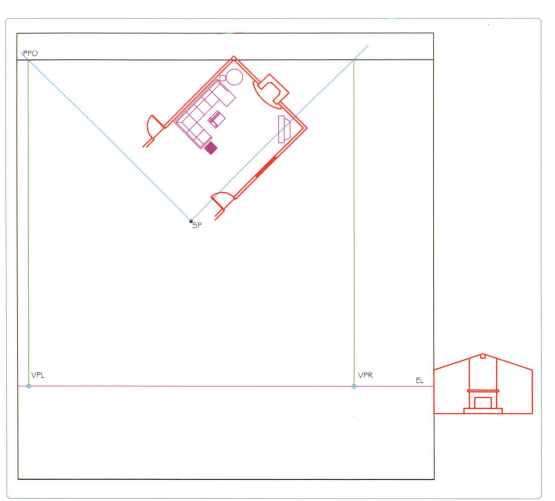

Step 1. Draw two guidelines that are parallel to the walls of the room from the station point (SP) to the picture plane overhead (PPO).

NOTE If these guidelines are not parallel to the wall, then the perspective will be wrong from the beginning and cannot be fixed.

Step 2. Draw guidelines down from the intersection point on the PPO to the eye-level line. These intersection points are now the vanishing point left (VPL) and right (VPR).

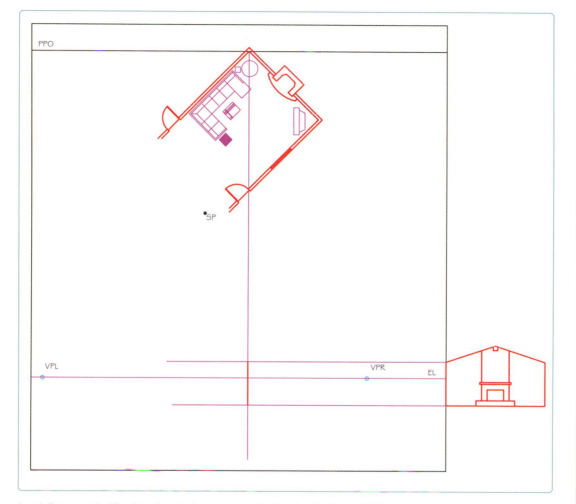

Step 1. Draw a vertical line down from the back corner of the plan view that is on the PPO.

Step 2. Draw horizontal lines from the floor and top of the wall of the elevation until they intersect the vertical line. This creates the height of the back corner. The height of the ceiling will be added later.

NOTE These lines are the only part of the drawing that are to scale in the perspective; therefore, all details from the elevation will be drawn to the back vertical line first and then transferred into the perspective.

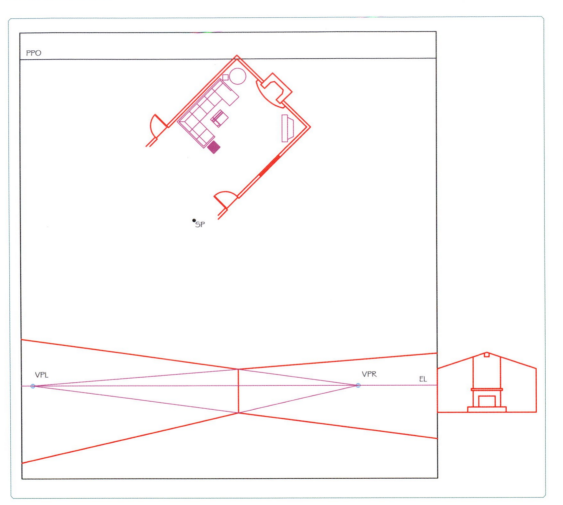

PPO

SP

VPL

VPR

EL

Step 1. Draw lines from the VPR through the top and bottom of the vertical line outward to create the left side wall.

Step 2. Repeat this step using the VPL to create the right side wall.

PART 4: CREATING THE VERTICAL EDGE FOR THE OTHER WALL

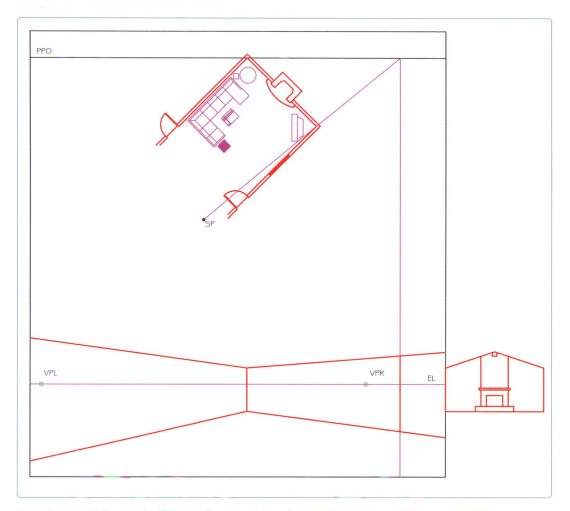

Step 1. Draw a guideline from the SP through the corner of the wall, and continue the line until it intersects the PPO.

Step 2. Draw a vertical guideline down from the intersection point on the PPO through the perspective drawing.

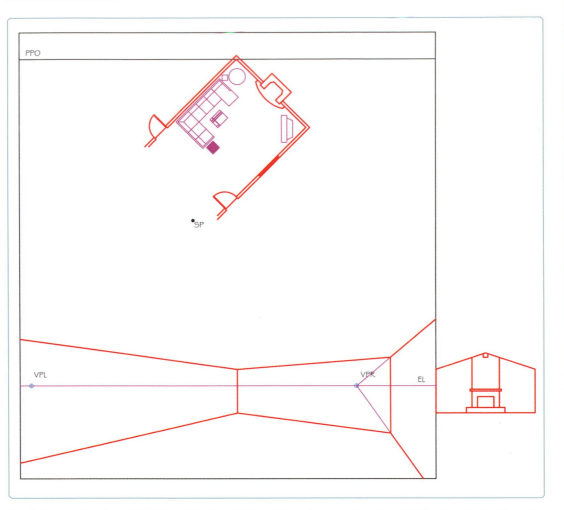

PPO

SP

VPL VPR EL

Step 1. Draw two lines from the VPR through the top and bottom intersection points from the vertical line to create the other wall.

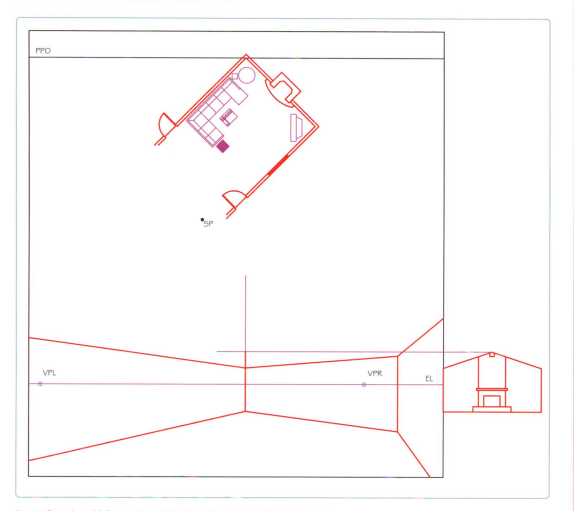

PPO

SP

VPL

VPR

EL

Step 1. Extend a guideline up from the back vertical corner of the perspective.

Step 2. Draw a guideline horizontally from the top of the elevation until it intersects with the vertical line in Step 1.

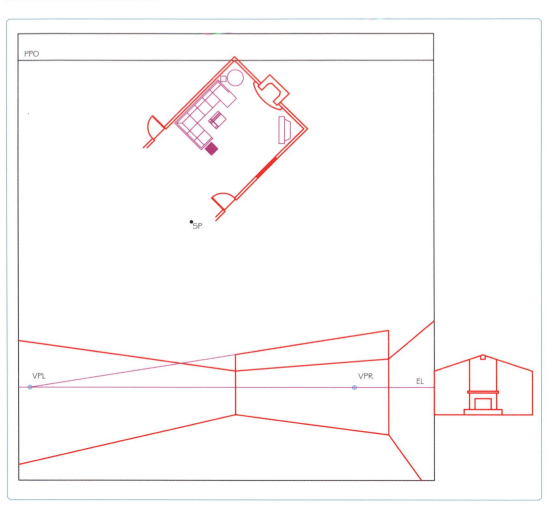

Step 1. Extend a guideline up from the vertical edge of the other side of the right side wall.

Step 2. Draw a guideline from the VPL through the top of the back vertical line across until it intersects with the line in Step 1. This creates the space for the pitch to be drawn.

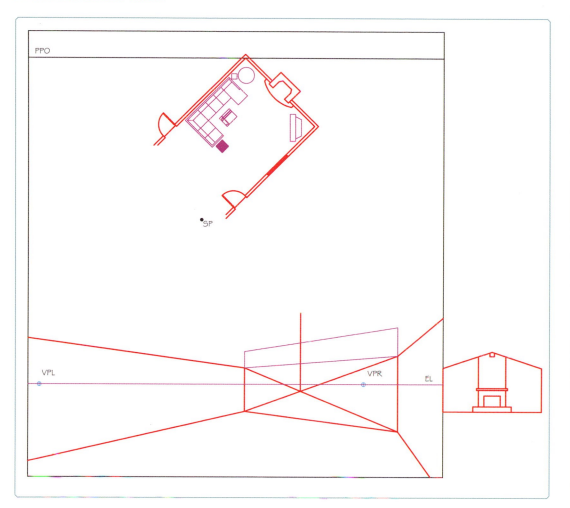

Step 1. Find center on the wall on which the pitch is going to be created by drawing lines from opposite corner to opposite corner.

Step 2. Draw a guideline up from that center point until it intersects with the top line. This top point is where the top wall corners connect.

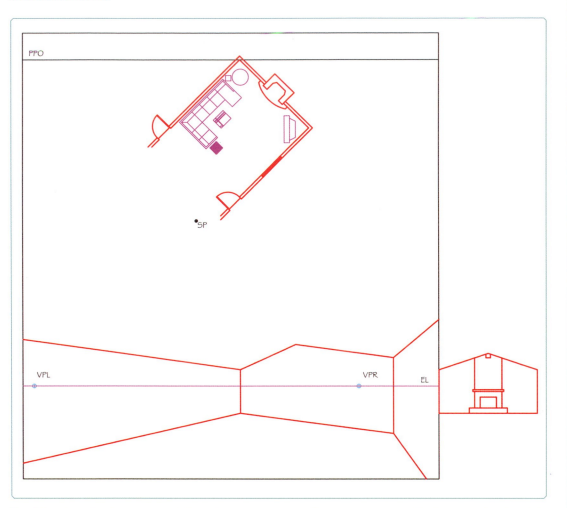

Step 1. Draw lines from the top corners of the wall to the center point and then erase the construction lines to complete the pitch on the right back wall.

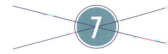

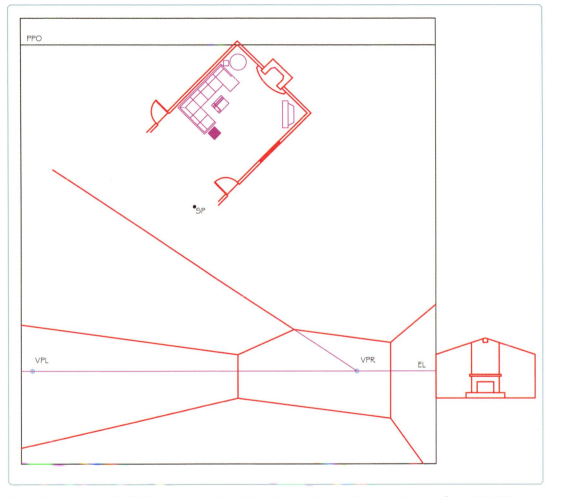

Step 1. Draw a line from the VPR through the top of the pitch, and continue it outward to create the two surface planes of the ceiling.

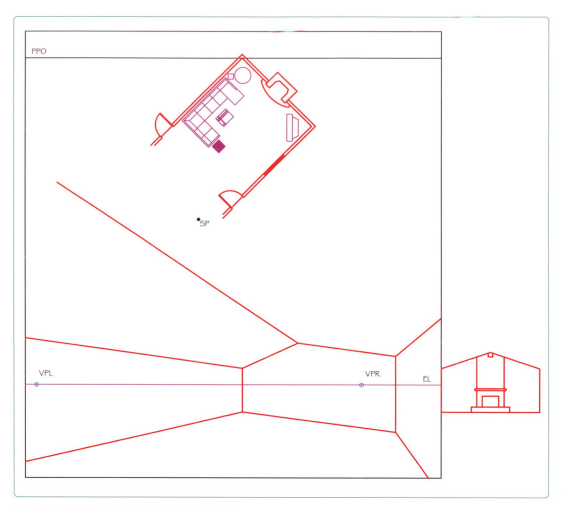

Basic completed space with construction line erased.

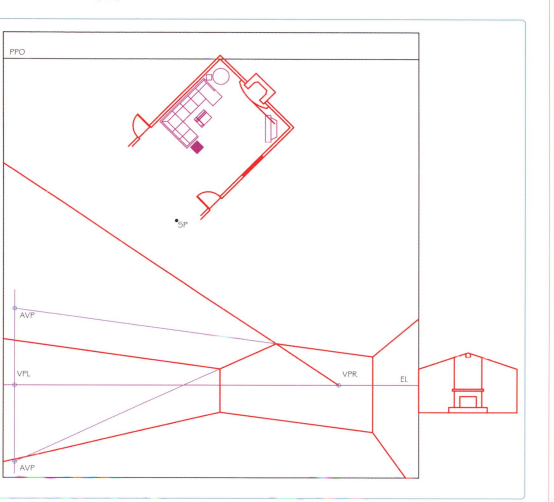

Step 1. Draw a vertical guideline through the VPL.

Step 2. Extend both lines of the pitched ceiling until they intersect the vertical line drawn in Step 1. These two intersection points create the two alternate vanishing points (AVPs). There are two because the ceiling surface planes are at different angles from one another.

USING THE ALTERNATE VANISHING POINTS (AVPS)

The VPR was used to create the beam running at the center of the pitch. The other beams used one of the other AVPs.

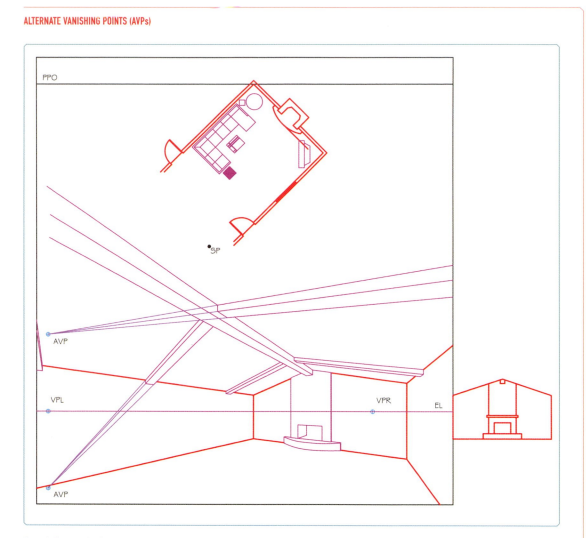

Step 1. Create the footprints of the beams along the left wall and then use the bottom AVP to extend the beams to the top.

Step 2. Transfer the dimension to the other side of the top beam and then extend the beam across the ceiling with the top AVP. Repeat these steps for the other beams.

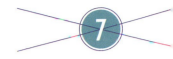

PPO

SP

The completed space with furniture, lighting fixtures, and artwork added as well as a tile floor surface.

Project 7.1 TWO-POINT CUBE FROM A PLAN AND ELEVATION

Create a cube with one hole and one beam piercing through it. This project is designed to show the basics of using plan and elevation views to create a perspective. Use 14" × 17" marker paper in vertical format and drafting tools (T-square, triangle, and ruler). Lay out your drawing in pencil, preferably an HB pencil.

1. Start with scaled plan and elevation views of the cube.
2. Create the two-point perspective using the plan and elevation views, as shown in this chapter.

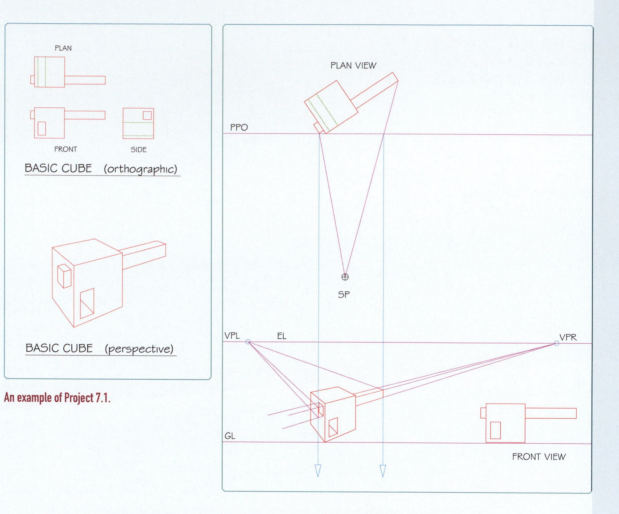

PLAN

FRONT SIDE

BASIC CUBE (orthographic)

BASIC CUBE (perspective)

An example of Project 7.1.

PLAN VIEW

PPO

SP

VPL EL VPR

GL

FRONT VIEW

Project 7.2 TWO-POINT FURNITURE FROM A PLAN AND ELEVATION

Create two different pieces of furniture, one piece per sheet of paper. Use 14" × 17" marker paper in vertical format and drafting tools (T-square, triangle, and ruler). Lay out your drawing in pencil, preferably an HB pencil.

1. Start with scaled plan and elevation views of the furniture.
2. Create two-point perspective using the plan and elevation views, as shown in this chapter.

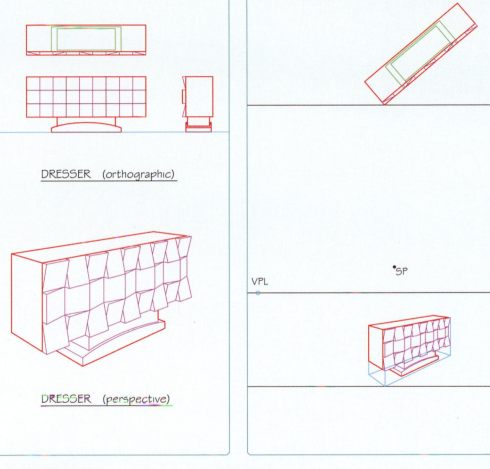

DRESSER (orthographic)

DRESSER (perspective)

An example of Project 7.2.

Project 7.3 TWO-POINT ROOM FROM A PLAN AND ELEVATION

Create a two-point perspective interior space. Use 14" × 17" marker paper and drafting tools (T-square, triangle, and ruler). Lay out your drawing in pencil, preferably an HB pencil.

1. Start with scaled plan and elevation views of the room.
2. As shown in this chapter, starting with the walls, create a perspective view using the plan and elevation views.
3. Add details to the walls and ceiling such as doors, windows, and light fixtures.
4. Add furniture to the space.

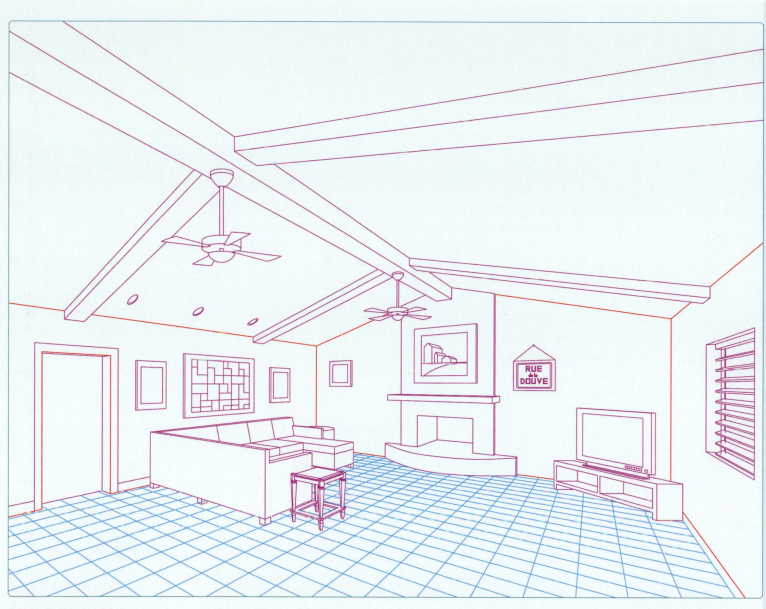

An example of Project 7.3.

8

Creating Other Interior Details in One- and Two-Point Perspectives

The purpose of this chapter is to show how to add different types of details into a drawing. By the end of this chapter, you will know how to add people into a space by creating a quick sketch and using a photograph to create the correct proportions. You will also see how to create shadows and different types of reflections for both individual objects and entire rooms. Finally, you will learn how to create the correct proportions for stairs.

ADDING PEOPLE TO A PERSPECTIVE

The reasons for adding people to an interior space are to help show proportion and to create a warm, inviting atmosphere in the room. There are two stumbling points when adding a person to an interior space: drawing the person to the right scale for the interior perspective, and drawing the person with correct body proportions. Both of these problems are easy to correct. To create the right scale, use the horizon line as eye level; therefore, the person's head should be at this basic height as shown in Figure 8.1a. Then, using the back wall as a guide, draw a line down to the floor line and outward, with the vanishing point at the spot where the person is to be placed in the room. Finally, draw a line vertically until it overlaps the horizon line. This line is now the correct height of the person. To draw the correct body proportions, an easy trick is to copy a photograph.

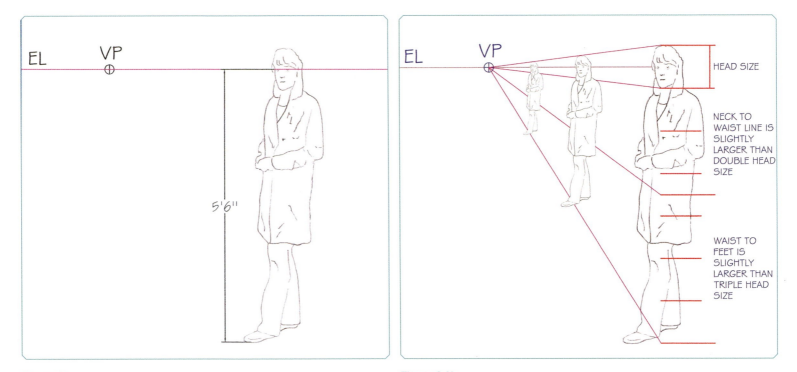

Figure 8.1a
This image shows the eye level of the observer at 5'-6".

Figure 8.1b
This image shows the basic body proportions when drawing the figure. The head size can be used as a reference to create the rest of the body.

NOTE Eye level of all three characters is at the same level.

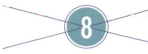

USING PHOTOSHOP TO ALTER PICTURES

The photograph in Figure 8.2a was altered in Photoshop. The adjusted image in Figure 8.2b now can be used to trace into the perspective. Using Photoshop saves time because you can easily change a photograph into a drawing using Photoshop's filters. This image was adjusted using the Sketch tab from the Filter drop-down menu and then printed to create the basic line image seen in Figure 8.2b. It can also be resized to fit the drawing's perspective. This makes the photograph easier to trace as shown in Figure 8.2c. There are also architectural tracing books that have people in different scale, as well as other details such as plants and automobiles.

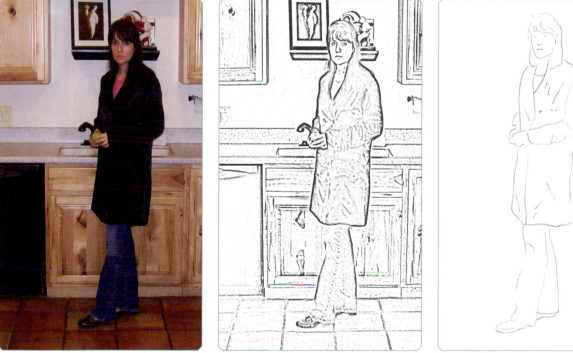

Figure 8.2a
Photograph of figure.

Figure 8.2b
Photograph adjusted in Photoshop.

Figure 8.2c
Photoshop image traced to simplify details.

Now that the figure as been simpli-
fied it can be added into a perspective.
Keep in mind where eye level is located
when adding the figure. Enlarge or re-
duce the size of the figure to fit the pro-
portions of the interior space, and draw
them into the perspective. If the figure's
scale to the interior is off it will destroy
the overall impact of the drawing, as
shown in Figures 8.3a through 8.3d.

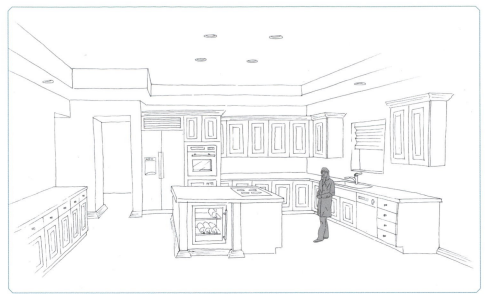

Figure 8.3a
This image is incorrect, showing the
figure too small for where it is placed
in the interior space.

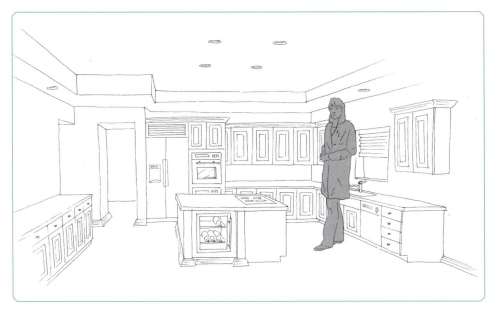

Figure 8.3b
This image is incorrect, showing the
figure too large for where it is placed
in the interior space.

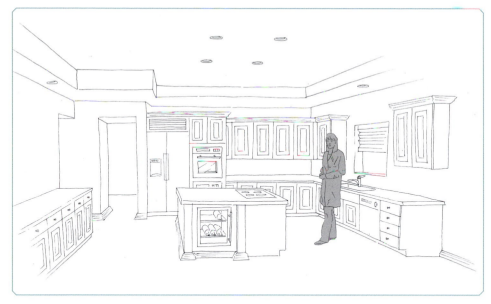

Figure 8.3c
This image is correct, showing the figure at the right scale for where it is placed in the interior space.

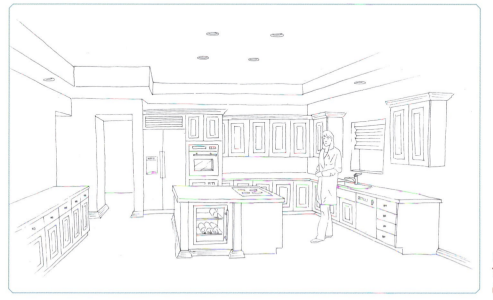

Figure 8.3d
This image is of the completed line drawing interior with figure.

SHADOWS

There are two basic ways to create shadows for an object or in a room. The first way is by creating a light source, such as a light fixture in the space or a window. The second way is by using the parallel method, which for interior spaces implies the shadow. The parallel method is a much faster way to create shadows and adds an illusion of depth and volume to an object or a room.

SHADOWS USING A LIGHT SOURCE

This type of shadow can use one, two, or many light sources in the space to affect the object and cast shadows on the floor or wall surfaces.

BASIC CUBE SHADOW

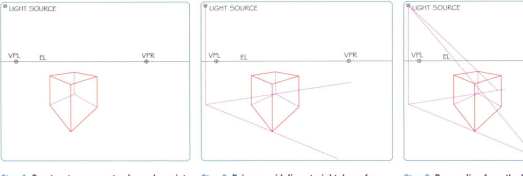

Step 1. Create a transparent cube and a point for a light source above the cube on the right or left side.

Step 2. Bring a guideline straight down from the light source to the ground. This end point can be slightly behind, in front of, or to the side of the cube. Draw a line from the end point through the front and back bottom edges of the cube.

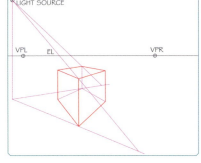

Step 3. Draw a line from the light source to the top front corner and continue it to the front line from Step 2. Repeat for the top back corner.

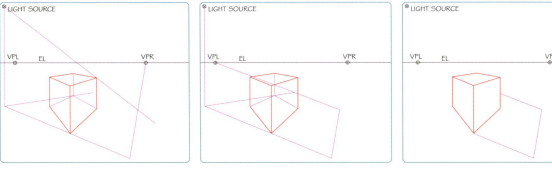

Step 4. Draw a line from the front intersection point from Step 3 to the vanishing point right (VPR). Then draw a line from the light source through the top side corner until it intersects with the line drawn to the VPR.

Step 5. Draw a line from the intersection from Step 4 to the vanishing point left (VPL). This completes the total space for the shadow.

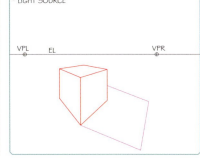

Step 6. Erase the construction lines of the shadow and the transparent lines of the cube to make it solid.

BASIC TABLE SHADOW

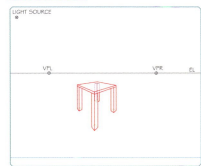

Step 1. Draw the object and place a point of reference above and to one side of the object. This point is the light source.

Step 2. Draw a vertical guideline down from the light source to the floor. The bottom of the line shows the relationship of the light to the object. Then draw guidelines from the bottom of the line outward through the outside base of the object.

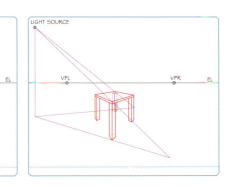

Step 3. Transfer base marks to the top of object. Draw guidelines from the light source through the front top marks until the guidelines intersect the base guidelines in Step 2.

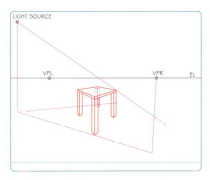

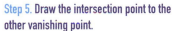

Step 4. Draw the front intersection point to the vanishing point right (VPR). Draw the next corner down until it intersects that line.

Step 5. Draw the intersection point to the other vanishing point.

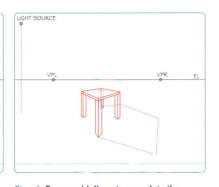

Step 6. Erase guidelines to complete the outside volume of the shadow, but keep the original guideline from the light source.

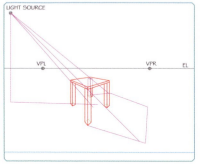

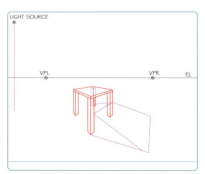

Step 7. Add the furniture details to the shadow. For this piece, draw guidelines from the light source to the underside of the top and a guideline from the ground through the front line.

Step 8. Connect all the intersection points from Step 7.

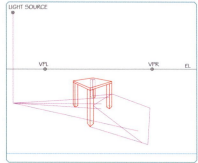

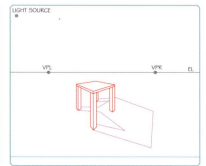

Step 9. Draw lines from the base point through the footprints of the legs to the lines drawn in Step 8.

Step 10. Erase construction lines to complete the shadow. The guideline from the light source can also be erased.

SHADOWS USING THE PARALLEL METHOD

The parallel method is a shortcut for implying shadows, by creating a starter guideline and then producing parallel lines from that first guideline. With a simple cube the shadow is the total volume of the cube casting the shadow. When creating a parallel shadow for more detailed objects such as a table, it is typically easier to create the total volume of the shadow first as if it were a cube; then repeat the steps for the details.

BASIC CUBE SHADOW

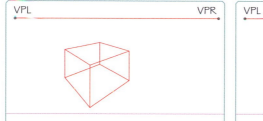

Step 1. Create a transparent cube.

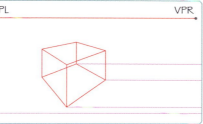

Step 2. Draw a ground guideline from the front bottom corner of the object; then add parallel guidelines to the other bottom corners.

Step 3. Draw a second set of guidelines to represent the angle of the light. Draw the first guideline from the front corner angled down until it intersects with the front base guideline. Repeat that angle from the other top corners.

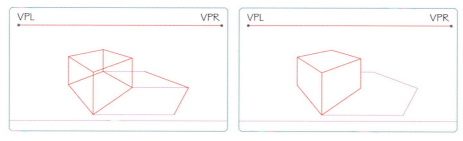

Step 4. Draw lines connecting the intersection points from Step 3.

The cube as solid with all guidelines erased.

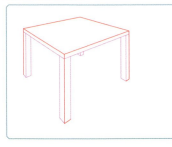

Step 1. Create the object.

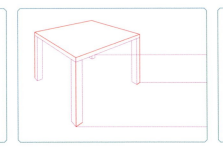

Step 2. Draw a ground guideline from the front bottom corner of the object and then add parallel guidelines to the other bottom corners.

NOTE The table is being treated as a solid cube first to create the total outside shadow; the detail will be added later.

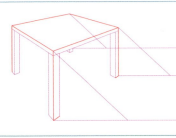

Step 3. Draw a second set of guidelines to represent the angle of the light. Draw the first guideline from the front corner angled down until it intersects with the front base guideline. Repeat that angle from the other top corners.

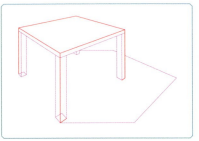

Step 4. Draw lines connecting the intersection points from Step 3, and erase any guidelines. This is the total outside shadow.

NOTE The footprints of the legs have been added.

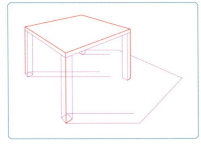

Step 5. This step repeats Step 2 by drawing parallel guidelines from the bottom corners of three of the legs.

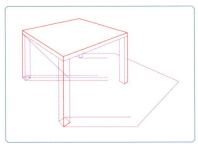

Step 6. Draw a center guideline from the left side leg. The rest of this step is a repeat of the angle in Step 3. Draw these guidelines until they intersect the center line.

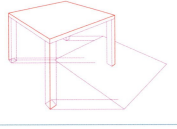

Step 7. Connect the intersection points from Step 6 with the outside edges of the shadow where the top meets the legs.

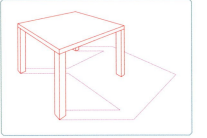

Table with all guidelines erased.

VERTICAL REFLECTIONS

One way to get started drawing reflections is to create a sketch of the rough idea. This can help with the proportions of the object itself along with the space needed for the vertical reflection.

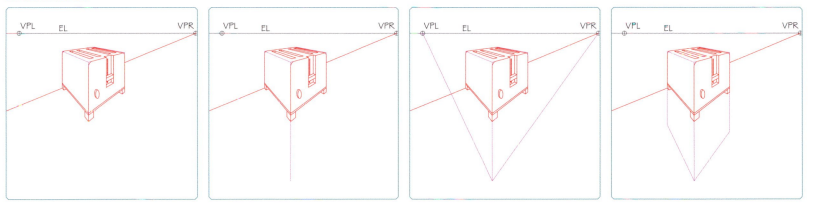

VERTICAL REFLECTIONS

Step 1. Start by creating the object. (This example uses a toaster.)

Step 2. Draw a vertical construction line down from the front vertical edge of the object.

Step 3. Draw construction lines from the bottom of that front line to the VPL and VPR.

Step 4. Draw vertical lines from the outside edges downward. Where these lines intersect the lines from Step 3 creates the total volume of the reflection.

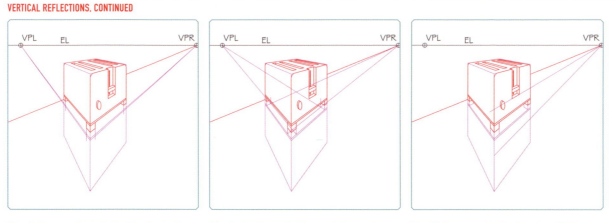

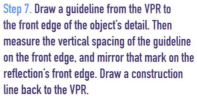

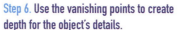

Step 5. Measure the height of the front edge only and reproduce that measurement on the front vertical line below the object. This example also shows the detail of the toaster's feet.

Step 6. Use the vanishing points to create depth for the object's details.

Step 7. Draw a guideline from the VPR to the front edge of the object's detail. Then measure the vertical spacing of the guideline on the front edge, and mirror that mark on the reflection's front edge. Draw a construction line back to the VPR.

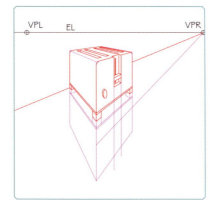

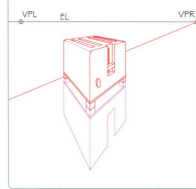

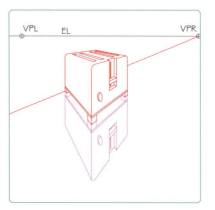

Step 8. Draw vertical lines downward from the detail through the reflection. Where the lines intersect the line from Step 7 and the edge on the total volume is where the detail is created on the reflection.

Step 9. Erase any construction lines to see the basic shape of the object.

Step 10. Repeat Steps 7 and 8 to add the rest of the dimension and detail. Also repeat these steps if the object has details on the other side.

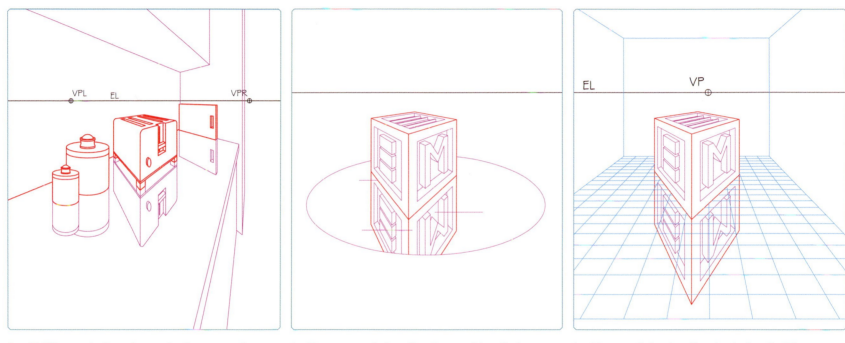

Step 11. This example shows the completed countertop. Repeat Steps 1 through 10 for the other objects.

An object on a round mirror. Note that part of the reflection was erased at the edge of the mirror.

An object on a tiled surface. Note that the floor detail lines are drawn through the reflection, but not through the object.

CREATING A HORIZONTAL REFLECTION IN A ROOM

Start with a sketch to help determine the placement of objects in the room and to create the best angle for the reflection.

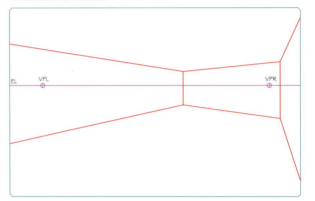

Step 1. Draw a light line for the eye-level line (EL) and place the vanishing point left (VPL) and vanishing point right (VPR) on the EL. Because this is an interior space, the EL can be erased after the vanishing points have been placed.

Step 2. Draw the back vertical wall height.

Step 3. Use the vanishing points to complete the total size of the room.

PART 3: FINDING THE EDGE OF THE WALL

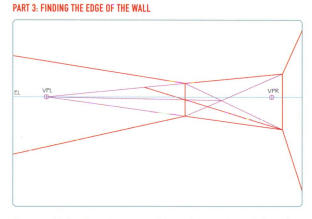

Draw a guideline from the corner of the wall (top or bottom) through where the center line intersects the back vertical line. Continue this line until it intersects the top or bottom wall line.

PART 2: STARTING THE HORIZONTAL REFLECTION

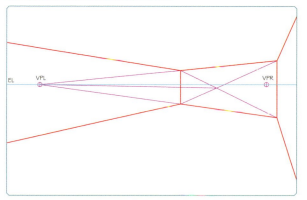

Step 1. Find center of the wall that is to be reflected.

Step 2. Extend the top and bottom of the wall to the VPL.

Step 3. Draw a guideline from center to the VPL.

PART 4: COMPLETING THE FIRST REFLECTED WALL

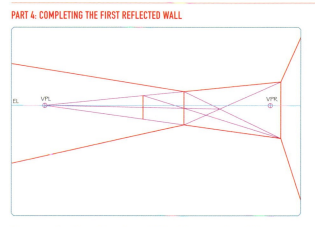

Draw a vertical line where the guideline intersects the wall line to create the back of the reflected wall.

PART 5: ADDING THE OTHER REFLECTED WALL

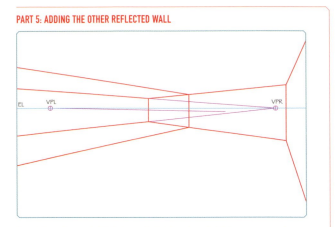

Draw lines from the VPR through the back vertical line to create the other reflected wall.

PART 6: ADDING DETAIL TO THE WALL

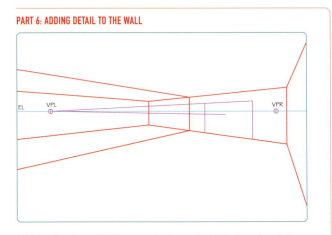

Add detail to the wall. This example shows the beginning of a window seat.

NOTE The center line has not been erased because it is going to be used to reflect the window detail.

PART 7: REFLECTING THE WINDOW DETAIL

Step 1. Draw two guidelines from the bottom of the window through the center mark on the wall to the ceiling in the reflection.

Step 2. Draw vertical lines down from the intersection marks on the ceiling to the floor.

PART 8: ADDING FREESTANDING FURNITURE

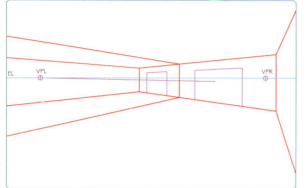

This image shows the center guideline still in the perspective, but the rest of the construction lines erased.

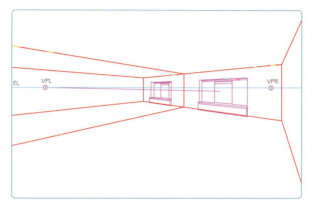

This image has the window detail added to show a window seat and blinds. The detail was transferred into the reflection in the same way the window was done in Part 7.

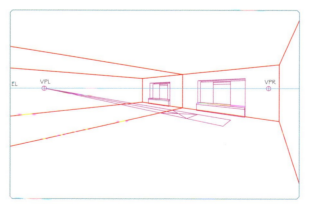

Step 1. For this example, the footprint of a coffee table is created in front of the window seat.

Step 2. Draw the edges of the footprint through the reflection to the VPL.

Step 3. Find center in the space between the footprint and the mirror surface plane.

Step 4. Draw a guideline from center through the reflection VPL.

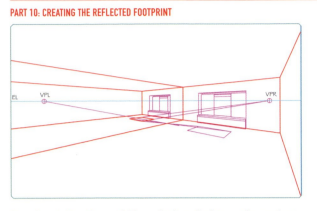

Draw lines to the other vanishing point from the intersection marks to reproduce the footprint in the reflection.

PART 9: FINDING THE REFLECTION OF THE FOOTPRINT

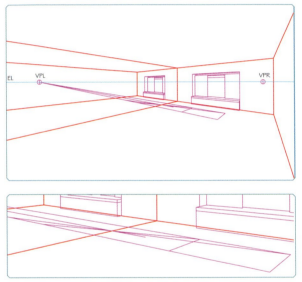

Draw guidelines from the front and back of the footprint through the center line where it intersects the mirror line. Continue the lines until they intersect the guideline that is drawn to the vanishing point.

NOTE The example contains a close-up view to show where the lines intersect.

PART 11: ADDING DIMENSION TO THE TABLE

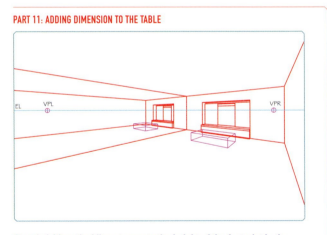

Step 1. Add vertical lines to create the height of the footprint in the room and reflection.

Step 2. Draw a line from the vanishing point to the desired height on the front corner of the table in the room.

Step 3. Transfer that height with the vanishing points to complete the table in cube form. The lines will also determine the height of the cube in the reflection.

PART 12: BED DETAIL

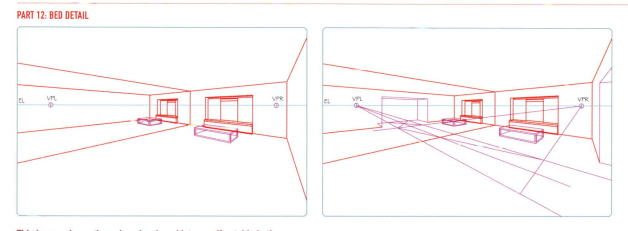

This image shows the cubes developed into a coffee table in the room and in the reflection.

NOTE A niche was created on the left side reflection wall for the bed.

Step 1. Create the bed footprint proportion using the vanishing points and extend the line from the reflection across the room.

Step 2. Find center in the bed footprint.

Step 3. Draw a guideline through the center of the bed and continue across the room floor.

Step 4. Draw a guideline from the front of the bed reflection through where the center line intersects the floor of the mirror. Continue that line until it intersects the bed guideline.

Step 5. Create the edge of the bed in the room by drawing a line from the vanishing point through the intersection in Step 4.

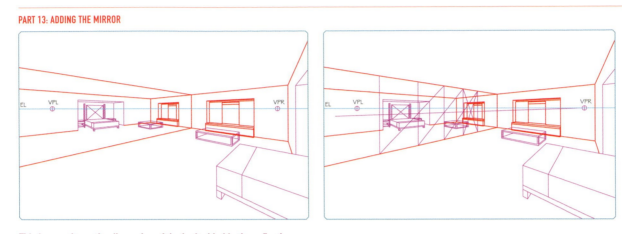

This image shows the dimension of the bed added in the reflection and transferred to the bed in the room.

Step 1. Draw two vertical lines on the left wall at the desired spacing for a floor-to-ceiling mirror.

Step 2. Find center between the vertical lines and draw a guideline from the vanishing point through center across the wall.

Step 3. Draw a diagonal guideline from the top corner through the center line until the line touches the floor line.

Step 4. Draw a vertical line up from the intersection point from Step 3 to create another mirror. Repeat Steps 3 and 4 to create more mirror panels.

PART 14: DEFINING THE MIRROR SPACE

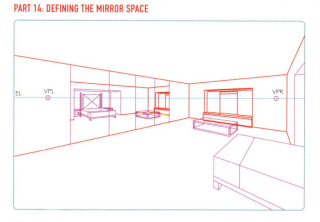

After the mirror panels are created, erase the construction lines from Part 13. Also erase any reflection lines from the left wall that are not on the mirror panels.

This image shows the completed room and reflection.

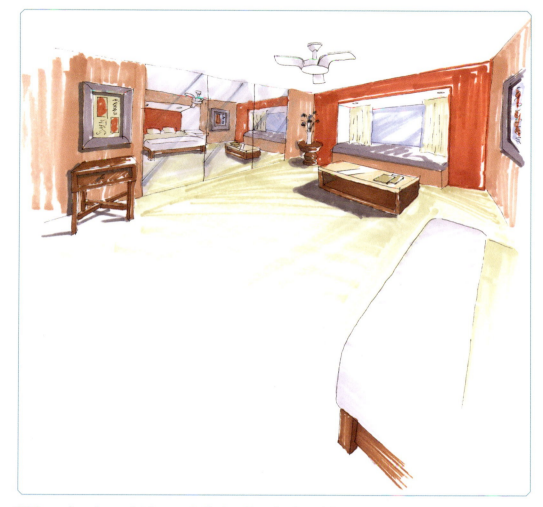

This image shows the completed room and reflection with rendered materials.

CREATING STAIRS

When creating stairs in a space, a common mistake is misjudging the proportions of the stair tread and riser. This mistake happens because the artist divides the space for the stairs' length and height equally, making the stair tread the same size as the riser. The tread should be a minimum of 11", and the riser should be a maximum of 7"; therefore, to simplify the process in perspective, make the tread 12" and the riser 6", so the riser is half the size of the tread. This can be done by creating vertical spacing for the risers, then creating a perpendicular guideline with spacing twice the size of the vertical spacing.

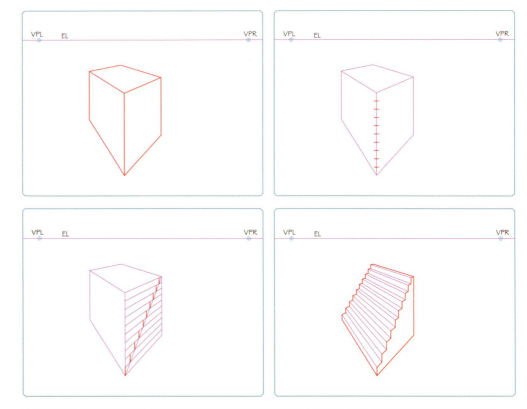

This example show the incorrect way to create stairs. Note the front vertical spacing; the diagonal line divides the spacing equally, which creates stairs that are too steep.

CREATING STAIRS

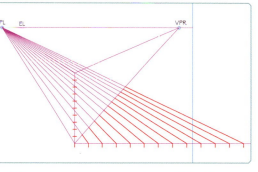

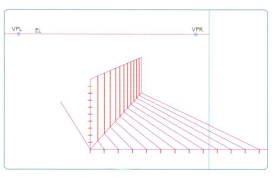

Step 1. Create a guideline to represent the total height of the stairs; then draw guidelines to the VPR. This creates the direction of the stairs.

Step 2. Create vertical spacing on the front guideline. Draw a perpendicular guideline with spacing twice the size of the vertical spacing; then line up the marks to the VPL and transfer to the base guideline.

Step 3. Draw vertical guidelines up from the base guidelines.

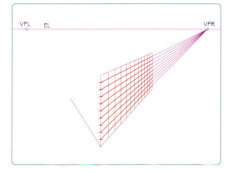

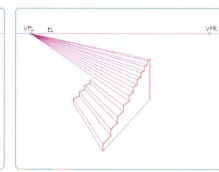

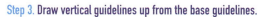

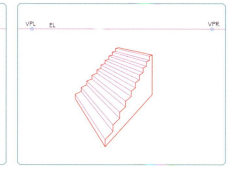

Step 4. Draw guidelines from the vertical spacing to the VPR.

Step 5. Connect the stairs on the front surface plane by erasing unused guidelines.

Step 6. Draw lines from the front surface plane to the VPL and then connect the back edge of the stairs by drawing lines vertically or to the vanishing point.

Step 7. Erase any guidelines from back edge of stairs.

ADDING ACCESSORIES

The first example is adding pillows in two-point perspective to a sofa that was sketched in one-point perspective. The second example shows how to add objects to a two-point perspective drawing, such as an object on top of an ottoman, and how to add a potted plant to the side of an object.

ADDING PILLOWS

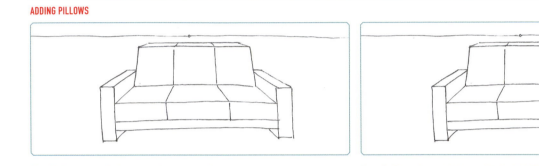

Step 1. Create a sofa in one-point perspective.

Step 2. Place the vanishing point right (VPR) on the eye-level line. From the VPR draw the top and bottom of the left side pillow. Connect these lines with vertical lines to create the size of the pillow.

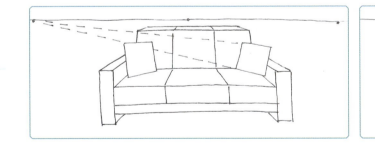

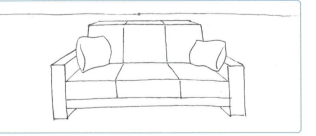

Step 3. Place the vanishing point left (VPL) on the eye-level line. Use the (VPL) to create the right side pillow.

Step 4. Using the placement of the pillows from Steps 2 and 3, create volume to the pillows.

ADDING OBJECTS

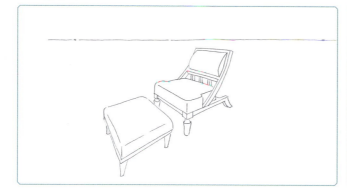

Step 1. Create a piece of furniture; this example shows a chair and ottoman.

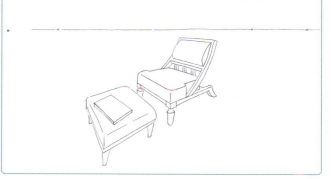

Step 2. A book was added to the ottoman.

NOTE The vanishing points were moved to the right on the eye-level line so that the book is not square to the ottoman.

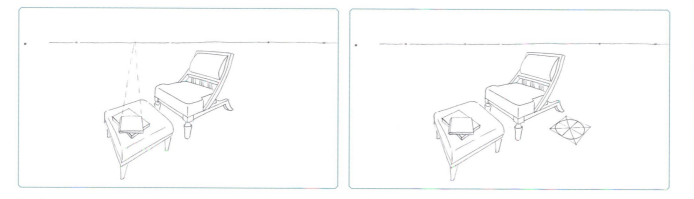

Step 3. A second book was added in one-point perspective. Remember that the vanishing point needs to be on the eye-level line.

Step 4. To create a potted plant start by the placement of the footprint.

NOTE The footprint was created by using the vanishing points from the chair. Center was also found in the footprint to create an ellipse.

Step 5. Create the volume of the object by using vertical lines from the footprint to the desired height.

Step 6. Erase any construction lines, and use the cylinder as a guide to add other detail to the base.

Step 7. To complete the detail draw in the plant.

NOTE This example shows the plant to the side and in front of the chair, so drawing over the chair will make the total volume look correct.

Project 8.1 DRAWING A CUBE AND FURNITURE WITH SHADOWS IN TWO-POINT PERSPECTIVE

Part 1: Create two drawings with shadows from a light source. Use 14" × 17" paper in vertical format and divide horizontally into two parts.

The top portion should have two geometric forms with a light source between them.
The bottom portion should have a piece of furniture with a light source to one side.

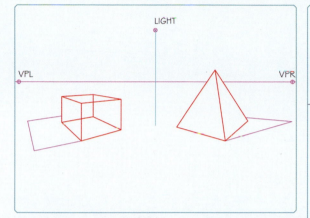
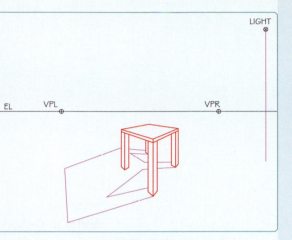

An example of Part 1 of Project 8.1.

Part 2: Create two drawings with shadows produced using the parallel method. Use 14" × 17" paper in vertical format and divide horizontally into two parts.

The top portion should have an object against a wall.
The bottom portion should have an object with negative space, such as a table.

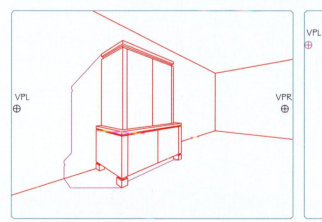
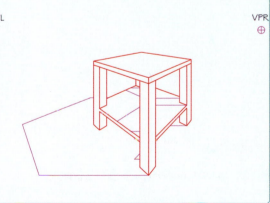

An example of Part 2 of Project 8.1.

Project 8.2 ADDING SHADOWS TO A ROOM IN TWO-POINT PERSPECTIVE

Create a room in two-point perspective. Add furniture and details such as doors, windows, molding, and so on, on 14" × 17" paper.

Use the parallel method to create shadows for the furniture in the space.

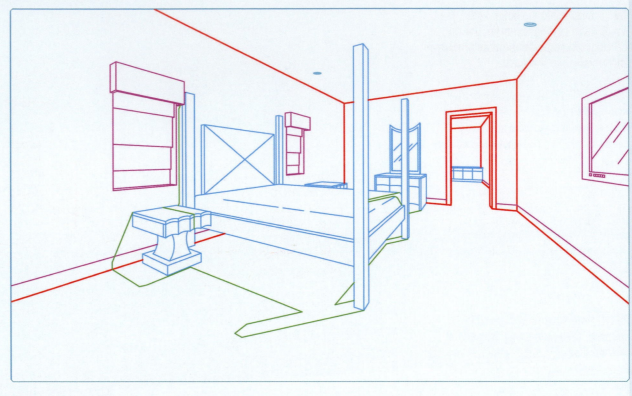

An example of Project 8.2.

Project 8.3 ADDING VERTICAL REFLECTION TO A ROOM IN TWO-POINT PERSPECTIVE

Create a room in two-point perspective. On 14" × 17" paper add furniture and details such as doors, windows, molding, and so on.

Create a vertical reflection on the floor or countertop surface.
When inking the images, use a thicker line weight for the objects in the room and a thinner line weight for the reflections.

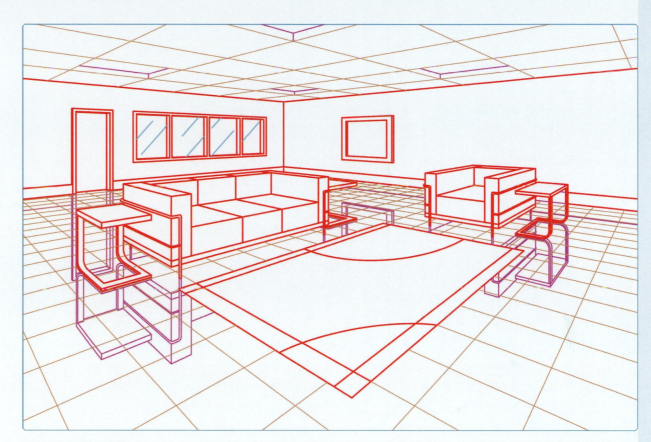

An example of Project 8.3.

9

Creating Exterior Details in One- and Two-Point Perspectives

The purpose of this chapter is to show how to create exterior architectural details. These details start in one-point perspective and show how to create rooftops, doors, windows, and sidewalks. From there the chapter shows the same types of details in two-point perspective. Remember that the same rules and principles that you learned in previous chapters for interior spaces apply to exterior drawings.

EXTERIOR STRUCTURES IN ONE-POINT PERSPECTIVE

The purpose of showing exterior details in this book is so the reader can create exterior structures to enhance their interior drawings. Depending on the space, the view from the windows, patio, or balcony could be a selling point for the project. This part of the chapter shows how to create basic architectural details in one-point perspective.

CREATING ANGLED ROOFTOPS AND DIVIDING SPACE

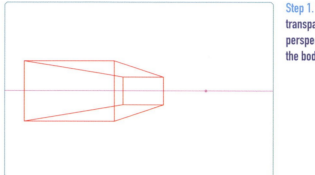

Step 1. Start by drawing a transparent cube in one-point perspective. This cube represents the body of the building.

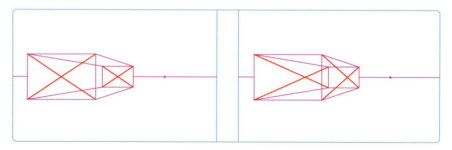

Step 2. Draw lines from corner to opposite corner to find center on the surface planes that the roof pitch will be created.

NOTE The building on the left has center on the front and back surface planes. The building on the right has center on the two side surface planes. This creates two different directions for the roof.

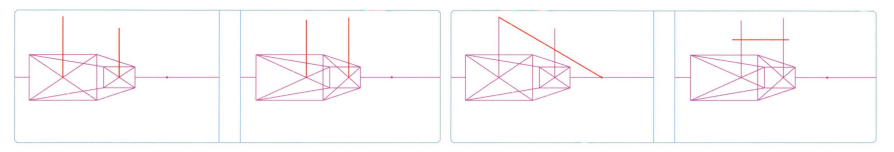

Step 3. Draw lines from the centers upward.

Step 4. In the image on the left, choose a height on the front center line and transfer back to the VP. In the image on the right, choose a height on the center line and connect them by drawing a line parallel to the HL.

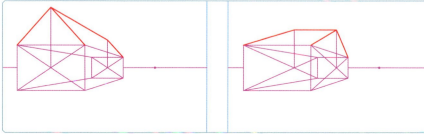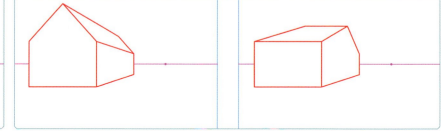

Step 5. Connect the height of the center lines to the top corners of the building.

NOTE The far back corner does not need to be drawn for a solid roof.

Step 6. Erase all construction lines to complete the basic pitched roof form.

CREATING OVERHANG TO THE ROOF EDGES

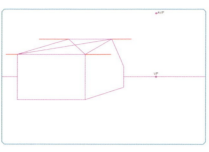

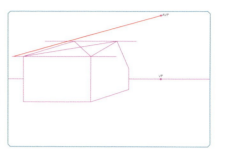

Step 1. To create the overhang, the alternate vanishing point (AVP) needs to be found. This is done by extending the edges of the roofline outward until they intersect.

NOTE They should be in line with the VP.

Step 2. Find center on the roof pitch.

Step 3. Extend the top and bottom of the roofline outward from the house on both sides.

Step 4. On one side draw a line from the AVP through the top and bottom line drawn in Step 3 to create the overhang distance on that side.

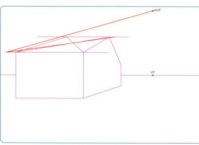

Step 5. Draw a line from the bottom of the overhang made in Step 4 through center until it intersects with the top of the other side.

Step 6. Draw a line from the AVP through the intersection in Step 5 until it intersects with the bottom roofline. This completes the equal overhang on each side of the front roof plane.

Step 7. To transfer the overhang to the back, start by drawing a line from the back top corner parallel to the HL. Next draw a guideline from the bottom front overhang back to the VP.

NOTE The depth of the back overhang is created where the lines intersect.

Step 8. Connect the outside of the line created in Step 7 to the top center with a line to finish the back plane overhang.

CREATING AN OVERHANG OF THE ROOF TOWARD THE GROUND

Step 1. Start by extending the rooflines downward from the roof surface plane edges.

Step 2. Draw a line at the desired depth that connects the front edges. This line should be parallel to the HL.

Step 3. Draw a guideline from the front edge of the new height from Step 2 to the VP. Draw another line parallel to the HL from the intersection point to create the depth on the back of the building.

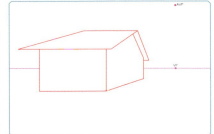

Step 4. Erase any construction lines to show the completed overhang.

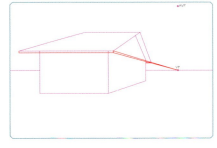

Step 5. Draw vertical lines from the outside corners of the roof. Add thickness to the front edge with a parallel line at desired thickness, and transfer to the back using the VP.

Step 6. Draw a vertical line down from the top roof edge. Then draw a line from the front corner to the AVP. This creates the dimension on the side of the front roof plane. Now draw a line connecting the back corner to the top vertical line.

Step 7. Erase any construction lines to complete the dimension to the roof pitch.

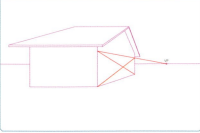

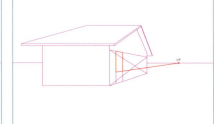

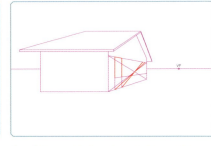

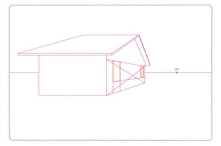

Step 1. Based on the size of the building draw a height guideline across the side surface plane. Then find center inside that front surface plane.

NOTE This guideline was drawn to create the height of the front door and windows, about 7'.

Step 2. Create the first window by drawing vertical line down from the guideline in Step 1 to the base of the building. Then draw a line from the VP to the desired windowsill.

Step 3. Draw guidelines from the base of the vertical lines from Step 2 through the center of the surface plane to the top guideline. This finds the placement of the back window.

Step 4. Draw vertical lines downward from the intersection points in Step 3 to the bottom windowsill guideline to complete the back window.

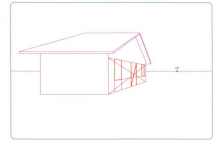

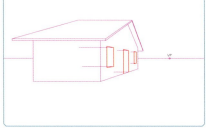

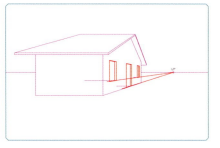

Step 5. To create a door repeat the same basic steps for the windows. Draw a vertical line downward on one side of center; then draw a guideline from the base of that line through center to the top guideline from the windows. Finally, draw a vertical line down from that intersection point to complete the door. This makes the height of the door and windows the same.

Step 6. Draw lines from the back corners of the windows and doorway to add dimension to these details.

Step 7. To define the depth, draw a line from the VP to the top edge of the windows and doorway at the desired dimension.

Step 8. Draw vertical lines downward from the top intersection points in Step 7; then draw lines from the VP to the intersection at the base of the doorway and windowsills.

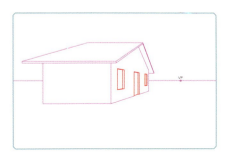

Step 9. Erase all construction lines to show the completed depth of the windows and doorway.

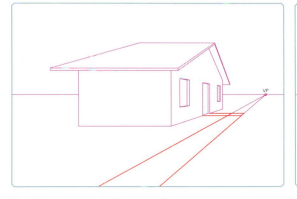

Step 1. Draw two parallel lines from the doorway outward and then draw two lines from the vanishing point forward at the desired width. Make sure these lines intersect with one another.

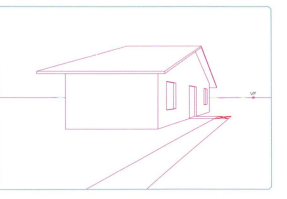

Step 2. Draw lines at the intersection point from opposite corner to opposite corner to determine the center point.

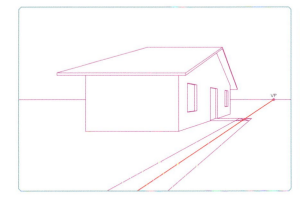

Step 3. Draw a guideline from the VP through the center point of the sidewalk.

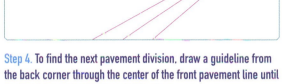

Step 4. To find the next pavement division, draw a guideline from the back corner through the center of the front pavement line until the line intersects with the outside edge.

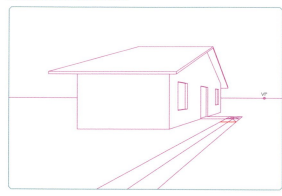

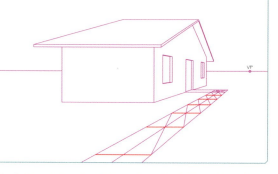

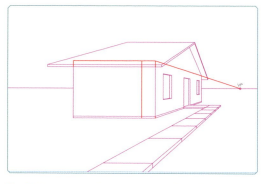

Step 5. Draw a parallel line from the front intersection line from Step 4 to create the next pavement division.

Step 6. Repeat steps 4 and 5 to continue the divisions forward.

Step 1. To create another structure, start by making a footprint on the side of the existing structure. This will make the starting point for the new structure.

NOTE In this example the roof comes lower, so the top edge of the front wall is redrawn.

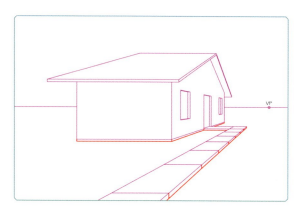

Step 7. Add the desired thickness to the pavement from the VP and then draw a vertical line down from the division lines.

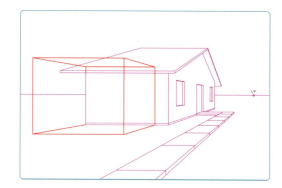

Step 2. Use the VP to draw the corners of the footprint outward and then draw the base, top, and sides to create a transparent cube at the desired length.

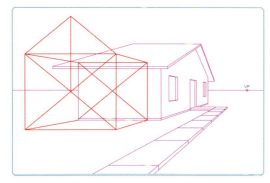

Step 3. To create the roof pitch start by finding center on the front and back walls. On the front wall draw a guideline up to the desired height. Draw lines from the front top corners to the top of the center guideline.

NOTE This is not repeated on the back wall of this example because of the different roof pitch from the existing structure.

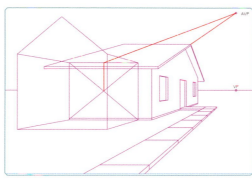

Step 4. To find the back roof pitch, first draw a guideline up from the center of the back wall to the top edge. Then draw a guideline from that point back to the AVP.

NOTE This example shows the edge of the roofline drawn back to show that it is the same AVP.

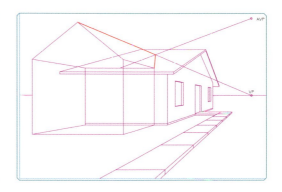

Step 5. To complete the top of the roof pitch draw a line from the front top pitch back to the VP until it intersects with the line to the AVP from Step 4. Draw another line from that intersection point to the top back corner of the new structure.

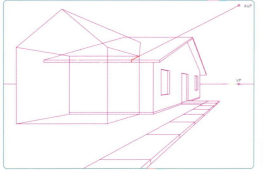

Step 6. This example shows the roofline drawn down from the AVP where the original structure pierces the new one. Depending on the angle this may end up being erased when the new structure's roof is drawn outward to overhang.

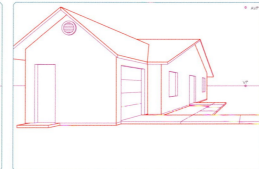

Step 7. This image shows detail added to the new structure as well as a driveway.

EXTERIOR STRUCTURES IN TWO-POINT PERSPECTIVE

This part of the chapter covers two-point exterior structures. Just like the one-point part of this chapter, the purpose of showing exterior details is so the reader can create exterior structures to enhance their interior drawings. Remember the view from the windows, patio, or balcony could be a selling point for the project. This part of the chapter shows how to create basic architectural details in two-point perspective.

CREATING ANGLED ROOFTOPS AND DIVIDING SPACE

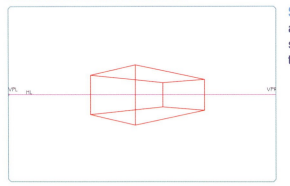

Step 1. Start with the dimension of the building as a transparent cube. The following images show the roof pitched in each direction using this same transparent cube.

Step 2. Find the center of the surface planes from which the roof will pitch.

Step 3. Draw lines perpendicular to the horizon line (HL) from those center points upward.

Step 4. Pick a desired height for the roof and make a mark on the front line. Line up that mark with the vanishing point, and draw a line to the back center line. This makes the top of the pitch.

NOTE For a one-point perspective with center lines, the lines for the sides are drawn parallel to the HL.

Step 5. Draw lines down from the top center line to the corners of the cube. This completes the roof without an overhang.

Step 1. Start with the basic construction of a roof from the previous section; then find the alternate vanishing point (AVP) by extending the roof angles until they converge with one another.

NOTE The AVP is used only for that surface plane.

Step 2. Find the center of that surface plane.

Step 3. Extend the top and bottom edges of the roof forward and backward from the VPR as a guide.

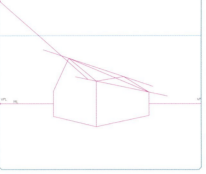

Step 4. Draw a line from the AVP to the desired distance past the front edge. This creates the front overhang.

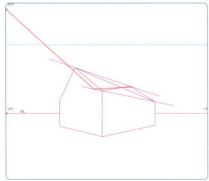

Step 5. Draw a guideline from the bottom front edge of the overhang through the center mark until it intersects with the back top line.

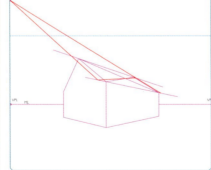

Step 6. Draw a line from the AVP through the top back intersection until it intersects with the bottom edge. This completes the overhang on the back.

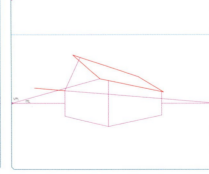

Step 7. Draw a guideline from the front bottom overhang across to the other front bottom extended guideline.

Step 8. Connect that intersection with the top overhang to complete.

CREATING AN OVERHANG OF THE ROOF TOWARD THE GROUND

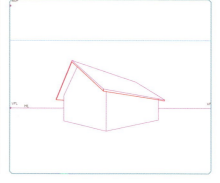

Step 1. Extend the overhang lines toward the ground.

Step 2. Pick a desired distance, and draw a line from the VPR to the front overhang.

Step 3. Draw a guideline from the front roof pitch overhang to VPL; then draw a line from that intersection point on the back overhang to the VPR. This creates the overhang on the back side.

Step 4. Erase any construction lines. At this point thickness can be added to the roof edge.

CREATING TWO EQUALLY SPACED WINDOWS AND A DOOR

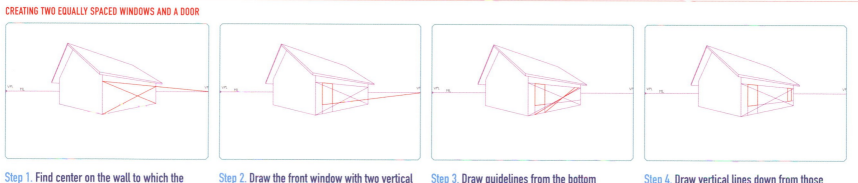

Step 1. Find center on the wall to which the windows will be added.

Step 2. Draw the front window with two vertical lines and two lines for the top and bottom of the window extended to the VPR. Extend the two vertical lines until they intersect with the base of the wall. Leave the top and bottom lines across the complete wall for now.

Step 3. Draw guidelines from the bottom intersection points in Step 2 through center until the lines intersect the top window line.

Step 4. Draw vertical lines down from those marks in between the top and bottom window lines.

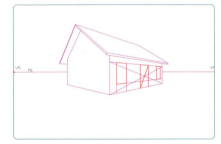

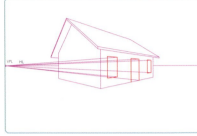

Step 5. To add a door, repeat the steps for the window division except continue the door line to the base of the wall.

Step 6. Draw lines from the corners of the windows and door to the other vanishing point.

Step 7. Draw a vertical line to create the wall thickness on the front window.

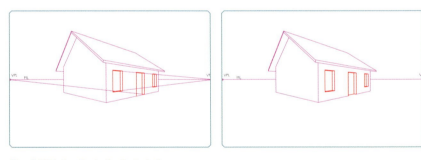

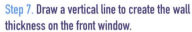

Step 8. With the size in the first window thickness, use the vanishing points to transfer it back to the other details. This makes all the proportions correct.



CREATING A BANK OF WINDOWS

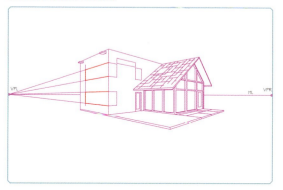

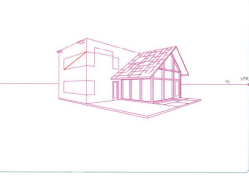

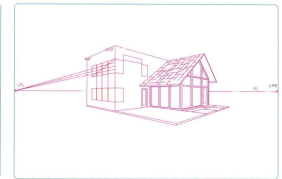

Step 1. Create the total overall dimension of each window space on the wall with two vertical lines and two lines drawn to the VPL. This example shows a first- and second-story window at the same time.

Step 2. Draw a diagonal construction line from corner to opposite corner in the window.

Step 3. Create equally measured marks on the front vertical line of the window. (The number of marks determines the number of mullions in the window bank. Three marks make three mullions and four windows.) Draw construction lines from those marks to the vanishing point and then draw vertical lines from the top line of the window to the bottom line through each of the intersection points to divide up the window bank.

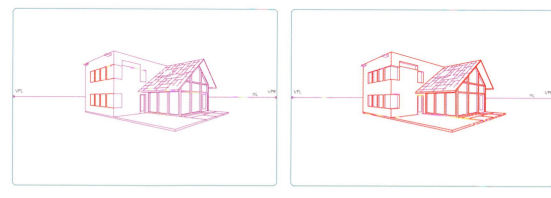

Step 4. Add thickness to the division by drawing vertical lines on each side of the lines created in Step 3.

Step 5. Add depth to the window bank to show the glass recessed.

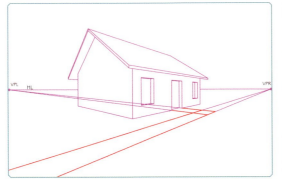

Step 1. Draw two construction lines from the vanishing point to create the width of the sidewalk; then draw two lines between the lines of the sidewalk to the other vanishing point to create the desired size of the concrete pad. (This proportion is used to repeat the division.)

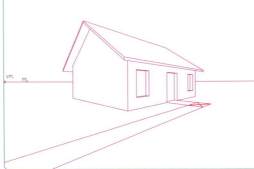

Step 2. Find the center of the first pad.

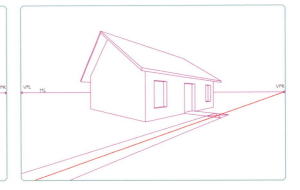

Step 3. Draw a guideline from the VP through the center, dividing the complete path.

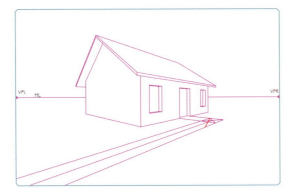

Step 4. Draw a guideline from one of the back corners through the intersection point of the center line and front edge. Continue that line until it touches the outside edge of the sidewalk.

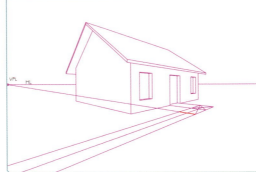

Step 5. In one-point perspective, draw a parallel line from the intersection on the outside edge in Step 4. For two-point perspective, draw a line from the other VP instead of a parallel line.

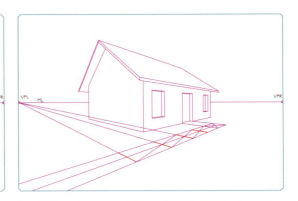

Step 6. Repeat Steps 4 and 5 to continue the division forward.

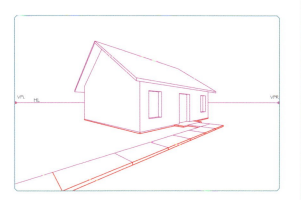

Step 7. Add a desired thickness to the front edge of the sidewalk and transfer back using the vanishing points. Add a vertical line to the side at the concrete divisions.

PART 2: CREATING THE DIVISION LINE BACKWARD

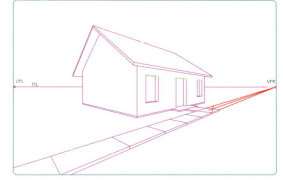

Step 8. Extend the sidewalk back to the VPR along with the center line. Draw a guideline from one of the front corners through the intersection point of the center line and back edge. Continue that line until it touches the outside edge of the sidewalk.

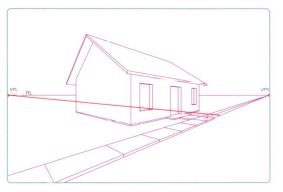

Step 9. In one-point perspective, draw a parallel line from the intersection on the outside edge in Step 5. In two-point perspective, draw a line from the other VP instead of a parallel line.

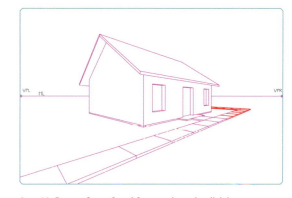

Step 10. Repeat Steps 8 and 9 to continue the division backwards.

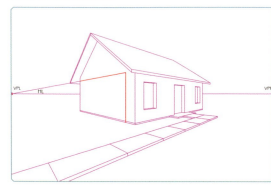

Step 1. Start by creating the footprint of the structure on the wall of the first building.

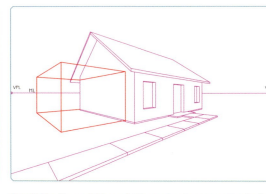

Step 2. Use the vanishing point to create a transparent cube to show the volume.

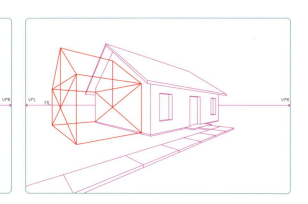

Step 3. Divide the footprint to create a pitched roof.

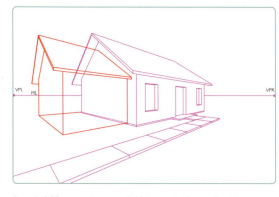

Step 4. Add an overhang and thickness to the roof surface.

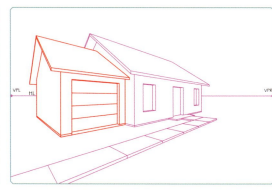

Step 5. Add details such as a door or windows using the vanishing points, and erase any construction lines.

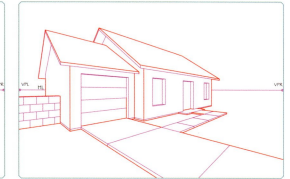

Step 6. Add other details around the structure such as walls, driveways, lighting, or trees.

Project 9.1 DRAWING A BUILDING SCENE IN ONE-POINT PERSPECTIVE

Create a one-point building. Eye level does not need to be placed through the center of the paper. The vanishing point can be placed in the center, off to the side of the frame of reference.

1. Use a photograph as a reference to help determine architectural details.
2. Develop objects in cube form to determine the correct size and proportions.
3. Draw a one-point building in one-point perspective with supporting elements.
4. Show windows on the side of the buildings using the division-of-areas measuring technique as covered in this chapter to develop the correct proportion.
5. Different line weights may be used—bold line for the structures and less bold for details.

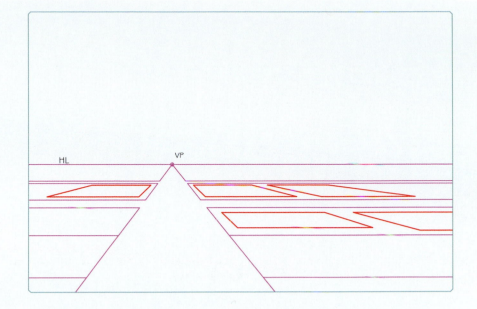

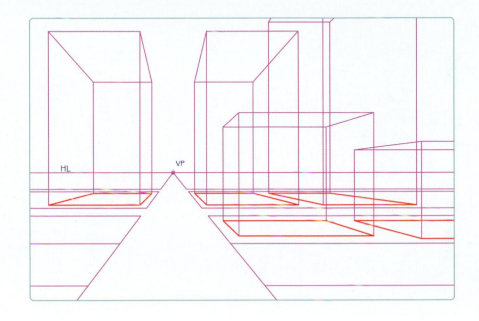

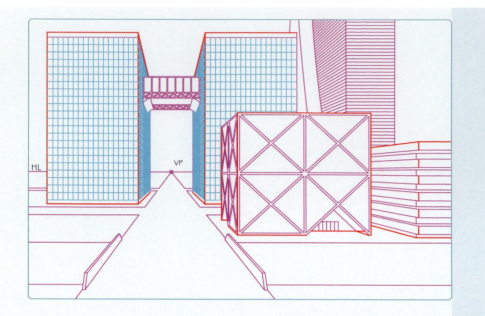

Project 9.2 DRAWING A BUILDING SCENE IN TWO–POINT PERSPECTIVE

Create a two-point building scene. Eye level does not need to be placed through the center of the paper. Vanishing points can be placed off the paper or outside the frame of reference.

1. Use a photograph as a reference to help determine architectural details.
2. Develop objects in cube form to determine the correct size and proportions.
3. Draw a minimum of five buildings in two-point perspective.
4. Show windows on the side of the buildings using the division-of-areas measuring technique as covered in this chapter to develop the correct proportion.
5. Different line weights may be used—bold line for the structures and less bold for details.

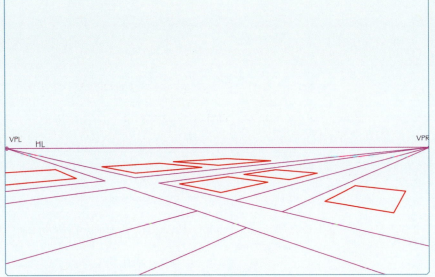

This example shows the building and street layout.

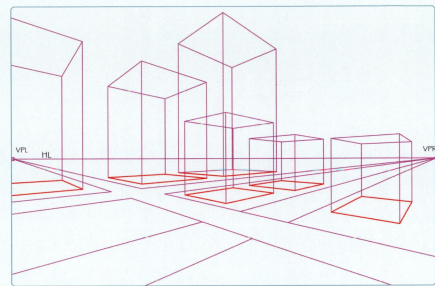

This example shows the buildings' volumes.

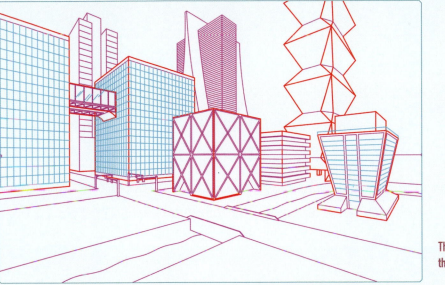

This example shows
the completed details.

10

Drawing Furniture and Interior Spaces in Three-Point Perspective

Three-point perspective involves viewing an object or a room from a high vantage point or a low one. These types of drawings have a vanishing point left (VPL) and a vanishing point right (VPR), just like a two-point perspective drawing; however, there is now a third point for the vertical lines. This vanishing point vertical (VPV) is the only technical difference between a three-point drawing and a two-point as shown in Figures 10.1a – 10.2b.

The photo in Figure 10.2b was taken from the top viewing area of a building. Figure 10.2b shows the edges drawn outward to create the vanishing points. These points are shown with arrows for the direction because the points are far off the page. *Note: The boat marina is at a different angle than the building; therefore, it has a different vanishing point. This is a single point in the center of the eye-level line* (EL).

Figure 10.1a
This photo was taken from the sidewalk level looking up.

Figure 10.1b
Shows the side edges of the building drawn outward to find the vanishing point left and right along the bottom. The vertical edges are drawn upward and where these lines intersect creates the vanishing point vertical.

NOTE This point is overhead because the photo was taken from the ground; therefore, the top of the building is the farthest away.

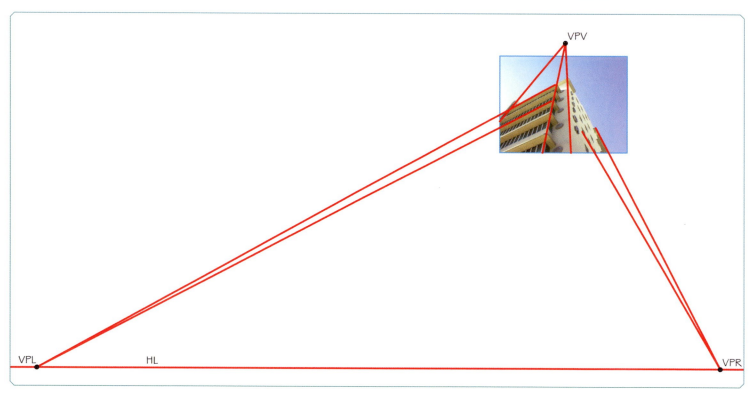

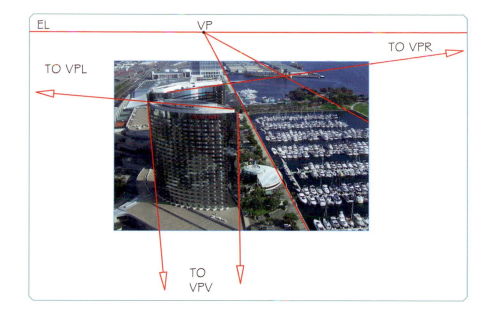

Figure 10.2a
This photo was taken from the top viewing area of a building.

Figure 10.2b
Shows the edges drawn outward to create the vanishing points. These points are shown with arrows for the direction because the points are far off the page.
This is a single point in the center of the eye-level line (EL).

NOTE The boat marina is at a different angle than the building; therefore, it has a different vanishing point.

TERMS FOR THREE-POINT PERSPECTIVE

Most of the terms listed below for three-point perspective are a review from two-point. The only new term is the vanishing point vertical (VPV).
- **Eye level (EL).**
- **Horizon line (HL).**
- **Vanishing point left (VPL) Vanishing point right (VPR).**
- **Bird's-eye view and frog's-eye view.**

NOTE Unlike one- and two-point perspective drawings, a three-point perspective drawing has only two different views because the horizon line is at the top or bottom of the paper; therefore, the complete object or the majority of the object will be below or above the horizon line.

- **Vanishing point vertical (VPV).** The third point in the three-point perspective is at the bottom or top center of the drawing. This is the point from which vertical lines are drawn.

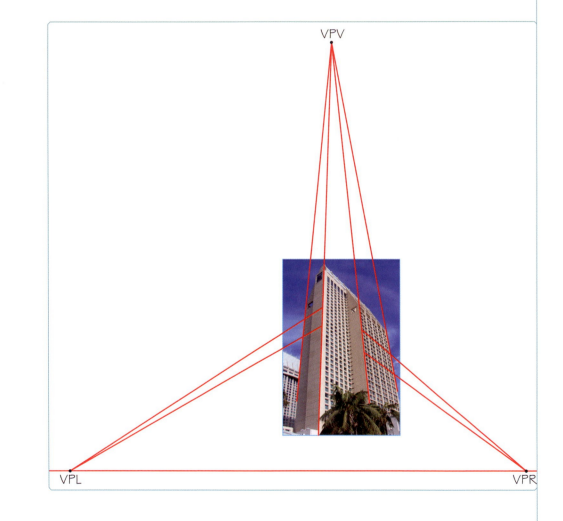

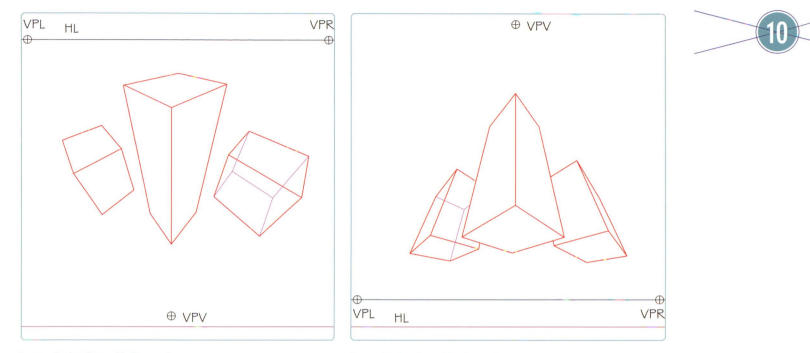

Image of cubes from a bird's-eye view.

Image of cubes from a frog's-eye view.

RULES FOR THREE-POINT PERSPECTIVE

When drawing a cube or object flat to the ground, the lines are drawn in only three basic ways.

1. Lines are drawn to the vanishing point left to create the depth on the left side of the object.
2. Lines are drawn to the vanishing point right to create the depth on the right side of the object.
3. Lines are drawn to the vanishing point vertical to create the object's height.

Repeating these lines will create the back of the object, add detail, and create volume. There are exceptions to these rules, however, such as if the object is tilted (not flat to the ground) or if there is an angle such as a wedge or pyramid-shaped object.

To set up the three-point perspective, start the same way as for the one- and two-point perspectives by creating the eye-level line (EL) or horizon line (HL). This EL/HL should be at the top or bottom of the paper. There are two vanishing points on the EL—the vanishing point left (VPL) and the vanishing point right (VPR). The third vanishing point is the vanishing point vertical (VPV). After these three vanishing points have been placed they cannot be moved. All objects drawn in three-point perspective have lines that converge to the VPL, VPR, or VPV in order to show depth on all sides.

BASIC OBJECTS

CUBE

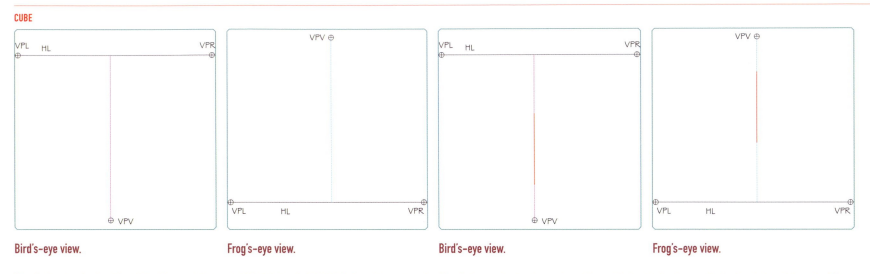

Bird's-eye view.

Frog's-eye view.

Bird's-eye view.

Frog's-eye view.

Step 1. Create a horizon line (HL) with a vanishing point left (VPL) and right (VPR). From the center of the HL draw a perpendicular guideline down and place a vanishing point vertical (VPV) on that line close to the edge of the paper.

Step 2. Draw a darker line on top of the vertical guideline to specify the front edge of the cube. This line determines the total vertical height of the cube.

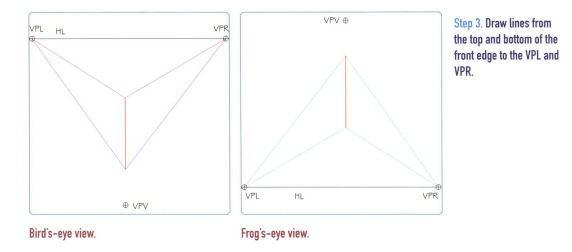

Bird's-eye view.

Frog's-eye view.

Step 3. Draw lines from the top and bottom of the front edge to the VPL and VPR.

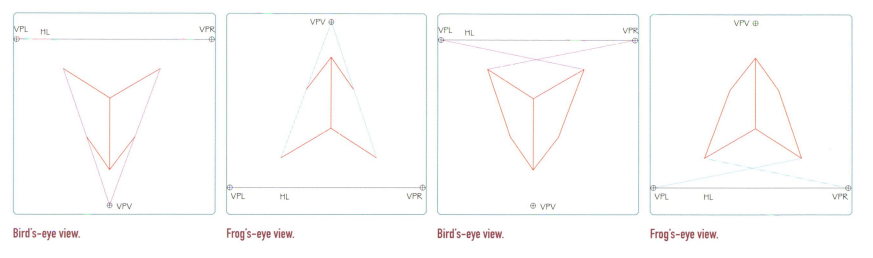

Bird's-eye view.

Frog's-eye view.

Bird's-eye view.

Frog's-eye view.

Step 4. Choose a desired depth and create a mark on each of the lines furthest from the VPV from Step 3; then draw guidelines from those marks down to the VPV to create the sides.

Step 5. Draw lines from the outside edges in Step 4 to the VPL and VPR to complete the top of the cube.

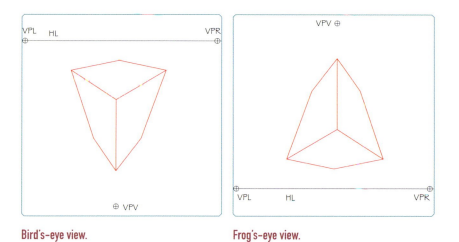

Bird's-eye view.

Frog's-eye view.

TRANSPARENT CUBE

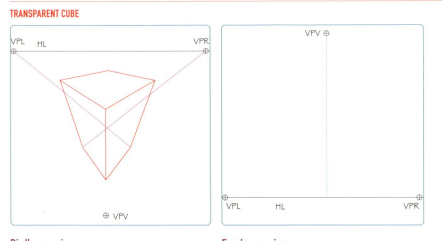

Bird's-eye view.

Frog's-eye view.

Step 1. Start with a solid cube and draw guidelines from the bottom side corners (bird's eye) or top corners (frog's eye) to the VPL and VPR.

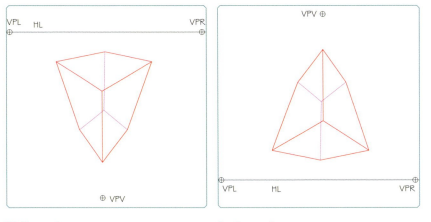

Bird's-eye view.

Frog's-eye view.

Step 2. Draw a line from the VPV through the intersection point from Step 1 to the back inside corner of the cube to complete the drawing.

PYRAMID

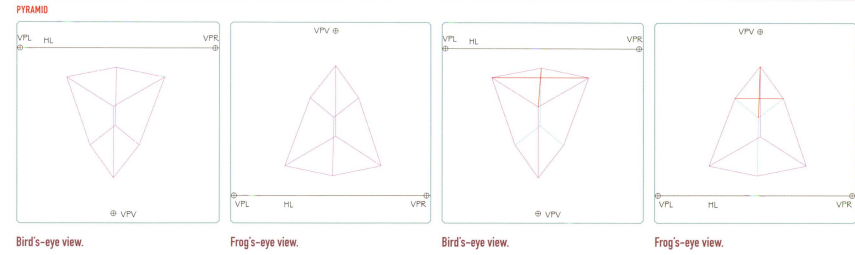

Bird's-eye view.

Frog's-eye view.

Bird's-eye view.

Frog's-eye view.

Step 1. **Start with a transparent cube.**

Step 2. **Find center of the top of the cube by drawing a line from opposite corner to opposite corner.**

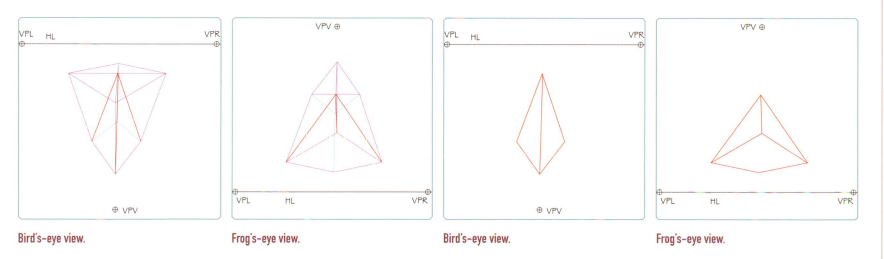

Bird's-eye view.

Frog's-eye view.

Bird's-eye view.

Frog's-eye view.

Step 3. **Draw lines from the center point to the outside corners of the cube to create the form of the pyramid.**

Step 4. **Erase the guidelines and the transparent cube to reveal the pyramid.**

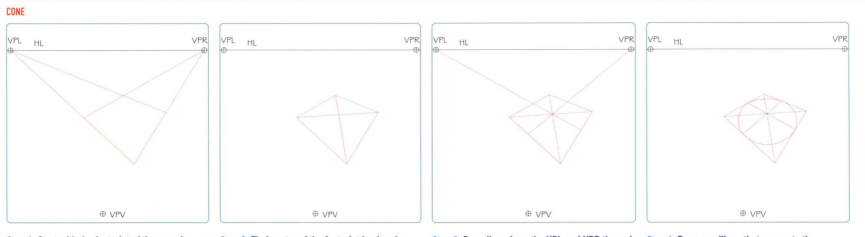

Step 1. Start with the footprint of the cone by drawing lines from the VPL and VPR to create the desired size.

Step 2. Find center of the footprint by drawing lines from opposite corner to opposite corner.

Step 3. Draw lines from the VPL and VPR through center to the front edges of the footprint.

Step 4. Draw an ellipse that connects the intersection points from previous step to create the base of the cone.

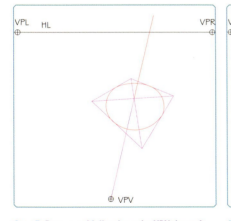

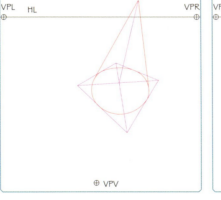

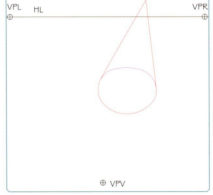

Step 5. Draw a guideline from the VPV through the center point of the footprint to the desired height.

Step 6. Draw lines from the height created in Step 5 to the outside edges of the ellipse.

Step 7. Erase any construction lines.

NOTE This example shows a transparent cone. To make a solid cone, erase the inside curve of the ellipse.

CYLINDER

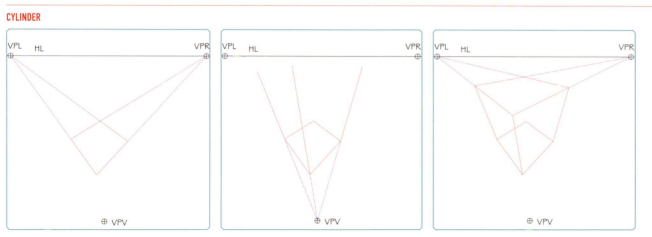

Step 1. Start with the footprint of the cylinder by drawing lines from the VPL and VPR to create the desired size.

Step 2. Draw lines from the VPV through the corners of the footprint.

NOTE The back corner is not used because it is not needed to create the total volume.

Step 3. Choose the desired height on the front vertical edge and draw lines back to the VPL and VPR. Also draw a line to the VPL and VPR where the top lines intersect the outside vertical lines.

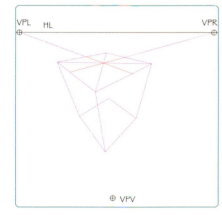

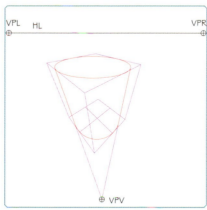

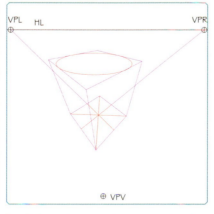

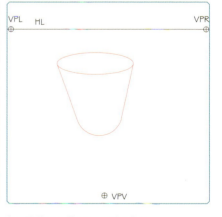

Step 4. Find center on the top surface plane and then draw lines from the VPL and VPR through the center point to the outside edges.

Step 5. Repeat Step 6 for the bottom of the cube. Also connect the top edge intersection point with an ellipse to create the top of the cylinder.

Step 6. Connect the bottom edge intersection point with an ellipse to create the base of the cylinder; then draw lines from the VPV through the outside edge of the base ellipse to the top ellipse.

NOTE This example is a solid cylinder so the base ellipse is shown as the front of the curve.

Step 7. Erase all construction lines.

TRANSFORMING A CUBE INTO FURNITURE

Step 1. Create a cube that is the total volume of the furniture. This example is a chair.

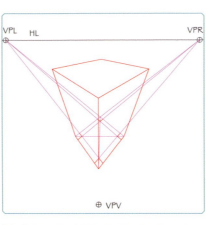

Step 2. Draw the footprints of the four legs from the VPL and VPR.

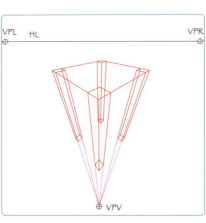

Step 3. Draw lines upward from the VPV through the footprints to the top of the cube.

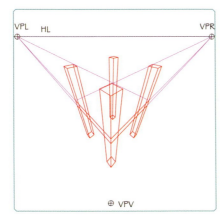

Step 4. From the VPL and VPR, create the seat of the chair.

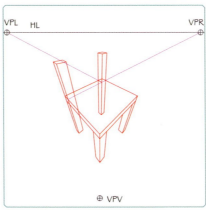

Step 5. Delete the front leg detail above the seat and notch in the seat on the back legs by drawing lines from the VPL and VPR.

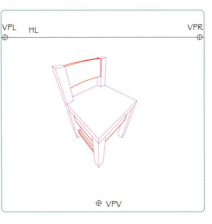

Step 6. Add detail to the seat back and legs using the vanishing points.

CREATING A ROOM IN THREE-POINT PERSPECTIVE

When creating a room in three-point perspective, the main difference from one- and two-point perspective is the visual angle of the drawing. In a one-point or two-point perspective you are showing the room as if someone is standing in that room. In a three-point perspective the view is going to be completely different, as if the ceiling has been peeled away and someone is looking down into the space.

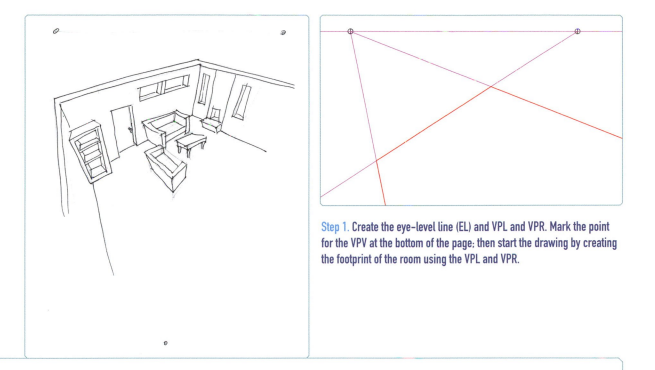

Step 1. Create the eye–level line (EL) and VPL and VPR. Mark the point for the VPV at the bottom of the page; then start the drawing by creating the footprint of the room using the VPL and VPR.

Create a quick thumbnail idea for the space. These types of sketches can help with room layout, furniture configuration, and vanishing point placement.

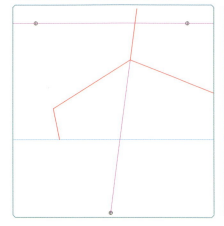

Step 2. Draw a line from the VPV through the back corner of the footprint to the desired ceiling height.

Step 3. Draw lines from the VPL and VPR through the top back line to create walls.

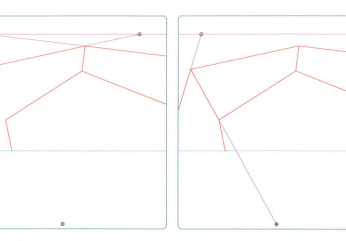

Step 4. Draw a vertical line through any other floor corners to the ceiling line; then at the intersection point, use the VPL or VPR to complete the wall height.

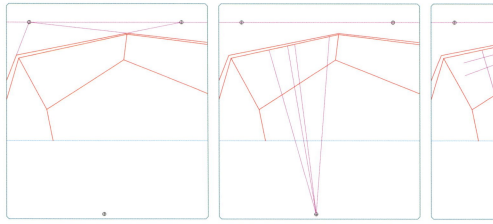

Step 5. Use the VPL and VPR to create thickness for the tops of the walls.

Step 6. Create detail on the walls. Use the VPV to place the doors and windows.

Step 7. Use the VPL or VPR to create the height of the door and window where they intersect the vertical lines.

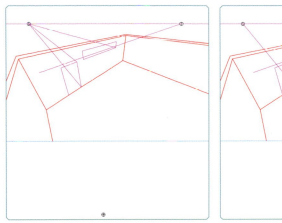

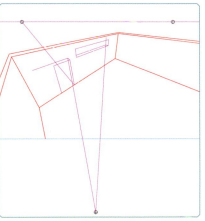

Step 8. Use the VPL and VPR to create the depth and dimension of the door and window.

Step 9. To complete the depth draw lines from the VPV through the intersection points in Step 8.

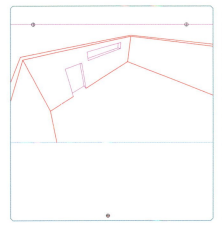

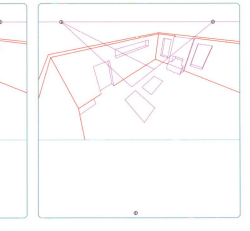

Erase any construction lines to complete the detail on that wall.

This example shows the other wall completed by repeating the beginning steps.

Step 10. Create furniture in the space. Start by using the VPL and VPR to create the footprints of each piece of furniture. This way it is easier to see the total size of the furniture and the negative space between each piece.

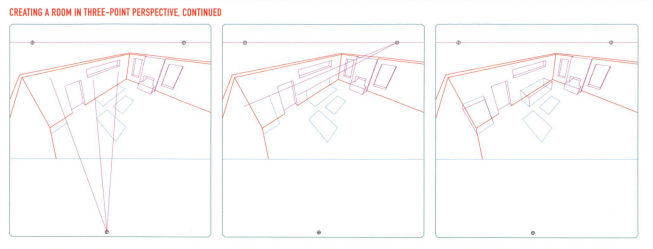

Step 11. Start with any item against the wall and add vertical dimension by drawing lines from the VPV through the corners against the wall.

Step 12. Use the VPL or VPR to create the height of the furniture. This step has created a footprint of the furniture on the wall.

Step 13. Use the VPL and VPR to create the volume of the furniture against the wall and the VPV to complete the cubes.

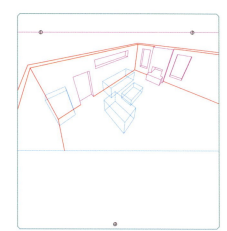

Step 14. Create the volume of the pieces in the center of the room using the VPV to add height to the footprints; then use the VPL and VPR to create height.

NOTE To get the correct height, use a guideline on the wall that has the proportional height from the furniture against the walls.

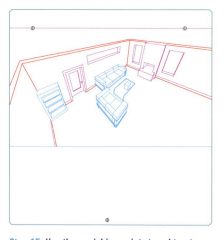

Step 15. Use the vanishing points to subtract space to create the furniture from the cubes.

TWO-STORY INTERIOR VIEW IN THREE-POINT PERSPECTIVE

This set of drawings will show an interior shopping mall space from a high vantage point looking down into the space. This type of interior was chosen because it shows many types of details including doorways, windows, signage, and walkways. The rules are the same for any three-point drawing: Start with a main structure to develop proportions and then transfer those proportions to other parts of the drawing.

PART 1: THREE-POINT PAGE SETUP

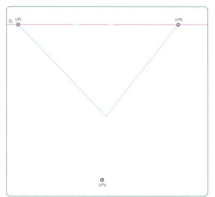

Step 1. Create the eye-level line (EL) close to the top of the page, and then establish the VPL and VPR.

Step 2. Create a point to be the VPV toward the bottom of the paper. This point can be centered between the VPL and VPR.

Step 3. Create the front bottom corner of the first object by drawing lines from the VPL and VPR. Where they intersect will be the front corner.

PART 2: CREATING THE FIRST STRUCTURE

Step 1. Start by drawing a line from the VPV through the front corner upward.

Step 2. Draw a line from the VPV on each side of the center line to create the depth of the first object.

Step 1. Draw a line from the VPL through the bottom right corner to create the right surface plane.

Step 2. Repeat this with the VPR to the left side.

NOTE The EL was erased behind the front structure. This can help you to see the depth if the lines are confusing.

Step 3. Using the VPV, draw a line through the side surface planes to divide up the space.

Step 1. Use the VPL to divide the front structure.

Step 2. Continue the line from Step 1 across the right side surface plane to the VPR. This space makes up the ceiling height for the first floor. This height was chosen by looking at the front proportions of the object.

NOTE The EL has now been completely erased to show the solid structure.

Step 3. Transfer the height line across the other surface planes using the VPL and VPR from the back line created in the last part. This divides the space to create a ground floor and second floor.

Step 1. Continue the floor on the right side. To show it pushed back, start with the VPR and draw construction lines to the ground and second floor lines on the right side.

Step 2. Using the VPV, draw a construction line to create the depth.

Step 3. Draw lines from the VPL through the intersection points. This creates the floor lines on the right side. After these lines are drawn, the construction lines can be erased.

PART 6: CREATING DOORWAY ON THE GROUND FLOOR

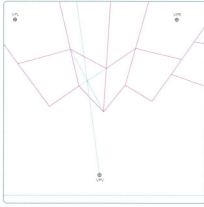
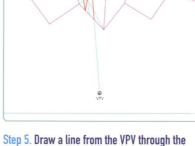
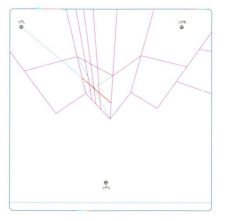

Step 1. To create a doorway on the front of the structure, start by finding the center between the ground and second floors by drawing lines from opposite corner to opposite corner.

Step 2. Draw a center guideline through that center intersection from the VPV.

Step 3. Pick a dimension from one side of the center guideline and draw a line for the doorway from the VPV.

Step 4. To find the proportion of the other side draw a guideline from the base of the doorway through center until that line intersects with the second floor.

Step 5. Draw a line from the VPV through the intersection on the second floor from Step 4. This makes up the equal vertical spacing of double doors on the ground floor and second floor.

Step 6. Draw a line from the VPL through the center intersection across the complete surface plane.

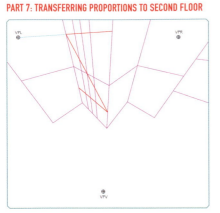

Step 1. To transfer this height from the ground floor to the top floor, draw a line from the bottom center line in the previous Step 6 upward through the center line of the second floor until it intersects with the edge of the wall.

Step 2. Draw a line from the VPL through the intersection of the edge across the surface plane. This creates the same proportion on both floors.

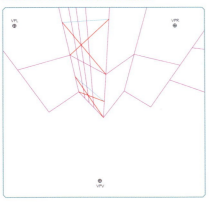

Step 1. To create the tops of the doors, divide the space on both floors by drawing lines from opposite corner to opposite corner from the ground line to the center lines.

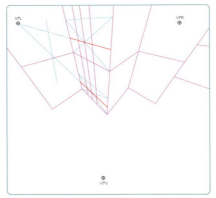

Step 1. Draw lines from the VPL through the center intersections from Part 8 to create the tops of the doors; then erase all construction lines.

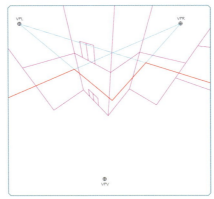

Step 1. Use the VPL to create the distance for the second-story walkway on the front left side.

Step 2. Transfer that spacing to the right side by drawing a line from the front to the VPR.

Step 3. Use the VPL and VPR to create the spacing on the sides.

PART 11: CREATING A HALF-WALL AROUND THE SECOND FLOOR

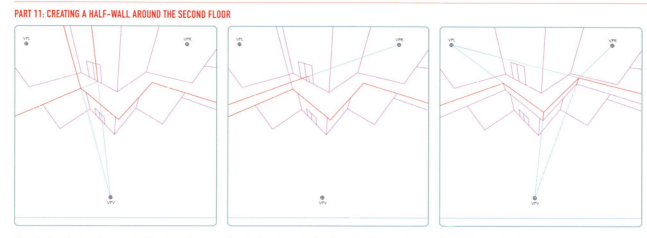

Step 1. Start by drawing a guideline from the VPV through the inside corner of the second floor.

Step 2. Draw another guideline through the doorway that lines up with the first guideline.

NOTE Erase the building lines for the second floor to help visualize the second floor.

Step 3. Use the guideline from the doorway in Step 2 to create the height of the wall.

Step 4. Draw a guideline from the VPR through that line to create the wall on the left side.

NOTE The height of a doorway is 80"; therefore, a line halfway through the doorway would be 40" or 3'-4".

Step 5. Draw guidelines from the VPV through the other corners of the second floor.

Step 6. Transfer the wall height by drawing a line from the VPL through the height of the wall on the inside corner until it intersects with the line from the VPV. Continue the height using the VPR and VPL until the wall is complete.

PART 12: ADDING WALL DIMENSION

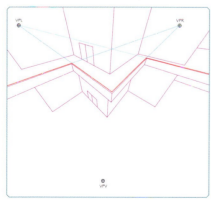

Step 1. Add the wall thickness by drawing a line from the VPR to the far left side of the wall, creating the desired dimension.

Step 2. Transfer that thickness with the VPL to the front edge and continue this process until the wall is done.

PART 13: TRANSFERRING DOOR PROPORTIONS TO OTHER WALLS

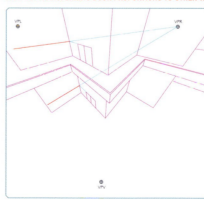

Step 1. Draw a guideline from the door heights to the VPL and stop the line at the edge of the wall.

Step 2. Use the VPR to transfer that height to the left surface plane.

PART 14: CREATING OTHER DOORS

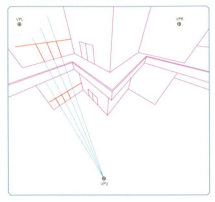

Step 1. Create the doors on the ground and second floors by drawing lines from the VPV to the guidelines from Part 13.

PART 15: CREATING ADDITIONAL DOORS

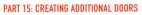
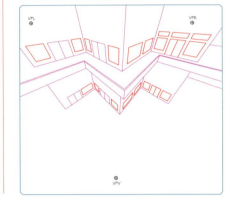

Step 1. Repeat this same process from Parts 13 and 14, adding doors and windows to the other surface planes.

PART 16: CURVING A WALL

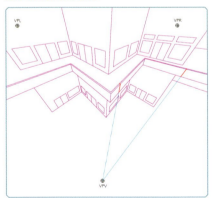

Step 1. Start by drawing two lines from the VPV through the half wall where the curve is going to begin and end on the second-floor wall.

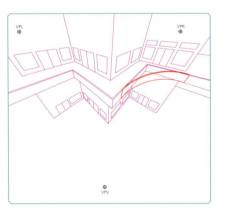

Step 2. Connect the lines from Step 1 by drawing a curved line from the bottom edge of the wall; then repeat by drawing another line on the top edge.

Step 3. Add one more curved line for the thickness of the top edge. Finish by erasing the straight part of the wall that the curve replaces.

PART 17: CREATING A WALKWAY

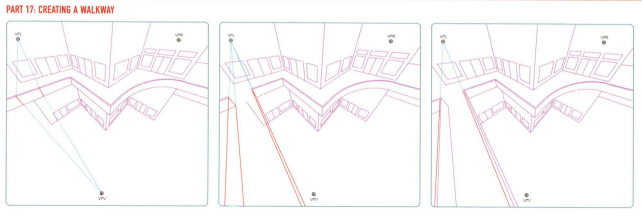

Step 1. Start by using the VPV to define the space on the second–floor wall that will become the walkway.

Step 2. Draw lines from the VPL through the lines in Step 1 to create the walkway.

Step 3. Use the VPL to create the thickness to the top edge of the walkway walls. Erase any part that the new walkway covers.

PART 18: CREATING DIMENSIONS FOR THE WINDOW

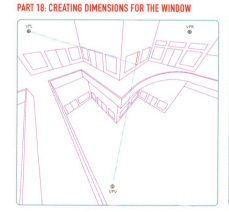

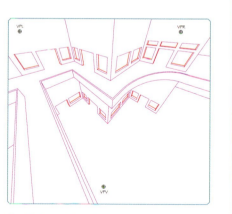

Step 1. Start by drawing a line from the VPL to the inside corner of the window on the right side of the center structure.

Step 2. Draw a line from the VPV to the top edge of that window to develop the desired thickness.

Step 3. Draw a line from the VPR through the intersection from Step 2 to create the bottom sill of the window.

Step 4. To add thickness to the other window, draw a line from the bottom corner to the VPL; then draw a line from the VPV through the intersection to complete the back window dimension.

Step 5. Repeat Part 18 to create the dimension on the other windows and doorways on both floors.

Step 1. Use the vanishing points for the placement of the signage the same way the windows were placed and then add dimension to those details.

Step 1. Add other details such as people, flooring materials, displays, and graphics.

NOTE This example was hand-sketched over original line drawing.

This final image shows the three-point perspective with materials and shadows rendered.

Project 10.1 DRAWING GEOMETRIC FORMS IN THREE-POINT PERSPECTIVE

Create a geometric environment in three-point perspective.

- Use 14" × 17" marker paper in vertical format.
- Use drafting tools (T-square, triangle, and ruler).
- Lay out your drawing in pencil, preferably an HB pencil.
- Ink exterior object lines with a .03 (thicker pen tip), and use .01 (thinner pen tip) for transparent objects.

Image of the three-point cube altered with a cone, pyramid, and cylinder added.

Project 10.2 DRAWING FURNITURE IN THREE-POINT PERSPECTIVE

Create a single piece of furniture in three-point perspective.

- Use 14" × 17" marker paper in vertical format.
- Use drafting tools (T-square, triangle, and ruler).
- Lay out your drawing in pencil, preferably an HB pencil.
- Ink exterior object lines with a .03 (thicker pen tip), and use .01 (thinner pen tip) for the furniture details.

These are examples of a nightstand for Project 10.2. Note that details can be added such as wood joinery.

Project 10.3 DRAWING AN INTERIOR SPACE IN THREE-POINT PERSPECTIVE

Create an interior room in three-point perspective.

- Use 14" × 17" marker paper in horizontal format with the vertical vanishing point off the paper.
- Use drafting tools (T-square, triangle, and ruler).
- Lay out your drawing in pencil, preferably an HB pencil. Ink the final drawing using different line weights.

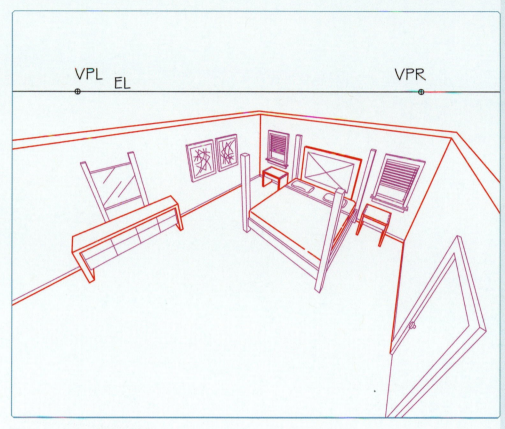

This is an example of Project 10.3.

APPENDIX A

PERSPECTIVE
GRIDS

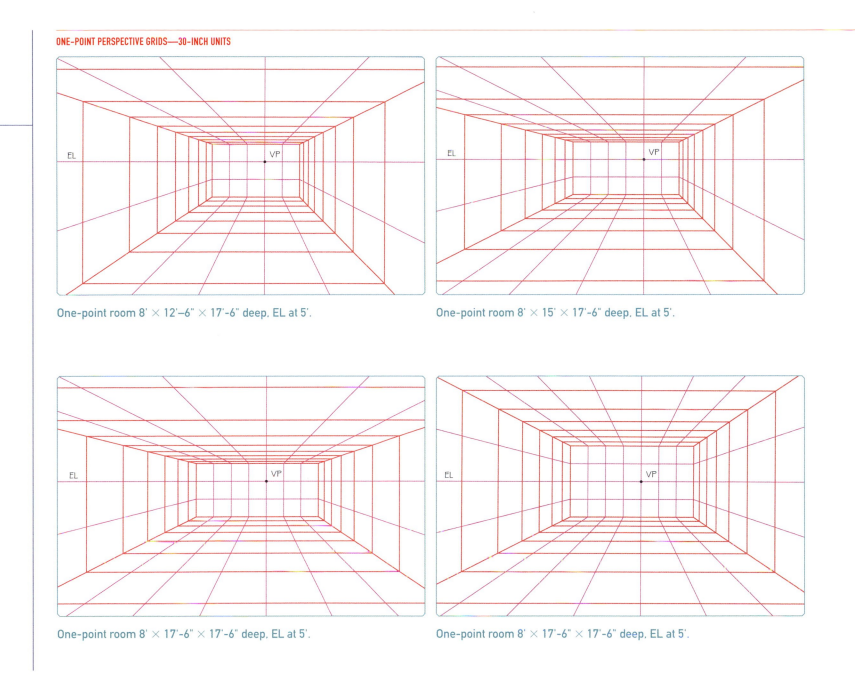

One-point room 8' × 12'-6" × 17'-6" deep, EL at 5'.

One-point room 8' × 15' × 17'-6" deep, EL at 5'.

One-point room 8' × 17'-6" × 17'-6" deep, EL at 5'.

One-point room 8' × 17'-6" × 17'-6" deep, EL at 5'.

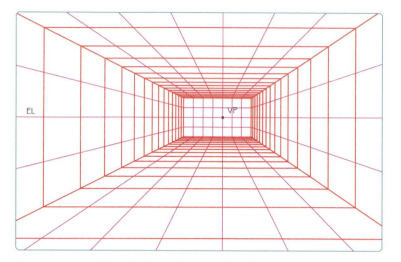

One-point room 12' × 17'-6" × 35' deep. EL at 5'.

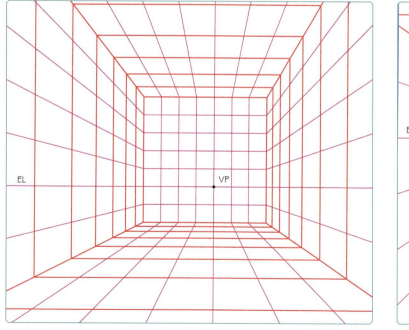

One-point room 17'-6" × 17'-6" × 17'-6" deep. EL at 5'.

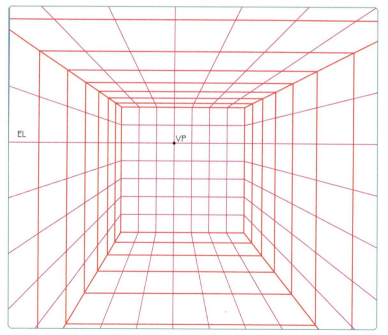

One-point room 17'-6" × 17'-6" × 17'-6" deep. EL at 15'.

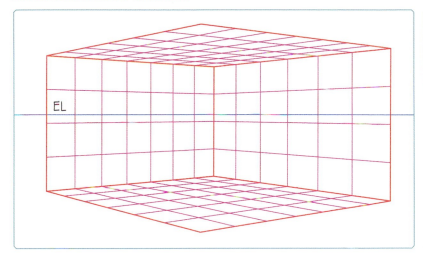

Two-point room 17'-6" × 15' × 10' high, EL at 5'-6".

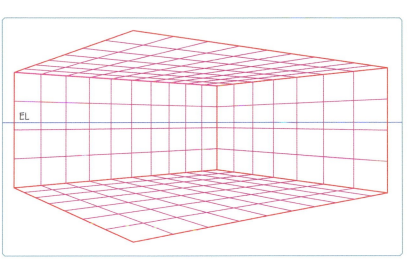

Two-point room 25' × 17'-6" × 10' high, EL at 5'-6".

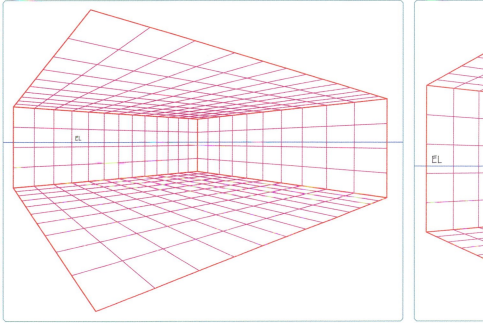

Two-point room 32'-6" × 25' × 10' high, EL at 5'-6".

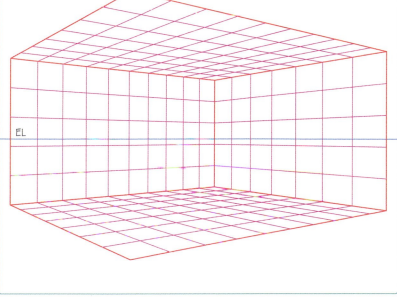

Two-point room 25' × 17'-6" × 12'-6" high, EL at 5'-6".

APPENDIX B

BASIC METRIC CONVERSION TABLE

DISTANCES

ENGLISH	METRIC
1 inch	2.54 centimeters
1 foot	0.3048 meter / 30.38 centimeters
1 yard	0.9144 meter

METRIC	ENGLISH
1 centimeter	0.3937 inch
1 meter	3.280 feet

WEIGHTS

ENGLISH	METRIC
1 ounce	28.35 grams
1 pound	0.45 kilogram

METRIC	ENGLISH
1 gram	0.035 ounce
1 kilogram	2.2 pounds

GENERAL FORMULA FOR CONVERTING:

Number of Units \times Conversion Number = New Number of Units

TO CONVERT INCHES TO CENTIMETERS:
[number of inches] \times 2.54 = [number of centimeters]
To convert centimeters to inches:
[number of centimeters] \times 0.3937 = [number of inches]

TO CONVERT FEET TO METERS:
[number of feet] \times 0.3048 = [number of meters]

TO CONVERT METERS TO FEET:
[number of meters] \times 3.280 = [number of feet]

TO CONVERT YARDS TO METERS:
[number of yards] \times 0.9144 = [number of meters]

TO CONVERT OUNCES TO GRAMS:
[number of ounces] \times 28.35 = [number of grams]

TO CONVERT GRAMS TO OUNCES:
[number of grams] \times 0.035 = [number of ounces]

TO CONVERT POUNDS TO KILOGRAMS:
[number of pounds] \times 0.45 = [number of kilograms]

TO CONVERT KILOGRAMS TO POUNDS:
[number of kilograms] \times 2.2 = [number of pounds]

GLOSSARY

A

Above eye level Where the object is drawn above the horizon line, or looking up at the object.

Alternate vanishing point (AVP) Created for surface area that is angled, such as a pitch roof or interior vaulted ceiling.

B

Below eye level Where the object is drawn below the horizon line, or looking down at the object.

Bird's-eye view Where the object is drawn below the horizon line, or looking down at the object. In a three-point, the horizon line or eye level line is close to the top of the paper.

C

Center axis of vision Refers to the center of the cone of vision; therefore, the center has a 30-degree angle to each side, making up the cone of vision.

Cone of vision A 60-degree cone, which is the limit of the human eye. In a perspective drawing items outside this cone can be distorted because they are in the peripheral vision of the eye.

E

Eye level (EL) Same as the horizon line. Eye level is the term used for interior drawings because the actual horizon may not be seen.

Eye-level view Where the object is drawn over or in front of the horizon line, so that part of the object is slightly above and below the horizon line.

F

45-degree vanishing point A point created by dividing the one-point footprint diagonally and extending the line until it reaches the horizon line. Dividing the footprint on each side creates two 45-degree lines, which can be used to draw objects in two-point perspective.

Frog's-eye view Where the object is drawn above the horizon line, or looking up at the object. This is also known as **worm's-eye view.** In a three point, the horizon line is close to the bottom of the paper.

G

Ground line (GL) The base line of a room or object. Some drawings use a ground line in the setup stages.

H

Horizon line (HL) Represents the eye-level view in the drawing; known as *eye level* in interior drawings.

M

Measuring points (MPL and MPR) Create the ability to use standard units to develop measured volume in the perspective.

P

Perspective drawing Creates three-dimensional depth in one-, two-, or three-point views on a flat two-dimensional surface.

R

Reflection A mirrored image on an object.

S

Shadow The image cast on the ground by an object from blocking light.

Station point (SP) Represents the placement of the view in relationship to the object or the room.

Surface plane In perspective, this refers to a complete side of an object.

V

Vanishing point (VP) This single point in the one-point perspective represents where lines are drawn from to create distance and is placed on the horizon line or eye-level line; therefore, any line traveling from the front to the back of an object will line up with the vanishing point.

Vanishing point left (VPL) In a two-point perspective, one vanishing point is to the left of the center of the picture plane and on the horizon line or eye-level line; therefore, any line traveling from the front to the back on the left surface plane lines up with the vanishing point left.

Vanishing point right (VPR) The second point in the two-point perspective is to the right of the center of the picture plane and on the horizon line or eye-level line; therefore, any line traveling from the front to the back on the right surface plane lines up with the vanishing point right.

Vanishing point vertical (VPV) The third point in the three-point perspective is at the bottom center of the drawing. This is the point from where the vertical lines are drawn.

INDEX

A

accessories, furniture, 234–36
alternate vanishing point (AVP), 54–55, 57, 203–4

B

barstools, 86, 89
beams, exposed, 45–46
beds, 88, 130, 133, 135
bird's-eye view, 23
buildings. *See* exterior structures

C

ceilings, 42–47, 74, 126, 191–205
chairs, 62–64
 barstools, 86, 89
coffee tables, 85
cone of vision, 5, 54–55
cones, 20, 27, 272
conversion tables, 294–95
cross-hatching, 103–4
cubes, 16–18, 24–25, 35, 144, 268–70, 274
 shadows, 216, 219
 transforming into a sofa, 38–39
 transforming into a table, 36–37, 58–61
cylinders, 21, 28, 273